Sold

Frances S. Sward 42
2825 Greenvale St.,
Chevy Chase, Md. 20015

Frances S. Sward 42
2825 Greenvale St.,
Chevy Chase, Md. 20015

Painting and Drawing Children

Painting and Drawing Children
by John Norton

WATSON-GUPTILL PUBLICATIONS/NEW YORK

PITMAN PUBLISHING/LONDON

Copyright © 1974 by Watson-Guptill Publications

First published 1974 in the United States and Canada by Watson-Guptill Publications,
a division of Billboard Publications, Inc.,
1515 Broadway, New York, N.Y. 10036

Published in Great Britain by Pitman Publishing Ltd.,
39 Parker Street, Kingsway, London WC2B 5PB
ISBN 0-273-00804-8

Library of Congress Cataloging in Publication Data
Norton, John, 1919-
 Painting and drawing children.
 Bibliography: p
 1. Children—Portraits. 2. Children in art.
 I. Title
N7643.N67 1974 757'.5 73-18055
ISBN 0-8230-3555-7

Manufactured in U.S.A.

First Printing, 1974
Second Printing, 1975
Third Printing, 1977

To my father; to Mimi Lineaweaver,
a devoted friend and patron of art and artists;
and to my daughters Jane and Patti.

Acknowledgments

I would like to thank Paul Laib and Fedor Bunge of London and Mr. Taylor of Taylor and Dull, New York, for their patience and skill in producing all the color transparencies for this book; Janette Field for her neat and indefatigable typing of part of the manuscript; and last but not least, Diane Casella Hines, Don Holden, and my editor, Lois Miller, who have been extremely patient and most encouraging as they helped to put this book together with such finesse.

Contents

Introduction

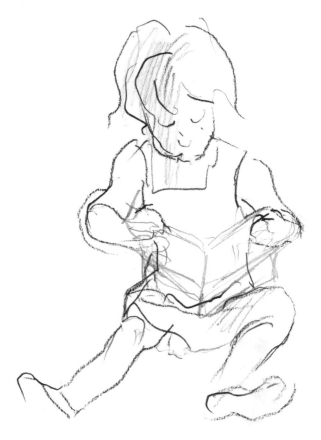

Throughout the history of art, children have been an inspiration and challenge to painters and sculptors all over the world, There are few great artists among these who have not responded to this challenge; most, if not all, have portrayed the seven ages of man, starting with the age of innocence. Some, such as Leonardo da Vinci, Velázquez, Rembrandt, Cézanne, and Picasso, produced masterpieces around the beauty and the innocence of children.

Children first appeared as angelic symbols in altarpieces painted throughout Europe during the Middle Ages and early Renaissance. They became the subjects of portraiture in the latter period, when feudal families such as the Medici, Gonzaga, and Sforza commissioned likenesses of their princely offspring. The royal houses and the bankers of Europe then followed, providing ample work for the great painters of the seventeenth, eighteenth, and nineteenth centuries and thereby making them famous.

The French impressionists finally introduced a new and revolutionary departure to the art of portraiture. In their work, they suppressed pure likeness—painting a record—by substituting a feeling for form for its own sake and emphasizing the value of color as an independent phenomenon. This provided the art of painting children with a new inspiration and impetus, thereby giving the world a gallery of masters of the new idiom.

During the past twenty or more years as a painter, I have spent many of my most enchanting moments in the company of little children. I can think of instances when a mood of depression was dispelled by their chatter or laughter, when an overpowering look of fresh innocence or a guileless

remark took my mind off all the disturbing influences that are experienced each day.

In the days of my apprenticeship, everything to do with art had a glorious, carefree ring. It was not until I came under the influence and direction of the late Harold Speed, who was a severe taskmaster at Goldsmiths College, London, that I was trained to accept new terms and values. Until then, I had approached art with the happy-go-lucky abandon of the bohemian spirit.

In fact, Speed produced an exhaustive textbook entitled, *Practice and Science of Drawing*, which I have listed in the Bibliography at the back of this book, and which I consider to be one of the best books written on this subject during his time. Through the years, the title and contents of this book have not escaped me. To a great extent, drawing remains a science for me, although its character and my feeling for it have changed, largely through the influence of such giants of draftsmanship as Leonardo, Tiepolo, Rembrandt, Daumier, Goya, Picasso, and Klee.

From science to romanticism to philosophy, these men have contributed their disparate interpretations to one of the most expressive languages man has at his disposal. But drawing and painting are in essence one and the same thing; as that controversial Frenchman and great art critic André Malraux says in *Saturn: An Essay on Goya* (listed in Bibliography), "The line that Goya was trying to grasp by means of nightmares, the line that would free from the theatre the human form, the setting of a picture and the world, is almost Rembrandt's. Rembrandt had in effect invented a new method of picture making. . . . Rembrandt had been the first to abandon out-

line. It is said that he put light in its place! he put a field of expressive signs in place of illusion. He seems to have worked from inside."

And he further says, "There is in some of Rembrandt's later work . . . a line that is crushed, stretched, and to all appearances diffident—this diffident line was going to change the whole world's method of drawing! . . . Goya took up the process where Rembrandt left it. He also worked for preference with a brush; he was also looking for a particular revelation; he was also less intent on the face than on movement, less on movement than on setting, less on setting than on complicated dramatic message whose unity produces the unity of the print or the picture and creates for him a work of art."

I had intended to keep this introduction as brief as possible, but felt it was necessary to quote André Malraux on these two great artists, to whom the language of drawing was everything. As I said earlier, the frontier between drawing and painting is barely visible; again, as Malraux says, "Rembrandt had in effect invented a new method of picture making."

Such a comparison between drawing and painting shows us that there are obviously many ways of doing each, since they are, after all, very personal means of self-expression. In this book I will attempt to show you how I as an individual portray children. I will try to explain something about the variety of mediums I use in my work, each of which I have found stimulating for one reason or another.

Indeed, one medium seems to encourage or suggest a new approach in another. I have sometimes arrived at a solution to a problem of creative portraiture by using two or more mediums together, just as many others have done before me.

I am then not sure whether to describe the result as a drawing or a painting!

For me, technique has always been a means to an end and not an end in itself. I feel that the whole art of painting should be spontaneous and effervescent, not bogged down by laborious technique. Only in this way can an artist maintain a quality of vitality in his work. As Jean Paul Sartre says in his powerful essay on Tintoretto in *Situations* (see Bibliography), "The logic of the eye should be respected, but at the same time, vanquished by the logic of the heart."

The canvas or paper should be alive with feeling and insight. But in order to give full reign to self-expression, mastery of the means, be it painting, singing, or dancing, is imperative. Self-expression should be a conscious and disciplined "happening."

"Education," said Paul Klee, in *The Thinking Eye*, "is a difficult chapter. The most difficult. The education of the artist above all. Even if one supposes it to be continuous, even if one supposes that there might be a certain number of real educators, many remain within the realm of the visible, because it is enough for them. Few get to the bottom and begin to create. Most stick rigidly to theories because they are afraid of life, because they dread uncertainty."

I hope this book will offer you some essential guidelines along with my exhortations to observe closely and practice diligently, using the medium that appeals to you. Store this knowledge away in your subconscious, so that you can then draw or paint children with skill and pleasure.

When you paint little children, there is no time to think or hesitate—you must act. You may sometimes feel like a street musician, who is a one-man band trying to play all the instruments at once!

I am sure you will have as much fun as I have had and I wish you the best of luck—you will need it!

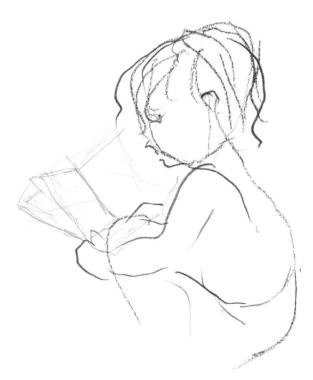

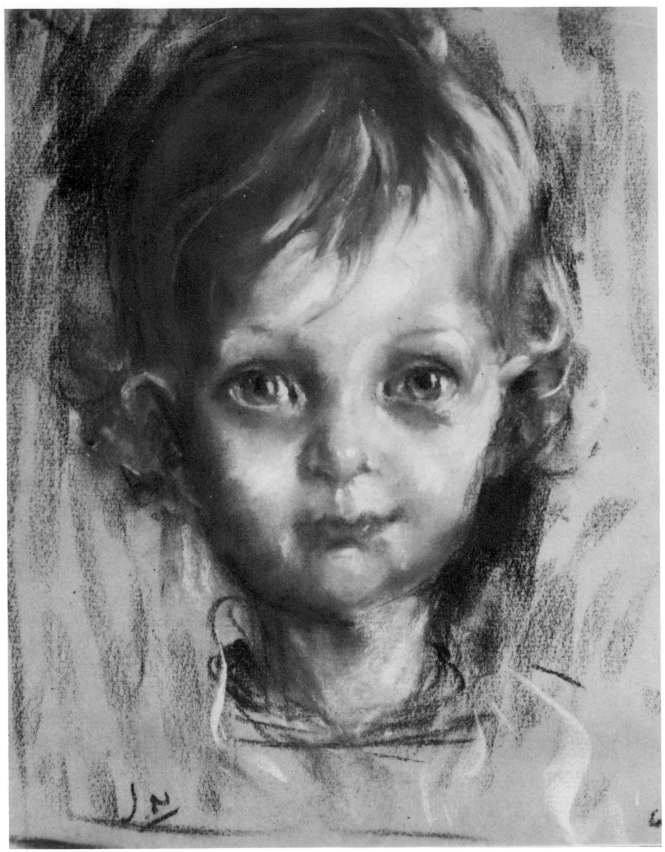

Emma de Vere Hunt. *Pastel on paper, 19" × 22". Collection Mr. and Mrs. John de Vere Hunt. I used soft and subtle grays on lilac paper to capture the lively face of this little girl, who was barely two years old.*

Chapter 1
The Anatomy of Children

While it is not necessary to become a professor of anatomy, any attempt to draw the human figure would be futile without some knowledge of and sensitivity for its anatomical construction. In drawing and painting children, it is essential to remember that there is more flesh and less formed bone in the head and body; hence that quality we generally describe as chubbiness. As the muscles are not fully developed, a child's limbs are also soft and round.

Further, since a child's vertebrae are unformed and therefore do not supply the rigid support necessary for erect posture, there is invariably a marked concave curve at the back and a protuberance of the stomach in front.

The Figure

When you draw a child's full figure either nude or draped, search for the substance beneath the flesh. The development of form as well as the play of light and shadow will be meaningless if not based on the knowledge of and feeling for anatomical structure. Attention to the obvious manifestations of the bony eminences will make all the difference between a good drawing and a weak and incoherent one. Accurate indications of the distribution of weight from the center of gravity, appropriate use of foreshortening or perspective, and a feeling for balance, mass, and line all help to give a drawing life and a sense of reality.

As you observe the figure, note for instance that the shoulder blade, the bone known as the scapula, is obvious when the arm is flexed and that the humerus, the bone of the upper arm, indicates a twist in the arm. The tarsal bones of the foot help to give the foot distinctive form and describe the direction of its planes. When

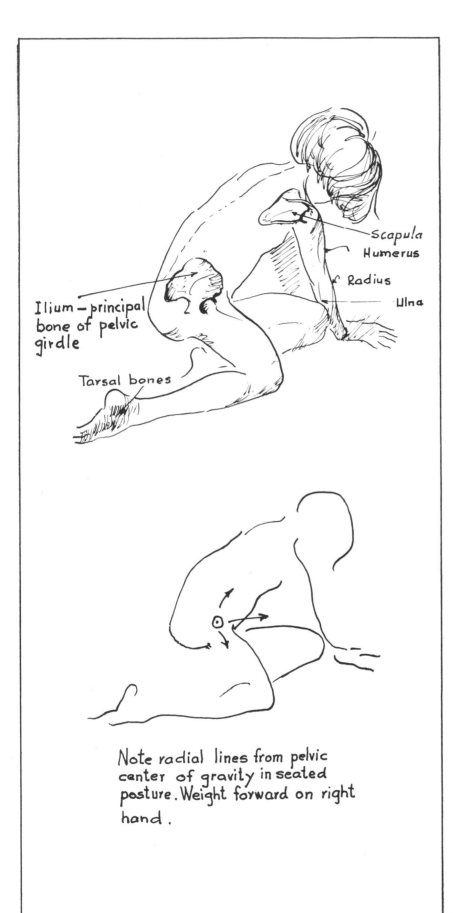

Ilium — principal bone of pelvic girdle

Scapula
Humerus
Radius
Ulna

Tarsal bones

Note radial lines from pelvic center of gravity in seated posture. Weight forward on right hand.

viewed from a lateral, or side, position, the vertebral column, or spine, presents yet another interesting visual quality in the rhythm of the concave and convex curves formed by the twenty-four true (articulated) and nine or more false (fused) vertebrae. Together with the intervertebral cartilages, these curvatures act as buffers to counteract the effects of violent physical shock.

Figure Proportions

Children's figure proportions are vastly different from those of adults. The height of a newborn baby is four times the length of its head, while a full-grown adult is between seven and a half and eight heads tall. Because the thyroid is still small, the neck of a child is quite short and almost contiguous with the shoulders.

As compared with those of an adult, the limbs of a child are short in relation to the torso. Consequently, the mid-height of a very young child occurs at the level of the navel, while that of an adult is located in the pubic region. As the child grows, the limbs lengthen and these proportions change significantly. At the age of one year, a child is four and a half heads tall; from then until the age of six the body grows to five or five and a half times the length of the head. The mid-height at age six is located between the navel and the pubic bone.

From ten to fifteen years of age the body reaches between six and seven heads in height. Since the proportion of arms to body is by this time the same in children as it is in adults, a child's hands reach almost to the middle of the thigh when the arm hangs at the side of the figure.

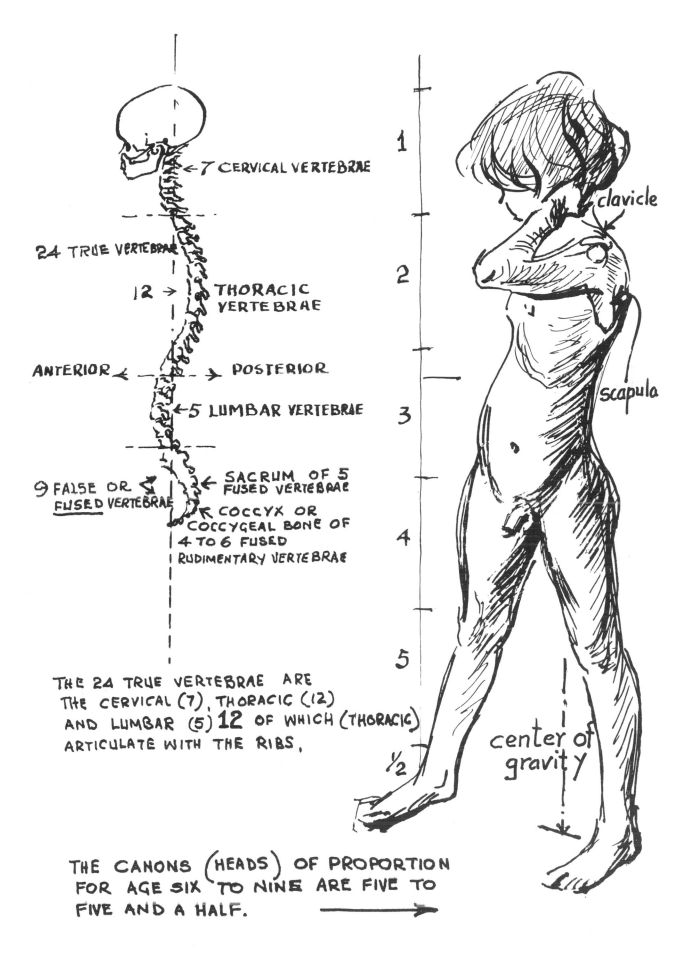

7 CERVICAL VERTEBRAE

24 TRUE VERTEBRAE

12 → THORACIC VERTEBRAE

ANTERIOR ← → POSTERIOR

5 LUMBAR VERTEBRAE

9 FALSE OR FUSED VERTEBRAE

SACRUM OF 5 FUSED VERTEBRAE

COCCYX OR COCCYGEAL BONE OF 4 TO 6 FUSED RUDIMENTARY VERTEBRAE

THE 24 TRUE VERTEBRAE ARE THE CERVICAL (7), THORACIC (12) AND LUMBAR (5) **12** OF WHICH (THORACIC) ARTICULATE WITH THE RIBS.

THE CANONS (HEADS) OF PROPORTION FOR AGE SIX TO NINE ARE FIVE TO FIVE AND A HALF. ⟶

clavicle

scapula

center of gravity

15

The Hands

In the early stages of infancy and childhood the hands are just beginning to develop the tactile sense, and their uses are therefore basic, simple, and limited in expression at this stage. Keep this in mind and draw children's hands with a feeling of roundness and simplicity. Remember too that the fingernail should never be drawn to fit the outline of the finger—look for its own distinctively shaped edge.

The hand of a child develops from the cartilaginous state at birth to the bony and skeletal form typical of later growth. The joints of extension in a child's hand are therefore suggested by dimples rather than by bony eminences and folds of skin. The wristbone is obscured by folds of integument (external covering) and the outline is therefore smooth and round rather than sharp.

The joints are capable of unlimited extension because of the softness of the bones. As you can imagine, the hand is capable of a variety of movements: it can be flexed or bent to an acute angle, extended, abducted (moved away) from the mid-line, and adducted (moved toward) the mid-line.

In addition to these movements involving the hand and four fingers, the thumb can also rotate around an imaginary axis. The structure of the thumb differs from that of the fingers in that the thumb has two joints with saddle-like articular surfaces, whereas the fingers have three carpo-metacarpal joints and can extend in a semi-circle from the center of the palm.

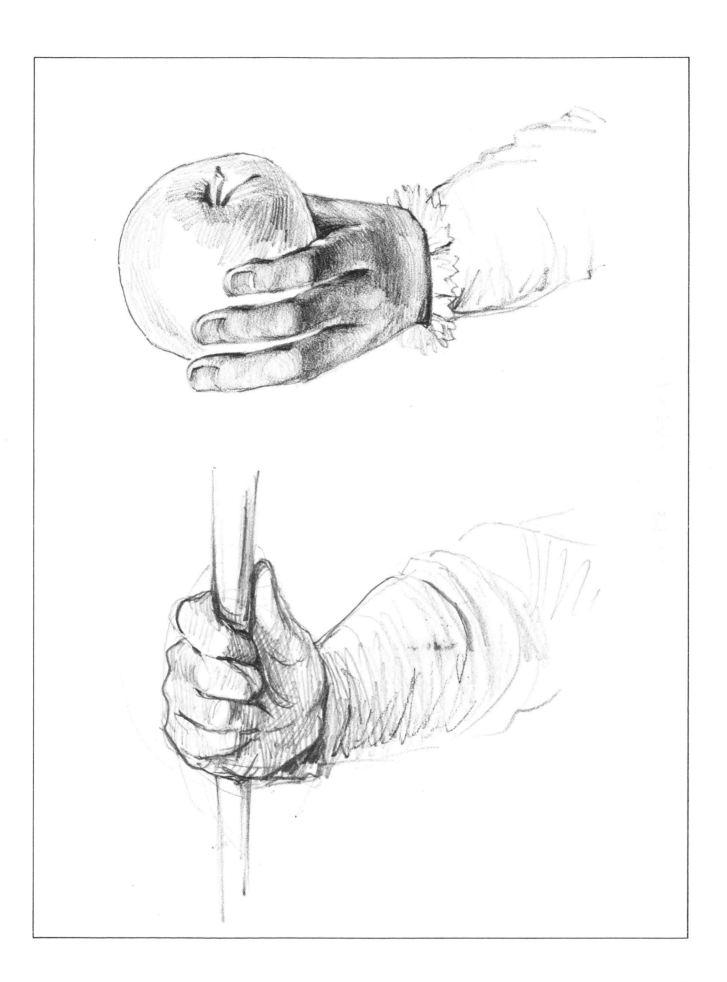

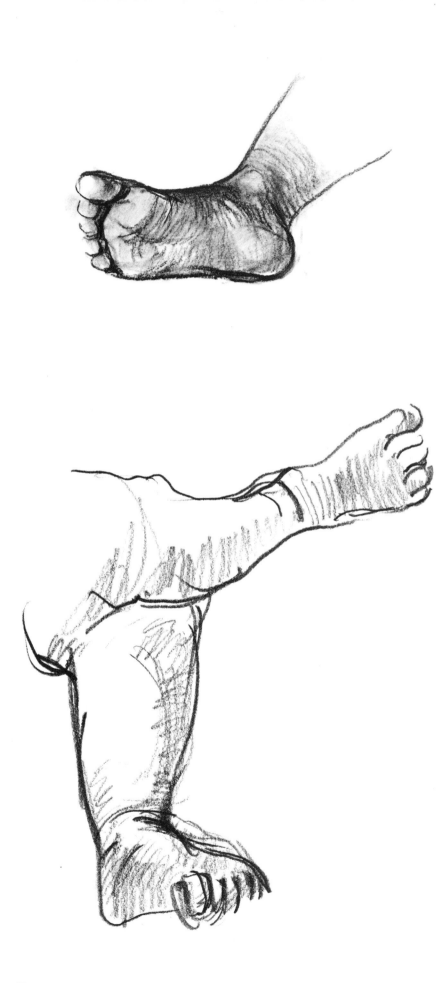

The Feet

Since even a child's foot carries the full weight of the body, it is important to understand its architecture, however superficially. Like the rest of the body, the foot is well padded with flesh and the bones are therefore obscured from view. However, knowing where these bones are located under the surface will help in developing the form of the foot in a natural way.

The foot has three basic points of support that you will begin to notice as you draw children in action and repose. To describe and illustrate the anatomy of the foot alone would require several pages, so I will mention only these three basic regions of support. The tarsus is the series of bones located around and containing the heel bone, or calcaneum. The metatarsus is the group of bones that connect the foot with the leg and the heel with the toes. The toes themselves comprise the third area of support.

When the weight of the body is thrust upon the instep, the metatarsal bones act like a spring and become less convex. When the pressure is removed, this part of the foot returns to its convex state. Owing to its elasticity and load-bearing qualities, the role of the arch consists of diminishing the jolt to the foot that results from walking. The metatarsal bones conduct the shock in the direction of the head and walking thus becomes smooth. The toes too behave like springs and also play a leading role in walking. When the heel is raised the elastic removal of the foot from the ground is made possible.

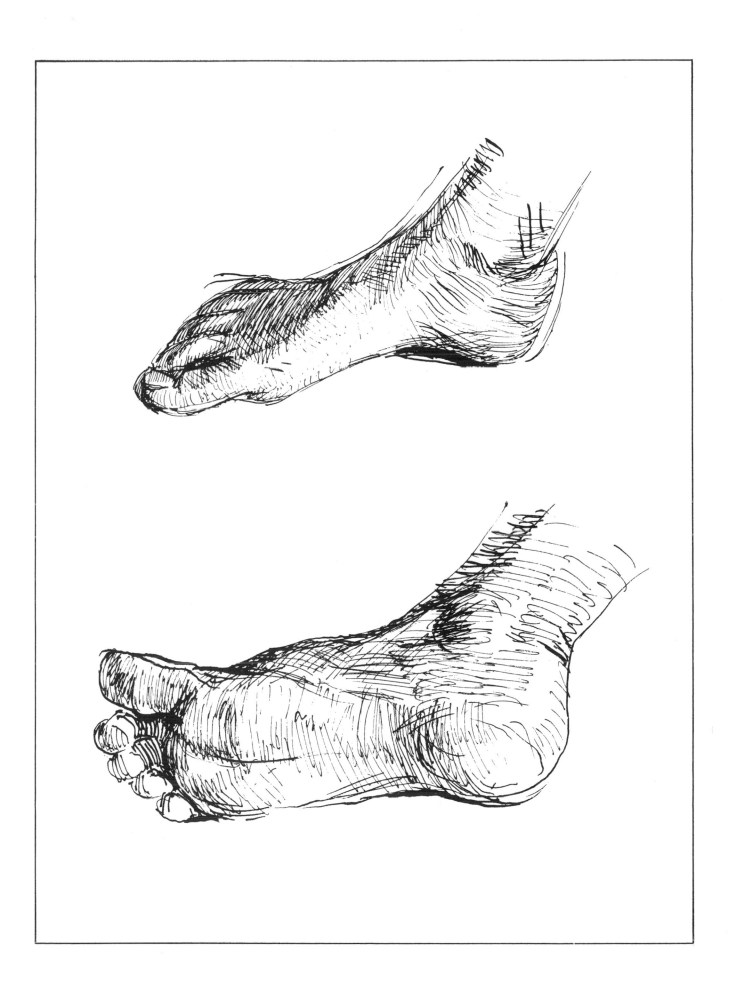

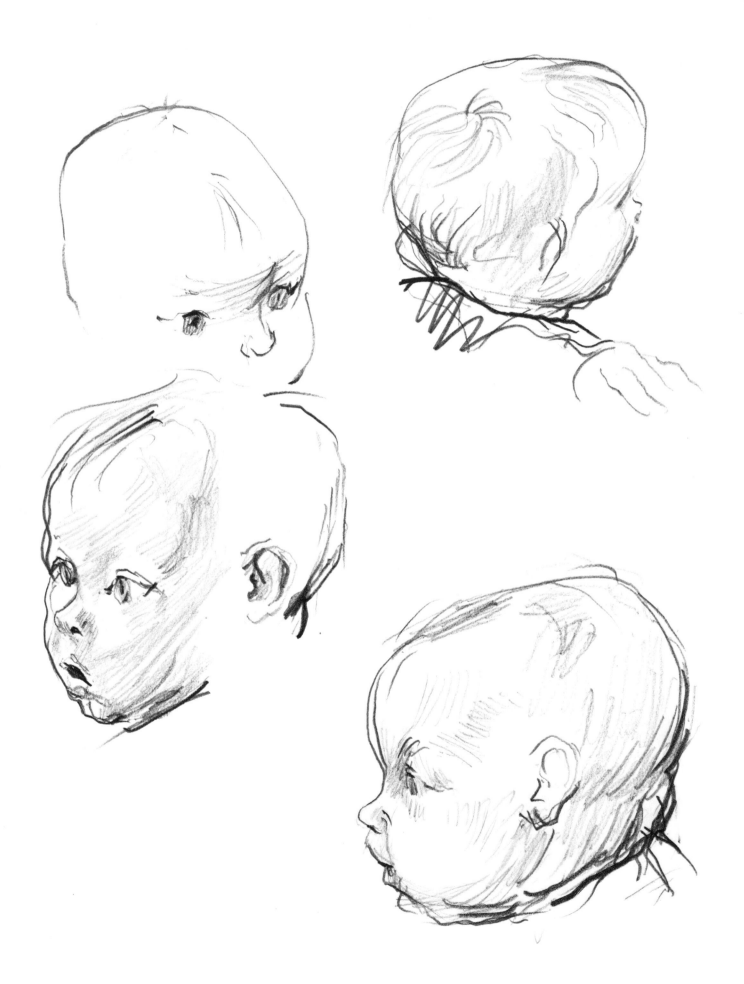

The Head

Since the art of child portraiture involves painting likenesses of particular children, close and meticulous study of each child's head and features, as well as of the interrelationship of the head and features, is called for. Toward this end, the study of the anatomy of the head, at least superficially, is important if not imperative.

There are innumerable angles at which the head can be tilted when being portrayed, and when you consider the conditions and the time factor involved in painting a child's portrait you will soon realize the difficulties you will have to face at every sitting. In fact, you will encounter what is almost the supreme test for the draftsman.

"The head is an egg" is an axiom for the portrait painter, and you will find you cannot be reminded of this often enough when you are faced with the formidable task of drawing or painting a child's head truthfully. When viewed from above, in front, or from the side, the skull is oval; from behind it is more or less spherical. Basically there are two groups of bones forming the skull: the calvaria, which protects the brain, and the group that forms the face and protects the sense areas. The mandible or lower jaw is the only movable bone in the skull.

An infant's or child's head is narrow in front and wide at the back and tends to sit less erect and firm on the spinal column than does the head of an adult. Boys' heads have more abrupt curves and lack the subtle changes of plane that distinguish girls' heads; as a general rule, girls' mouths, cheeks, and hairlines are softer and more fluid than boys'.

The head of a child differs from the head of an adult in that a child's head is rounder and larger in proportion to the overall height of the figure: its cerebral section is larger in proportion to the size of the whole head; the orbital cavities (eye sockets) and the large occiput (back part of the head) are also larger. A child's jaws are shallow, partly due to the absence of adult teeth, and the distance from the center of the orbital cavity to the chin is shorter in proportion to the height and depth of the cerebral section than that of an adult.

The form of the "egg" also suggests continuous changes of plane, as well as foreshortening, and requires careful attention to perspective. The head is a three-dimensional form described by three axes: vertical, horizontal, and sagittal. As the planes that lie along these axes get farther away from you, they appear to diminish in size. As I will discuss in a later chapter, the use of tonal values is essential in accurately describing the head in perspective.

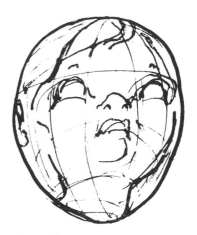

The Head is an Egg.

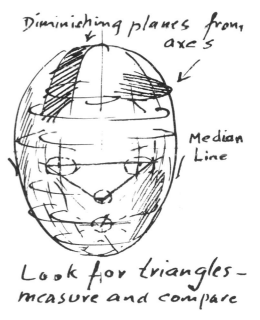

Diminishing planes from axe's

Median Line

Look for triangles— measure and compare

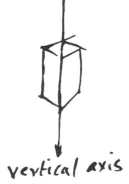

vertical axis

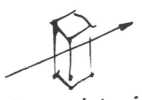

horizontal axis

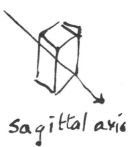

sagittal axis

Placement of the Features

The eyes of a child are placed below the mid-line of the head while those of an adult are located at the mid-line, and a child's eyes are larger in proportion to the rest of the face than are the eyes of an adult. Because they are in line with the eyes, a child's ears are also low on the head. The chin, mouth and nose are small and the nasal bone is flat, thereby projecting a concave nasal outline. The checks are pendulous and press forward.

All this compactness and fullness of form must be studied carefully, as the slightest deviation from accuracy in placing each feature in relation to the others will alter not only the likeness but also the expression of the subject. Study the triangles formed between the eyes and the tip of the nose, between the eyes and mouth, and the distances between the features. Notice also that when the features rest on horizontal lines, the face appears to be in repose; alterations above or below this horizontal axis change the expression to suggest either a happy look (corners turned up and above the line) or a disagreeable look (corners turned down).

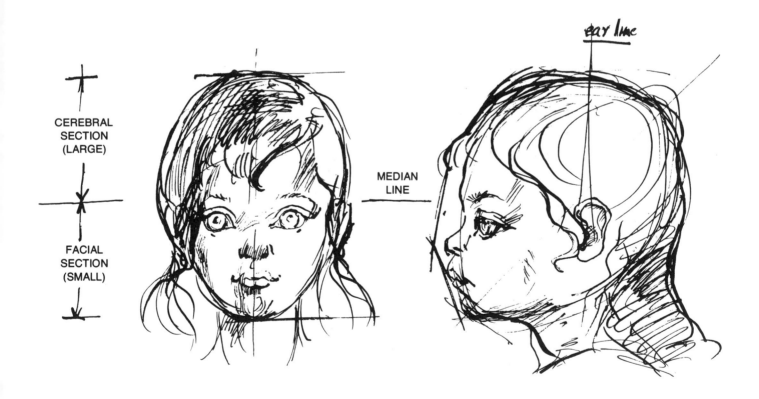

CEREBRAL
SECTION
(LARGE)

FACIAL
SECTION
(SMALL)

MEDIAN
LINE

ear line

Proportions of a two-year-old child's head.

Facial angles and divisions.

The Eyes

The orb of a child's eye fills the cavity, or socket, so that little of the white is visible. You will find that this hollow socket runs smoothly into the bony prominence at the top of the nose and that the rest of the edge around the socket is sharp. The eyebrow at first follows the upper contours of this bony socket and soon ends at the far corner of the eye leading toward the temple. The character of childrens' eyes varies greatly and is often modified by the degree of fleshy fullness that fills the space between the eyelid and the brow.

When drawing or painting an eye it is important to remember that what we call the white of the eye is part of a sphere. This sphere, or orb, displays the light and shadow values typically found on spheres. If the light is coming from the right, for instance, the left side of the sphere will be in shadow, and vice versa.

Note also where the upper eyelid meets the fleshy area beneath the eyebrow and that a variety of planes occur at this juncture. Inaccurate construction of the upper and lower eyelids is a common fault in poorly painted portraits.

The eyelashes do not count for much in drawing a head, except insofar as they affect the general tone or impression. They shade the white of the eye when the light is coming from above. However, since the lashes are much thicker on the outer than on the inner corner of the eyelid and have a tendency to grow in an outward direction, they do not create a significant shadow when the light shines through the lashes at the inner corner.

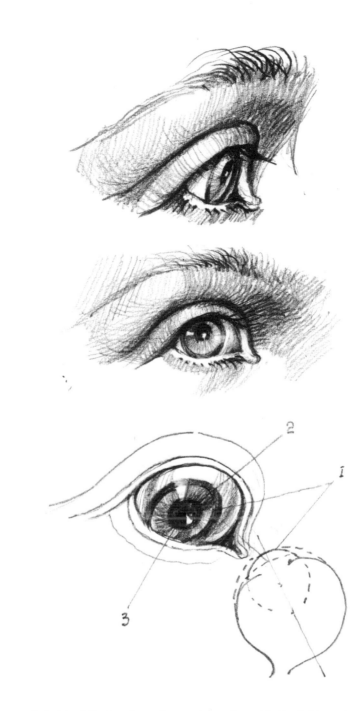

The pencil sketch at the top shows the eye in profile, with the light coming from the upper left. The eye in the middle is in three-quarter view. The sketch at the bottom is an exaggerated drawing of the eyeball, with its shell-like cartilaginous lid. The cornea (1) is transparent and projects beyond the eyeball. It protects the iris (2), which gives the eye its color. In or slightly above the center of the iris is the lens-like pupil (3), which dilates or contracts in reaction to light; the less light the eye receives, the wider the pupil opens.

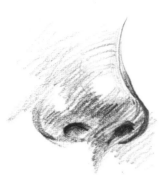

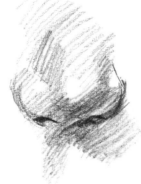

The Nose

The nose, particularly in very young children, is mainly composed of cartilaginous flesh, and the root or area where the nose leaves the forehead is shallow and does not indicate much change of plane. The tip, or apex, of a child's nose is fleshy and rounder than that of most adults, except in such cases as the well-known Mr. Micawber in Dicken's classic *David Copperfield*—the gentleman who liked his ale!

As you draw the shadow cast by the tip of a child's nose, notice that it follows and therefore helps describe the curve of the upper part of the mouth, the area between the nose and the upper lip. Indicating these contours accurately will make all the difference in the likeness or expression of the face.

The Mouth

Since the shape of a child's mouth is determined by the lips, they must be studied very carefully. It is always difficult to draw or paint the mouth. As you study children's faces, notice how soft and supple a child's mouth is, how perfectly designed by nature for the act of sucking. The upper lip is longer than the lower and protrudes beyond it. There is a central bulge or "cherry" on the upper lip that fits snugly into a corresponding concave curve in the lower lip.

Observe the difference in tone between the lower and upper lips and the cast shadow that occurs where the upper lip rests upon and follows the contours of the lower.

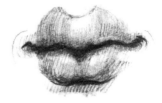

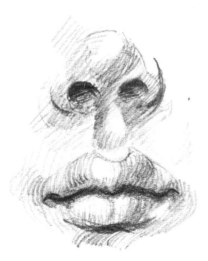

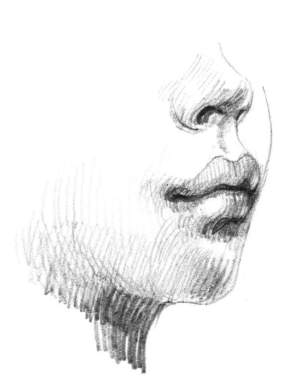

The Hair

When depicting hair, it is important to realize that different types of hair require different treatments. The particular beauty in drawing or painting hair lies in the swing of the lines, the flow of the waves, and the fall of hair as it follows the curves of the head and neck. Girls' hair is soft where it joins the nape of the neck; boys' is usually abrupt.

It is equally important to observe the direction taken by the hair of a child's eyebrow. Scant hair grows nearest the nose; this should be indicated in light tones. Then the hair suddenly reaches its thickest growth, requiring the darkest tones. Immediately after this juncture, the hair thins out again into a fine line that extends toward the temple, where the tone should become light again. The shape and qualities of the edges of the eyebrows are also important in achieving a likeness and describing an expression.

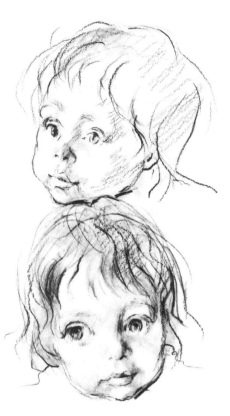

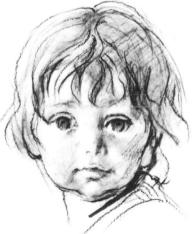

Racial Characteristics

One of the great attractions of drawing children is the never-ending variety of them. Within each of the three racial groups-Caucasoid, Mongoloid, and Negroid—there is a sufficiently stimulating prospect before the keen artist, who will seldom tire of his range of subjects. Whether on a bus, train, ship, or plane, I always see potential subjects for pencil or pen and ink drawings. I usually carry a sketchbook and a few sharpened pencils, and as soon as I become bored with my newspaper I bring out my sketchbook and draw my fellow passengers.

Getting to know the differences between racial types is a highly rewarding study, and the science of anthropology makes it quite fascinating. Without dabbling in anthropology, however, I think it would not be out of place to point out some of the features distinctive to each racial type. Like all other aspects of drawing and painting children, each item of knowledge acquired in this area will improve the visual awareness of the artist.

Each racial type has its own distinctively shaped skull. For instance, it is interesting to observe the differences between the skull of a Singhalese child, whose occipital is flattened because Singhalese children are made to sleep on hard pillows from birth, and the round head of an Eskimo child, which has a backward tilt.

There are two basic types of eyes: the Mongoloid and the non-Mongoloid. The external angle of the Mongoloid eye opens higher tnan the internal angle; the non-Mongoloid eye is more deeply recessed in its socket, thereby casting a darker shadow. The most striking feature of the Mongoloid eye is the fold of the upper lid, which may run the whole length of the lid.

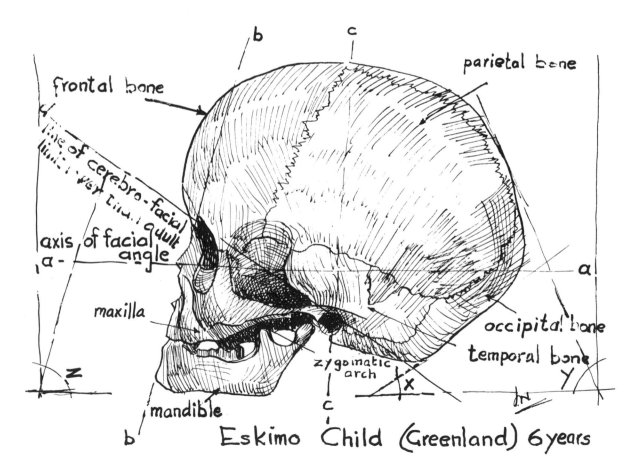

Eskimo Child (Greenland) 6 years

Noses vary greatly in size and shape, but for the sake of simplicity I will discuss them in terms of the three racial divisions. The Negroid nose is short and has a broad, depressed root; the bridge is also broad and may be concave or straight; the tip is thick and usually turned upward; the wings are thick and flaring; the nostrils are round. The Mongoloid nose is concave and in comparison to the Negroid nose it has a lower and narrower bridge, and thinner wings. Caucasoids are characterized by a nose that is often convex and narrow with a high root, long tip, and depressed wings.

There are other obvious differences between the features of the three races, in the mouth and ears for example, and these likewise require careful observation when you are drawing with accuracy in mind.

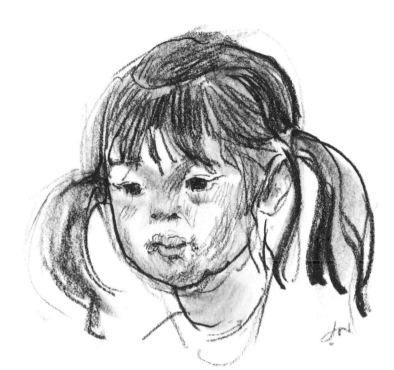

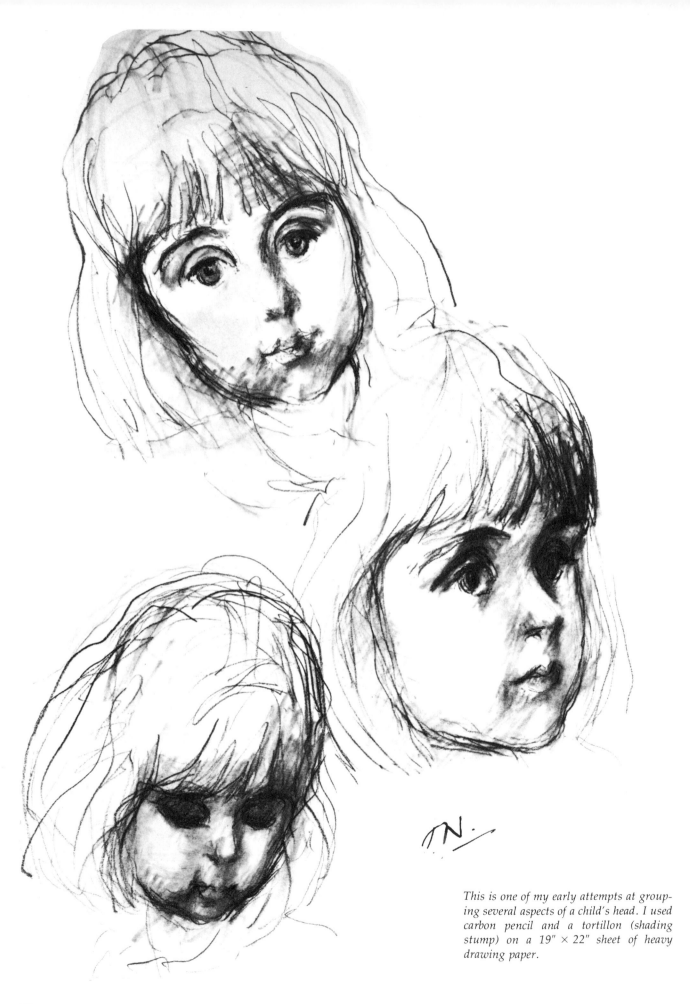

This is one of my early attempts at grouping several aspects of a child's head. I used carbon pencil and a tortillon (shading stump) on a 19" × 22" sheet of heavy drawing paper.

Chapter 2
Getting
to Know
the Sitter

Second in importance only to the ability to draw children is a fondness for them; an empathy with children is essential. This involves not only totally understanding the workings of a child's mind, but also being one with him.

First Impressions

You will probably agree that children are like young animals in that they can sense at once whether a stranger is friend or foe. When you face a child for the first time he can also sense whether you are relaxed and warm or ill at ease and impatient.

At the first meeting between painter and subject, and just before the first sitting, it is important to make a few quick mental notes of the shape of the child's head, his coloring, and any peculiarities about his features and posture. This first impression is necessary to the subconscious mind and tends to affect the outcome

of the portrait. Try to focus your analytical attention on faces as much as possible. It is also a good idea to get into the habit of unobtrusively studying the features and expressions of your subjects while talking to them or joining them for a family meal.

Child Psychology

I am sure most of us are aware that the two things a child does not have, which one assumes most adults possess, are knowledge and experience. Because of this lack, patience in dealing with children is essential to the painter. A really bad child is a rare phenomenon, and I must honestly say I have not yet come across one. I have had to draw and paint spoiled and difficult children, but I have found that with tact and patience such children can invariably be handled with some success.

Most children are easily bored

and just as easily distracted; it is therefore not difficult to entertain them with sufficient success to hold their attention and secure their cooperation during a sitting. Also, most children dislike being made to sit still. It is not in their nature, and being full of energy and curiosity they will, even if subconsciously, want to exploit the situation.

Therefore, plan your sittings with some sort of entertainment or distraction in mind, even if it only means getting the child absorbed in your equipment, paints, and so on. Above all, try to avoid talking down to a child, particularly a "grown-up" child or a teenager. You will achieve better results and cooperation by treating children as equals. Conversation of the right kind and level is important.

Parents and Domestic Help

Parents can be either a help or a nuisance, and the painter must decide early in the sitting whether he can do with their presence or should do without it. Some parents are thoughtful and considerate enough to realize that the artist's primary task is difficult and do not expect him to do many other things at the same time

that he paints their children. Unfortunately, many parents are strangely indifferent to the whole business yet look forward eagerly or hopefully to a charming masterpiece.

Nurses, nannies, governesses, babysitters, or whatever you like to call them, can likewise be either helpful or disastrous. You will quickly develop a sixth sense in deciding when to seek their help and when not to. Grandparents and other relations, not to mention well-meaning friends, will often gatecrash your sessions and offer help of one kind or another. Again, you will have to decide whether to decline or accept. I find isolation ideal.

Entertaining the Sitter

There are many ways of entertaining children for the short space of half an hour or an hour. Even though today's lifestyle does not provide painters with some of the advantages that Velázquez enjoyed when he painted those magnificent portraits of the children of Philip V of Spain, I think we can easily call upon today's resources. When Velázquez painted the *Infanta Maria of Spain*, he had the court dwarfs and the child's ladies-in-waiting, eight in all,

Below are some very spontaneous sketches of Nadia and Natasha Brooks-Baker, the finished oil portrait of whom is reproduced in color on page 89. The girls were painting and modeling with clay on the floor of my studio as I prepared my brushes. As I did not want to disturb them, I had to complete these sketches quickly and unobserved.

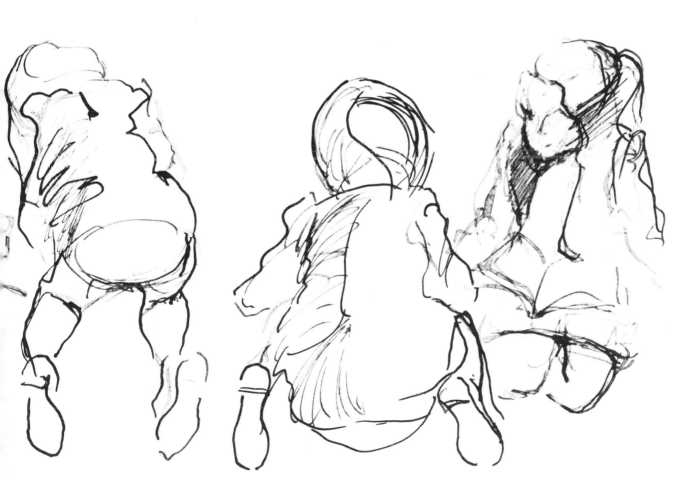

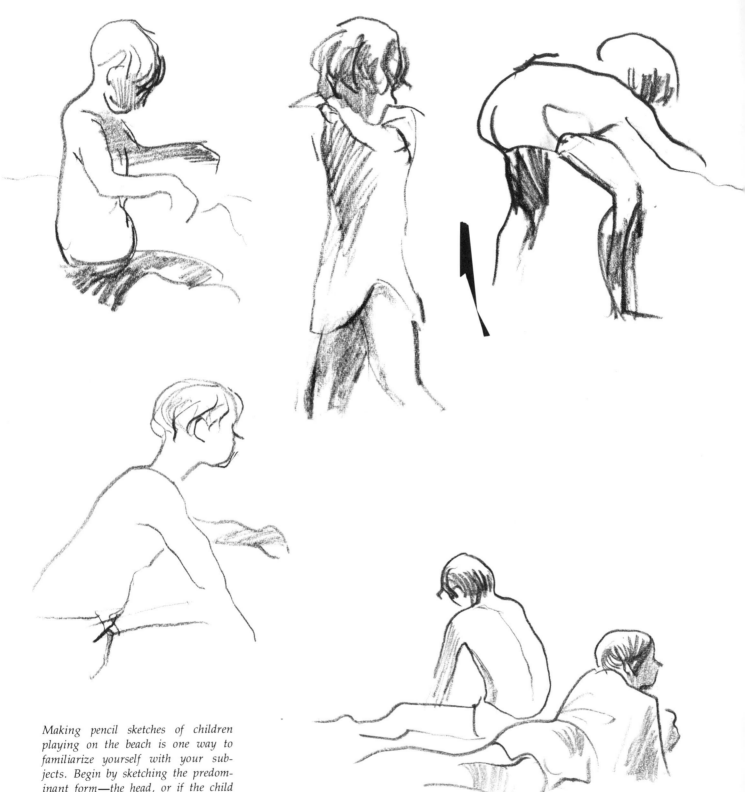

Making pencil sketches of children playing on the beach is one way to familiarize yourself with your subjects. Begin by sketching the predominant form—the head, or if the child is bending over, the rump. Gauge your proportions from this main form and use a free, loose line to lead along the path from one form to another. Allow yourself a maximum of two to three minutes for each sketch.

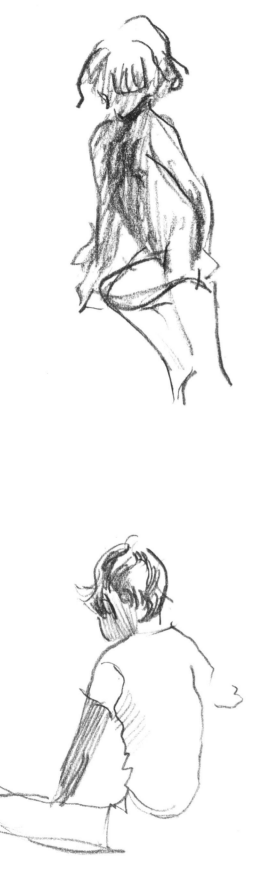

to entertain his royal subject.

Alas, the painter of today must resort to being his own clown, nurse, and companion to his young sitters. Although we cannot call upon lute players as Leonardo da Vinci did, we do have marvelous high fidelity music systems and a library of children's records to provide stimulating entertainment. There is also a vast library of children's books available, and you may have the occasion to call upon someone to read to the sitter while you draw or paint. I often tape record my own readings of children's stories and play the tapes as I paint. Many have been the occasions when I have had to lie flat on my stomach in a nursery and play with babies while drawing them.

It is important to try to determine the child's main interests at the earliest opportunity. Obviously, his age will decide this. Until about the age of seven, you can think of entertainment in kindergarten terms, but remember that a child naturally likes to be brought into a higher age bracket and usually needs a little more mental than visual distraction.

Animals are very natural and appropriate props to have around when working with children, and it is a great help to be able to draw them so that you can amuse a child this way. I have often put animals into portraits when either the composition or the character of the whole painting suggested it. This helps enormously to retain your subject's interest for as long as possible; the child will invariably be intent upon observing the progress of the pet's portrait and forget the boredom of sitting for you.

Feeding the birds on the patio of my London studio has often helped to break the ice and hold the sitter's attention. I rarely resort to the use of television as it

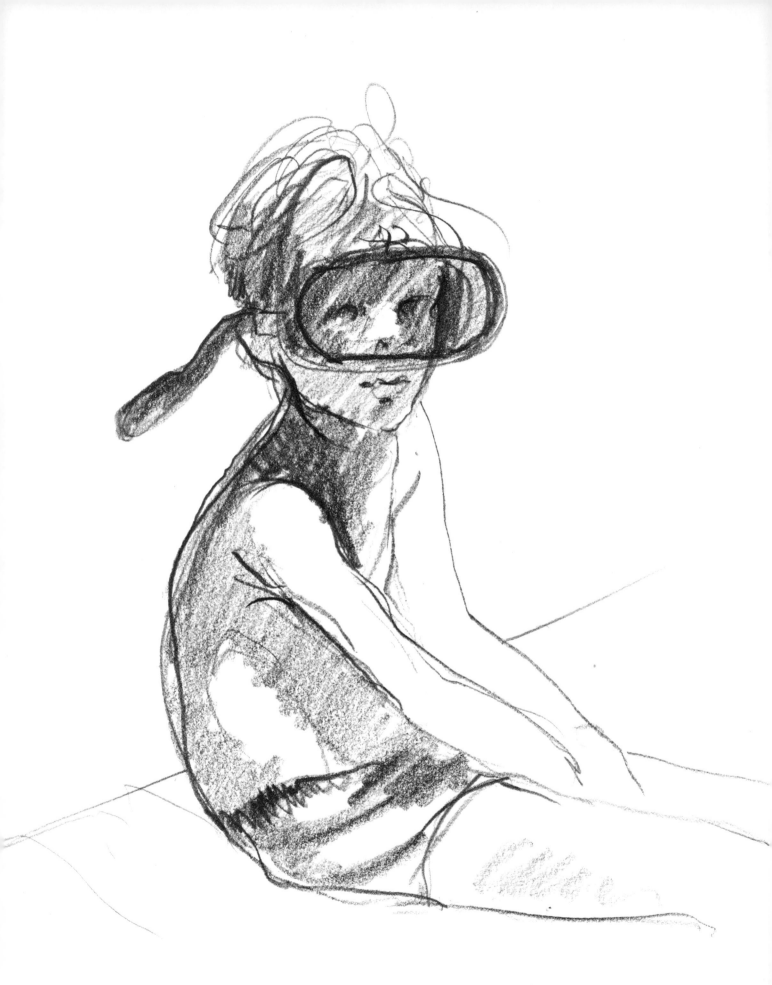

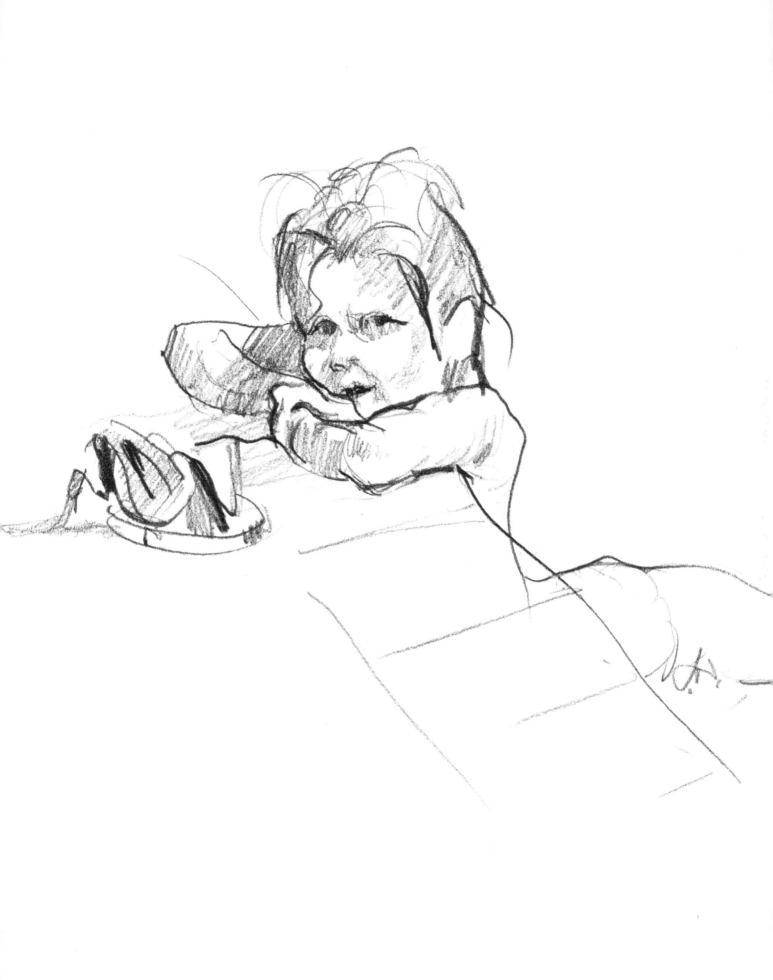

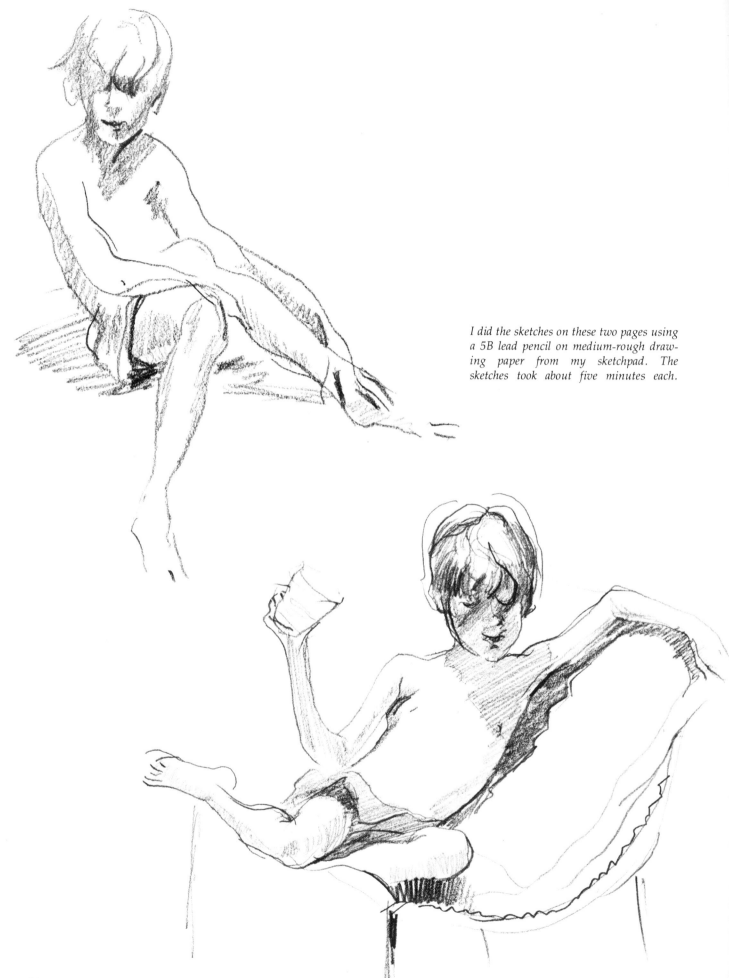

I did the sketches on these two pages using a 5B lead pencil on medium-rough drawing paper from my sketchpad. The sketches took about five minutes each.

is too much of a distraction. I use it only if I have to make a profile study of a child who is unconscious of being drawn. Indoor games are most useful in the early stages of the painting, when it is helpful to make mental notes during breaks in a session.

Playing Outdoors

Healthy children past the age of seven, and as some say, "the age of reason," usually prefer to be outdoors. They like to feel independent and free to assert themselves. Coming indoors to sit for you may not be one of their most exciting experiences, and you should therefore try to avoid making them feel imprisoned or possibly in the company of a boring or demanding adult. Try to partake of their fun and games in the garden, by the boat jetty, with their pets, or in their tree houses. I've also joined older children in games of tennis or croquet. Become one with their frolicking and you will soon gain their confidence sufficiently to enable you to bring them back into your studio.

There will inevitably be moments when the portrait is not going very well. Don't let your confidence flag; take a break outdoors that your sitter will welcome as much as you do. Keep your sittings as alive as possible to prevent yourself and your sitter from getting bored. Boredom is fatal to creative work.

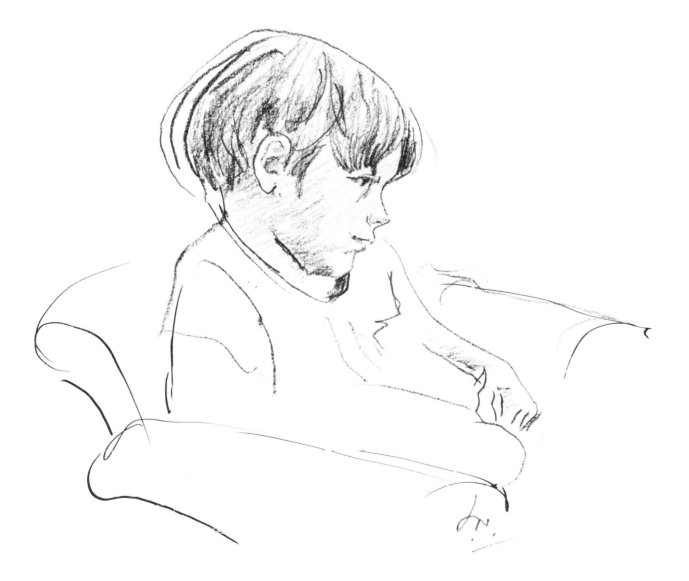

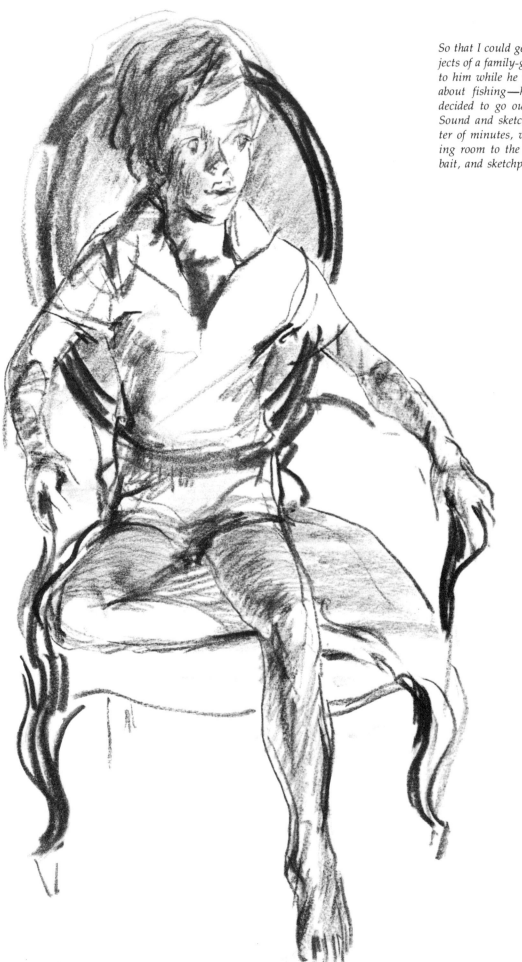

So that I could get to know one of the subjects of a family-group oil portrait, I talked to him while he sat in a chair. We talked about fishing—his passion in life—and decided to go out to nearby Long Island Sound and sketch him fishing. In a matter of minutes, we moved from the drawing room to the water with fishing rods, bait, and sketchpads!

Chapter 3
Studio and Equipment

Studio and equipment are very much personal and arbitrary questions. What is ideal for one artist may not be ideal for another. However, there are several primary considerations—such as space and light in the studio, and convenience and sturdiness of equipment—that you should keep in mind as you set up your studio and select your equipment.

Space

You will need a lot of space in order to view a large painting in true perspective and focus, as well as to hang finished paintings, store equipment, and move about without knocking over furniture and equipment.

My own studio in London measures 25' × 18'. This is large by today's standards, although in the Victorian era, for instance, my studio would have been considered small. The model's throne takes up an area approximately 3½' × 3½' and can be moved anywhere on the studio floor.

North Light

The ideal light is north light, which consists of sunlight reflected from the sky. North light is constant, and unlike direct sunlight, does not contain the direct rays of the sun. (There is nothing worse than starting a portrait with the sun streaming in, only to find an hour later that the sun has moved further east or west and no longer shines on the subject!) North light is a cool, slightly blue light that brings out all tones effectively.

Skylights

Skylights provide light from above and therefore create more cast shadows beneath projecting forms than does light from a window. For example, the hollows of the eyes are quite well defined when viewed in light from above.

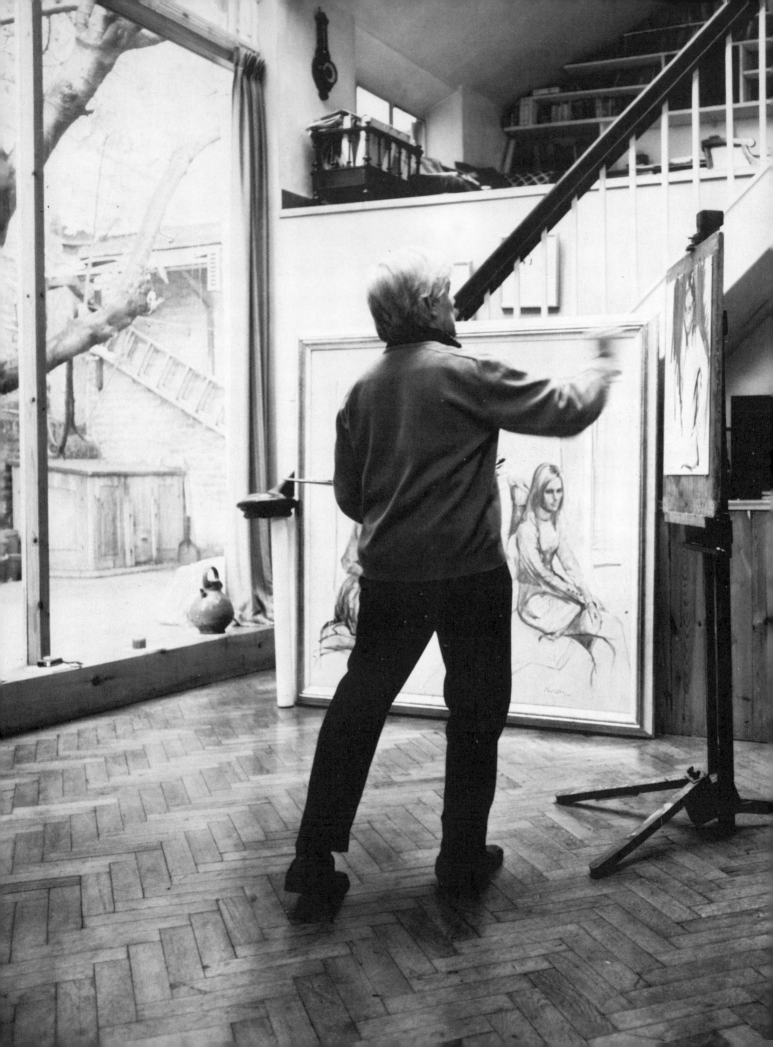

Artificial Light

If you do not have the advantage of working in natural light, you will have to resort to using artificial light. There are many varieties of floodlights and spotlights available in addition to the ordinary photographer's lights, and these are very useful in creating strong shadows and highlights when necessary. It is also useful to carry a portable spotlight or floodlight with you when you will be painting away from your studio.

Studio Atmosphere

The atmosphere in the studio is also important, but this is generally created by the artist himself and is a reflection of his own personality and tastes. Outside my London studio, I am fortunate enough to have a cheerful patio facing north and a 75-year-old giant fig tree. This area attracts sparrows, pigeons, blackbirds, and an occasional robin, and is a most appealing place for children to play during a break between sittings.

Since my studio has a large gallery and is built around an open design, I can even accommodate a number of people for studio parties and the annual musical soirée. So you will probably agree that my studio is in many ways the ideal place to work. But, alas, this sort of studio is rare, even in London.

Here you can see the large interior of my studio, as well as a glimpse of the giant fig tree on the patio outside. The large window faces north, which allows me to paint and view my model in north daylight.

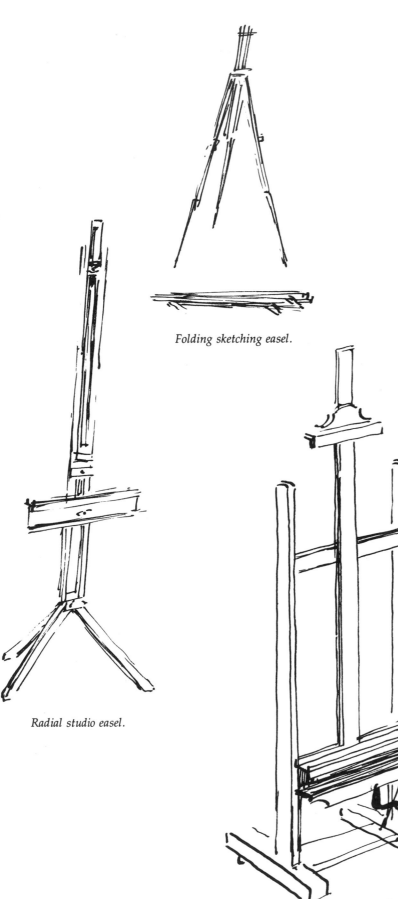

Folding sketching easel.

Radial studio easel.

Studio easel.

Easels

My studio easel was made at the turn of the century and is a rare piece of equipment nowadays. It is heavy enough to support large canvases and moves easily around the studio floor; it holds the canvas firmly and can be adjusted to any angle with the aid of a heavy steel screw.

When I travel I carry one of several easels. The radial studio easel weighs 16 pounds, can hold a stretched canvas 52″ wide very firmly, and can be adjusted to any angle. If I am traveling very light, I take either a folding sketching easel or a Eureka light metal easel made by a Swiss firm. Both of these are particularly suitable for air travel. (These easels are available at George Rowney & Company Limited in London; a variety of comparable easels is available from most major artist's supply dealers in the United States.)

It is important to look for strength, balance, and rigidity in an easel, as well as good grips for holding the canvas or board firmly and possibilities of tilting the canvas backward and forward. I also check the maximum length that an easel can be extended to hold a canvas to make sure this is adequate.

Sketchbox

Another handy item to have among your portable equipment is an easel sketchbox. The one I use is French-made and can hold a canvas or board about 24" long, a palette, my tubes of paint, brushes, a palette knife, and bottles of oil and turpentine. The whole thing folds up ingeniously into a very compact carrying case that weighs not more than 10 pounds. This is an ideal size if you are painting a small, perhaps a head-and-shoulders, portrait.

FOLDING LID OPENS
TO HOLD CANVAS

PAINT TUBES
AND BRUSHES

CARRYING HANDLE

This is the French-made easel sketchbox I carry with me when painting outside my studio. It folds up to about 18" × 16" × 6" and has a handy carrying handle.

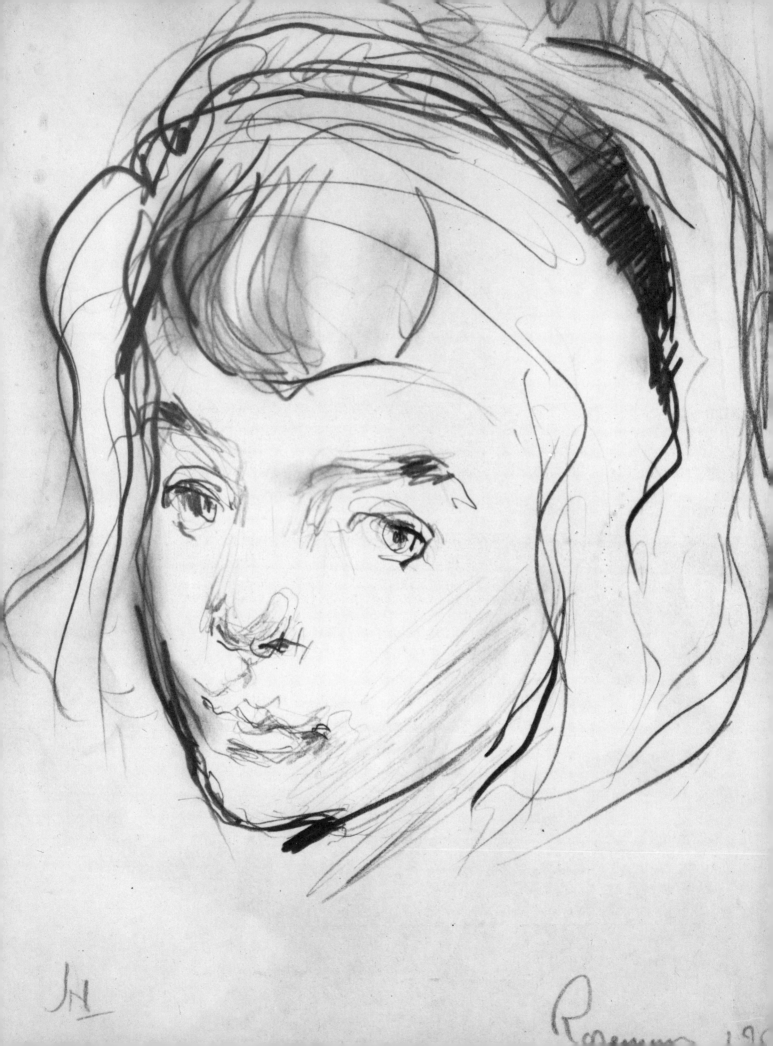

Chapter 4
Preliminary Sketches

Giorgio Vasari, that famous paint-er, architect, and chronicler of the sixteenth century, and friend of the great artists of the Italian Renaissance, says in his famous account of the techniques of the masters: "Sketches are in artists' language a sort of first drawing made to find out the manner of the pose, and the first composition of the work. They are made in the form of a blotch, and are put down by us only as a rough draft of the whole. Out of the artist's im-petuous mood they are hastily thrown off, with pen or other drawing instrument or with char-coal, only to test the spirit of that which occurs to him, and for this reason we call them sketches." Four hundred years later, I find it difficult to improve on Vasari's definition of a sketch.

Drawing Materials
Today there is an increasing vari-ety of drawing materials and tools available. In addition to a sharp scalpel-like knife for sharpening pencils and a strong portfolio to contain your equipment, you may use whichever of the following drawing and sketching materials you find best suited to your needs and techniques:

Lead Pencils. As you are probably aware, the ordinary lead pencil is one of the best mediums for the artist or draftsman. Pencils are ob-tainable anywhere, are convenient to carry, can be used for a great variety of attractive techniques, and they are cheap. Pencils are available in a wide range of grades; the softest grades, from B to B6, can be used for anything from the quick sketch to the fin-ished drawing, while the H grades are the hardest and are used main-ly by engineers and architects.

Actually, lead pencils are not really lead but graphite. In fact, graphite can be bought in pow-dered form and applied to large

This is an example (opposite) of a freely drawn sketch, in which I allowed the pencil to roam. As Paul Klee said, "the pencil should take a walk."

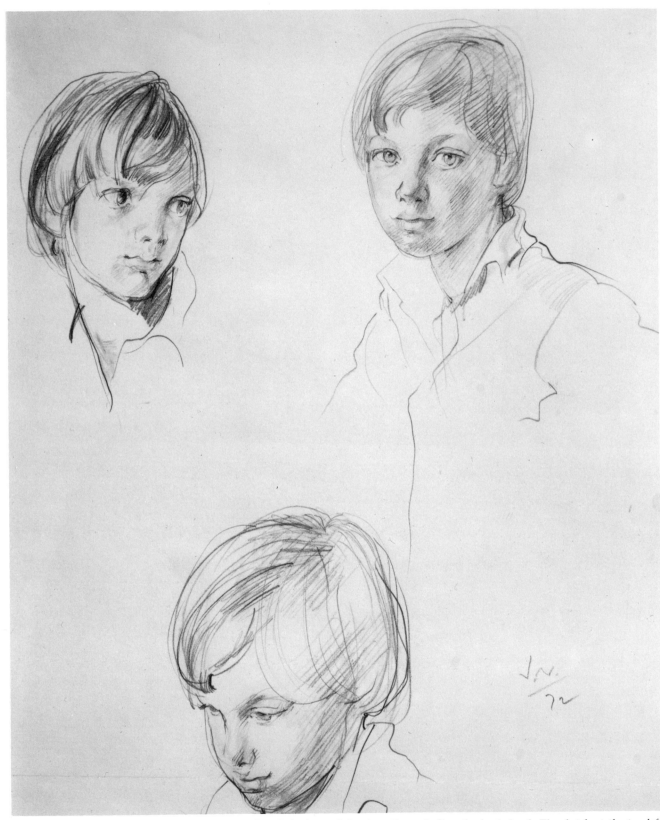

I used a 4B lead pencil for these three studies of a boy's head. The sketch at the top left is the most successful, in that it has movement and boldness of line. These elements are sometimes achieved at the expense of likeness; therefore, the more studies you make the more you will improve your control of technique and likeness, as well as your ability to convey an esthetic impression.

areas with a tortillon, or shading stomp, which is made from soft paper and rolled to a pencil point.

Carbon Pencils. These are a richer black than graphite pencils and are harder than charcoal pencils. Carbon pencils are made from carbonized natural gas, oil, or wood and are available in three grades: soft, medium, and hard.

Charcoal. Charcoal is the residue of dried distillation of wood and is made by heating the wood in closed chambers or kilns. The charcoal produced from the willow or vine is best for drawing and sketching.

Crayons. Conté crayon, as the name suggests, is a well-known French "chalk" manufactured by the French firm Conté of Paris. Since the days of Tiepolo, artists have used a similar type of medium made from the red earth of Sienna, Italy. The French red chalk was made very popular by Fragonard, Boucher, David, and many other painters of the eighteenth and nineteenth centuries. Conté crayons are available in four colors: sanguine (red), bistre (sepia), black, and white.

Pens. Pen and ink has been a favorite medium since the early Renaissance. The sketchbooks and notebooks of Leonardo da Vinci are filled with wonderful pen and ink drawings and sketches whose subjects range from seashells to children to the first flying machine. Dürer also left a legacy of inspiring pen and ink studies. The Chinese and Japanese used mainly ink applied with brushes instead of pens.

Today there is an increasing variety of such tools available, including the fountain pen, the fiberglass pen, the felt-tip pen, and a very useful instrument marketed as the Rapidograph. Any of these is excellent for quick sketches when you can carry with you only a pen and perhaps a small sketchpad.

Paper. For best results in drawing or sketching, it is very important to choose the paper best suited to the medium you are using. The quality of drawing paper is judged by its texture, its weight, and if you are using white paper, by its whiteness.

Drawing paper is available in a variety of textures, from hot-pressed, which is very smooth, to cold-pressed, which is moderately rough, to rough, which is not pressed at all and is quite coarse-grained. Very smooth paper does not have enough texture to hold charcoal pigment; conversely, a broken line results when fine pencil is used on very rough paper.

The weight of drawing paper varies from light to heavy, and you will soon discover the particular weight that suits your needs. The weight of paper is determined by the number of pounds a ream (500 sheets) of the paper weighs. For example, I generally prefer a 60 or 72 pound paper, which means that a ream of the lighter paper weighs 60 pounds and a ream of the heavier paper weighs 72 pounds.

Paper is also available in a variety of standard sizes. Sketchpads begin at 9″ × 12″ and range upward; when sold either by the pad or the sheet, drawing paper can be purchased in the Royal (19″ × 24″) size, the Imperial (22″ × 30″) size, and the Double Elephant (27″ × 40″) size. I find the Royal size convenient when I travel and the Imperial size more suitable for studio work.

For drawings, you may use either white or tinted paper. Several shades of warm and cool gray as well as buff-colored paper are available at most artists' supply stores.

For quick sketches, when I want to capture a detail or a movement,

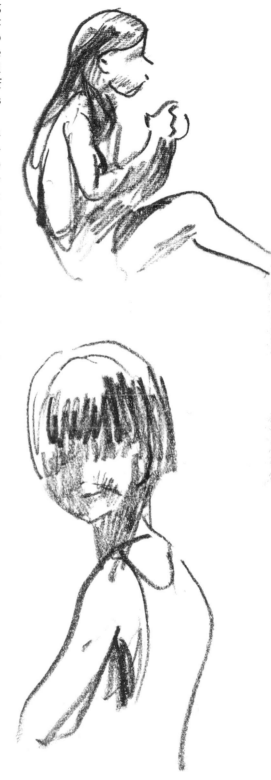

The carbon pencil, which I used in these sketches, produces soft, subtle tones.

I used a soft lead pencil for the sketches on this page. The main purpose of such preliminary sketches is to capture gesture quickly and spontaneously. When making sketches, you should draw with feeling; knowledge of technique and anatomy will increase with practice.

Chloë Reed. (opposite) Oil on canvas, 30" × 40". Collection Dr. James Reed, London, England. This is one of my early attempts at painting more than one aspect of a child in one portrait. I used a brush loaded with ultramarine blue to sketch in the figures and then proceeded to do the final painting. The colors are cadmium red, yellow ochre, viridian green, ultramarine blue, and titanium white. I used a palette knife to apply the paint in the background and in most of the secondary figures.

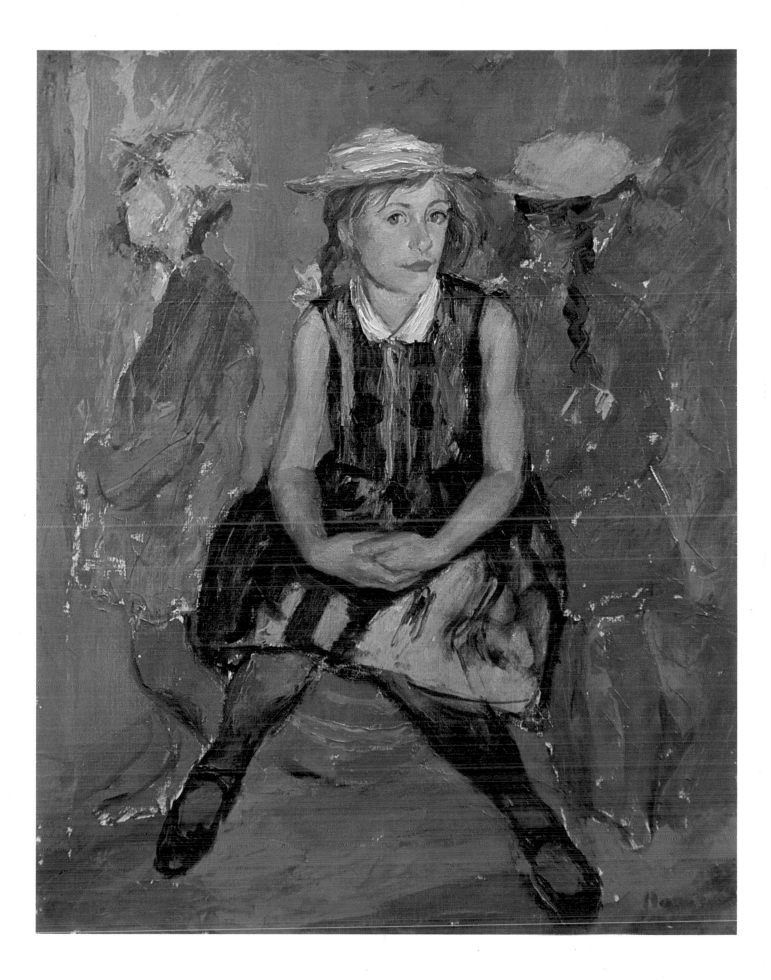

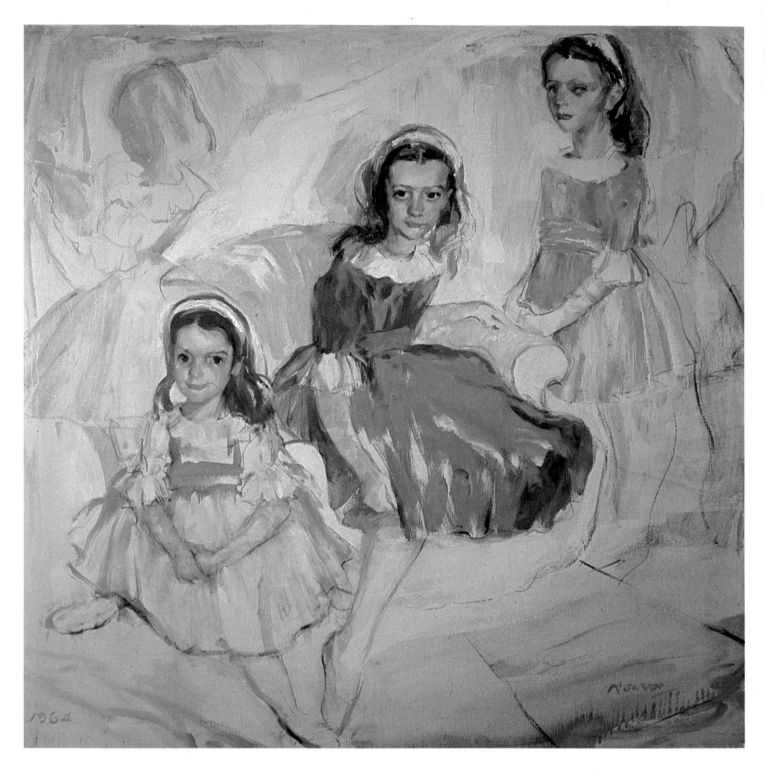

Alice, Charlotte, and Katherine Towneley. *(above) Oil on canvas, 42" × 48". Collection Mr. and Mrs. Simon Towneley, Lancashire, England. When I went to Lancashire to paint this portrait, I was almost carried away by the impressive sweep of the countryside in this northwestern part of England. I first tried to incorporate some of this feeling into the composition, but it looked too contrived. After many more sketches, I painted what you see here and felt satisfied with the portrait's simplicity. I added the shadowy, blurred shapes in the background to balance the composition.*

Peregrine and Victoria Towneley. *(right) Oil on canvas, 30" × 40". Collection Mr. and Mrs. Simon Towneley, Lancashire, England. This portrait followed the one of the three Towneley sisters by two years; it displays a more pleasing composition and perhaps a little freer execution. Also, I took a little more liberty with the local color in these two figures.*

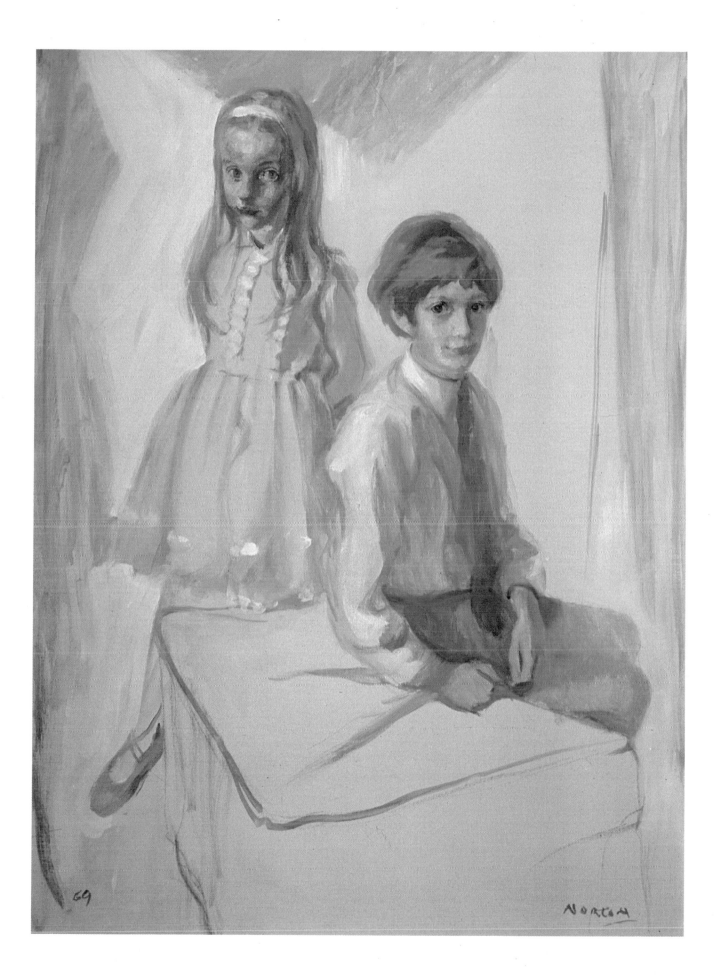

69

Norton

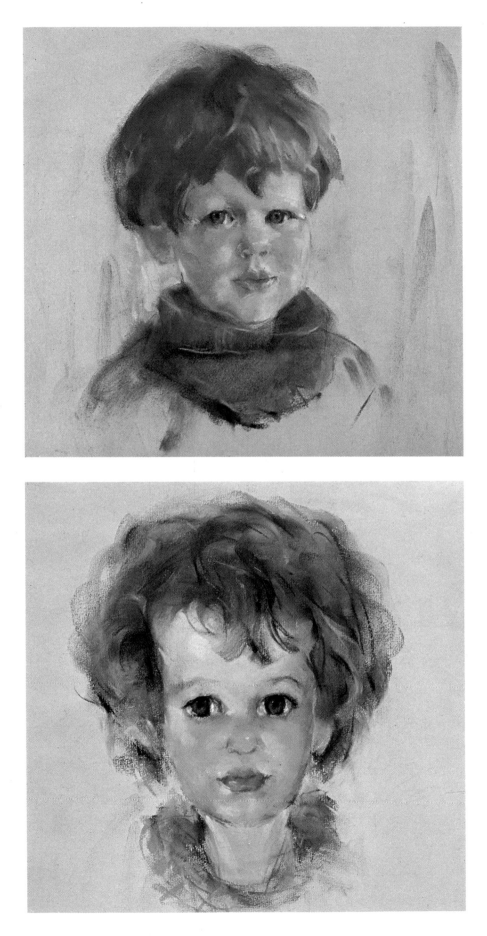

Andrew Hobbs. *(above) Pastel on paper, 19" × 22". Collection Mr. and Mrs. Richard Hobbs, Essex, England. It was a fascinating series of commissions to paint the six Hobbs sons (three of whom are shown on this and the opposite page) over a period of nearly ten years, with the sitters ranging in age from four to nine. Andrew's predominant feature was his red hair. I therefore painted a blue-green sweater to complement the hair and bring out the pink in his flesh tones.*

Christopher Hobbs. *(right) Pastel on paper, 19" × 22". Collection Mr. and Mrs. Richard Hobbs, Essex, England. Christopher's coloring is different from Andrew's; I had to carefully select a whole range of hues to go with the cool pink, almost translucent qualities of his skin tones. Notice that I chose a slightly different tint of pastel paper for each of the Hobbs children.*

Timothy Hobbs. *(far right) Pastel on paper, 19" × 22". Collection Mr. and Mrs. Richard Hobbs, Essex, England. Here are three different aspects of the same head, each depicting one of a child's many moods. I drew the head on the lower right almost as a quick sketch, using less intense colors so that they would not compete with those in the other two heads or make the whole composition monotonous.*

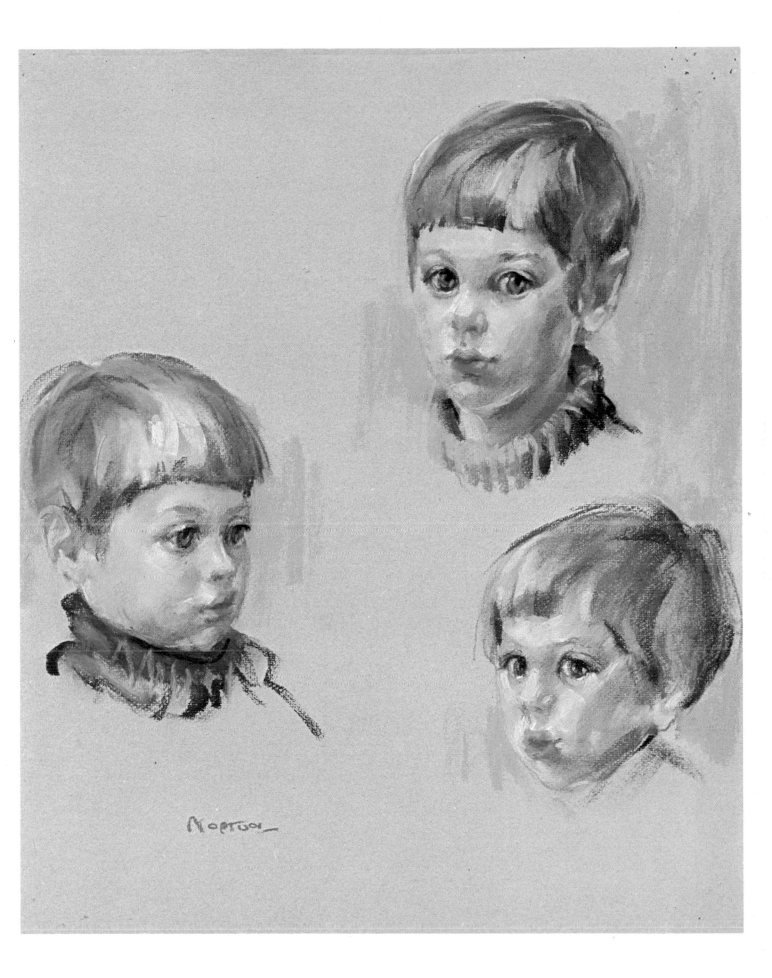

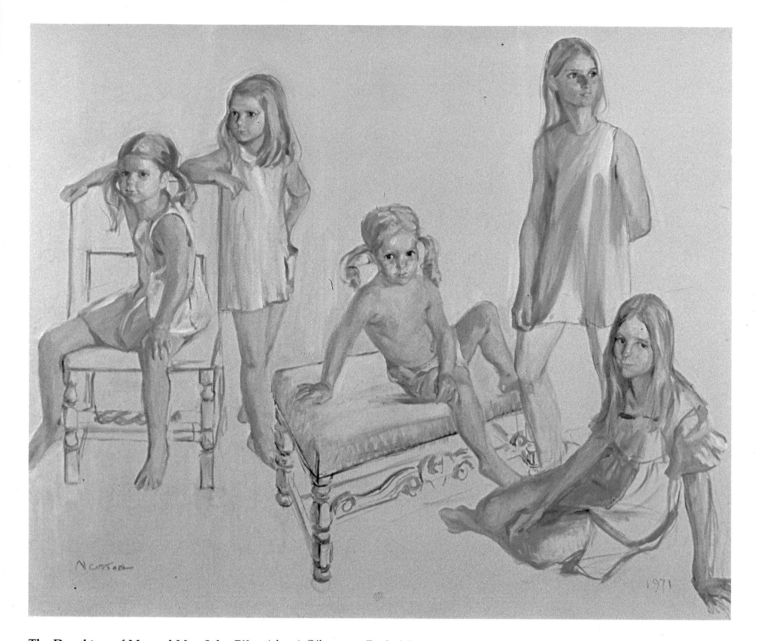

The Daughters of Mr. and Mrs. John Pike. *(above) Oil on canvas, 60" × 54". Collection Mr. and Mrs. John Pike, Pasadena, California. After making several sketches of each girl, I selected the poses most suitable for a pleasing composition. I placed the youngest girl in the center and the oldest standing in the background at the right. I sketched the figures lightly in charcoal, fixed the sketch, then went over it with a brush loaded with ultramarine blue. I used cadmium orange for the flesh tones, adding ultramarine blue and titanium white where necessary and retaining some of the neutral charcoal outlines for definition.*

Rachel Podolier. *(right) Pastel on paper, 25" × 19". Collection Mr. and Mrs. Paul Podolier, Surrey, England. I did this three-quarter length portrait on gray Ingres pastel paper, which is one of my favorite pastel painting supports. The texture of this paper and the subtle range of tints available make pastels painted on it attractive and exciting. Notice the interplay of warm and cool colors, particularly in the head and hands. I intentionally left the lower right-hand corner of the dress unpainted so that it would relate well to the paper.*

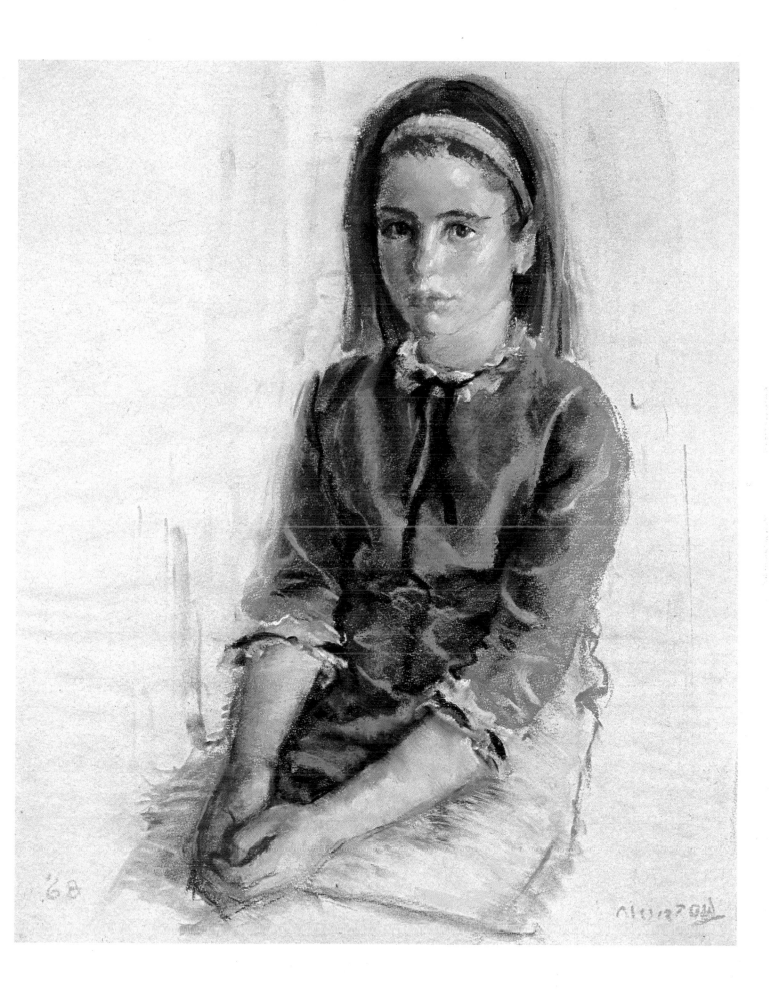

'68

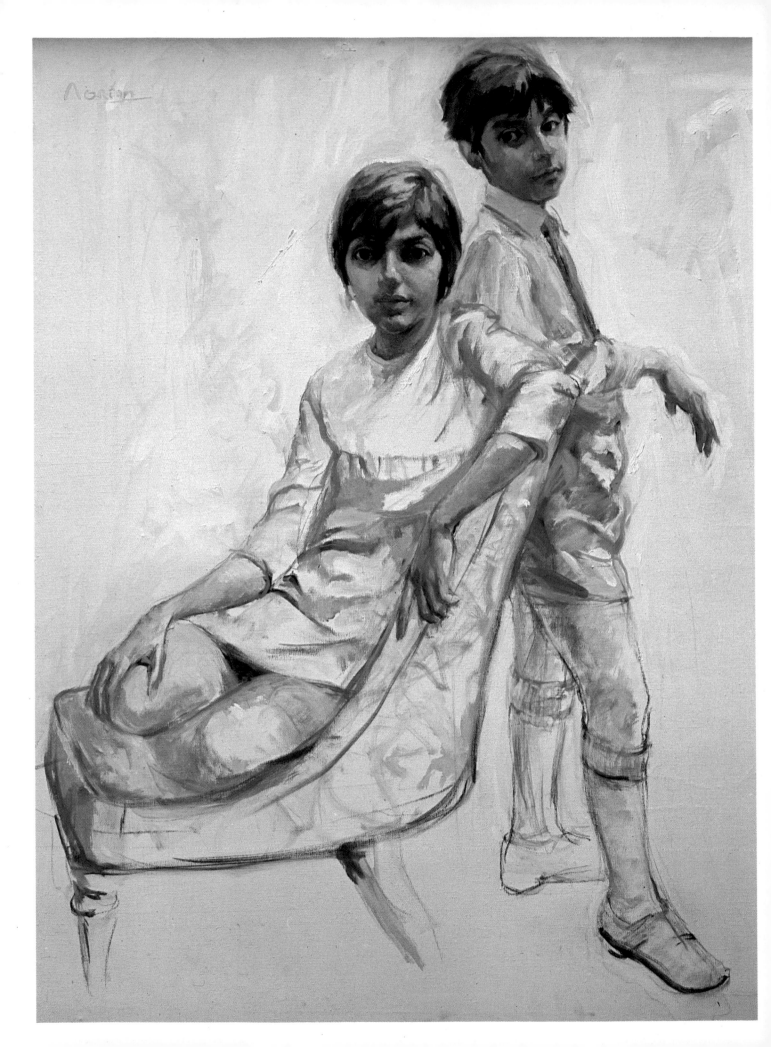

I often use ordinary bond paper, which is convenient to carry, commonly available, and inexpensive in sketchbook form.

Fixatives. When finished, pencil, charcoal, and crayon drawings should be permanently fixed with a fixative spray, such as those sold in aerosol containers in artists' supply stores.

Which Medium to Use

Preliminary sketches may precede either a black and white drawing or an oil or watercolor portrait. In Chapter 11, I will describe how to "paint" a full-color oil sketch to be used as preliminary work for the final oil portrait or as a final painting itself. If the end result is to be a finished black and white drawing, it might be a good idea to warm up to the finished work via one or two trial sketches, in which case charcoal is a useful medium. With just the flick of a handkerchief or tissue you can remove practically every trace of an incorrect charcoal line or tone; a harder pencil or crayon would require a lot or erasing and would thereby waste time. It is therefore advisable to use charcoal

for preliminary sketches. A soft lead pencil is good for quick short-hand notes.

Work lightly with these sketches and avoid putting in any detail except where you might wish to refresh your memory later. When sketching with a pencil, let your strokes follow the direction of movement and the main volume of the form.

As you can see, I have illustrated this chapter with many examples of the quick sketch, displaying both clearly visible strokes and strokes done with the flat edge of the pencil or charcoal in order to quickly cover and indicate the shadow areas. I generally use a 2B or 4B pencil or ordinary drawing or bond paper for such sketches.

Terminology of Drawing

Just as the tonal scale in music helps the composer construct a symphony, the following terms and the concepts they stand for are the graphic artist's materials, the alphabet of the language of drawing and painting:

Form. The shape of solid matter; anatomical volume.

Rana and Selwyn Soobiah. *(opposite) Oil on canvas, 36" × 42". Collection Mr. and Mrs. Sean Soobiah, London, England. These two attractive children proved to be very amusing and cooperative sitters. The white, unpainted background is an interesting contrast to the more formal blue background in the portrait of Nadia and Natasha Brooks-Baker on page 89.*

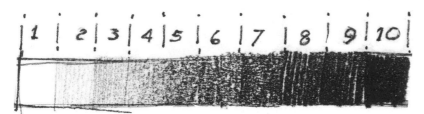

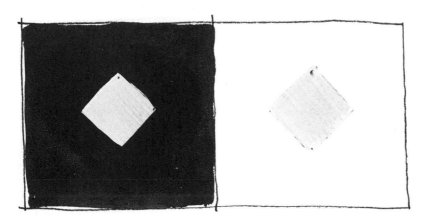

Tonal values, or gradations, between white and black, created with charcoal pencil on medium-rough drawing paper.

The inner squares are identical in tone, yet the square on the left looks brighter in contrast to the dark background.

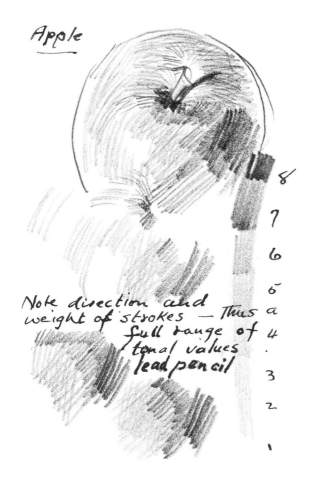

Mass. Solid form, usually represented by large areas of flat tone.

Value. The degree of gradation between black and white; also called tone or tonal value. Color value—that is, the intensity and hue of a color—can be used to create contrasts or complementary effects.

Light. The white or most nearly white areas; the areas not in shadow.

Shade. The opposite of light; those areas in shadow.

Line. That which encompasses and defines form or mass. Line can be thick, thin, or a combination of both, broken or continuous over contours.

Rhythm. The ebb and flow of line, mass, tone, or color in time and space.

When used by a great master such as Rembrandt, light and shade provide drama. In the hands of a Tiepolo, Picasso, or Klee, light and tone can be used to express structure, movement, and vitality. The secret of vitality is the sensitive and considered use of line as opposed to mass, and of light as opposed to shade.

Your line should have character and should, as Paul Klee said, "take a walk." Your tone should have richness and subtlety. Study and practice capturing the values in the scale from white to black, and experiment with the variety of textures that can be created by the use of line.

Using Lines

When you first begin a pencil, charcoal, crayon, or pen and ink sketch, try to use the technique known as hatching. This consists of making even, parallel, diagonal strokes that are placed fairly close together and that run in one direction throughout. At a later stage, you may use cross-hatching; that is, applying vertical, horizontal, or

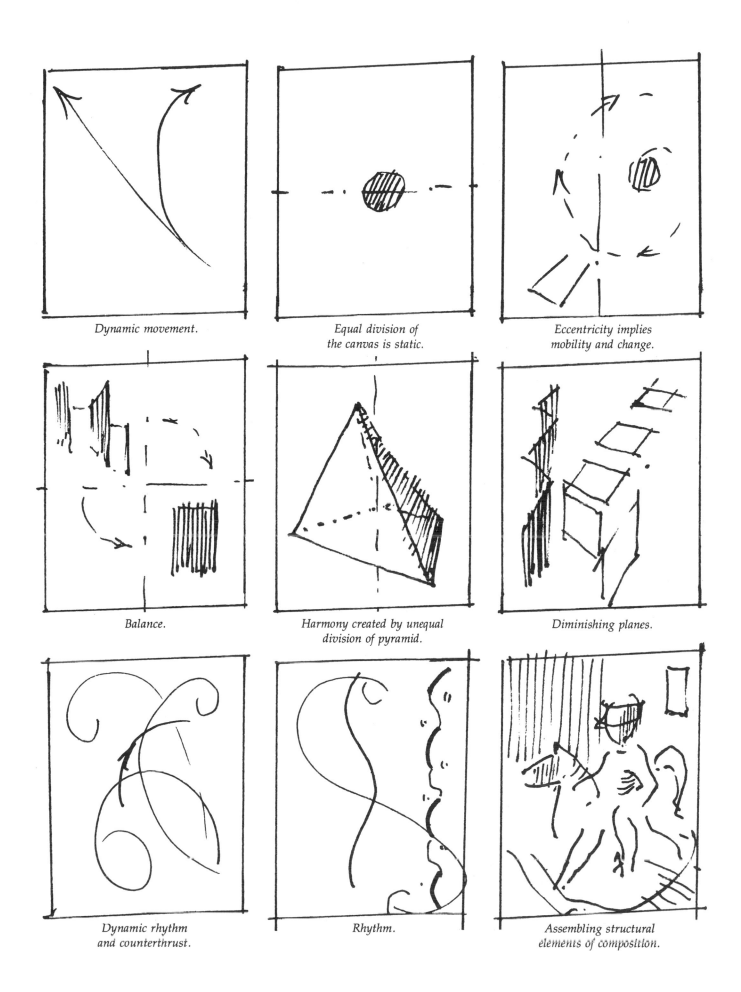

Dynamic movement.

Equal division of
the canvas is static.

Eccentricity implies
mobility and change.

Balance.

Harmony created by unequal
division of pyramid.

Diminishing planes.

Dynamic rhythm
and counterthrust.

Rhythm.

Assembling structural
elements of composition.

59

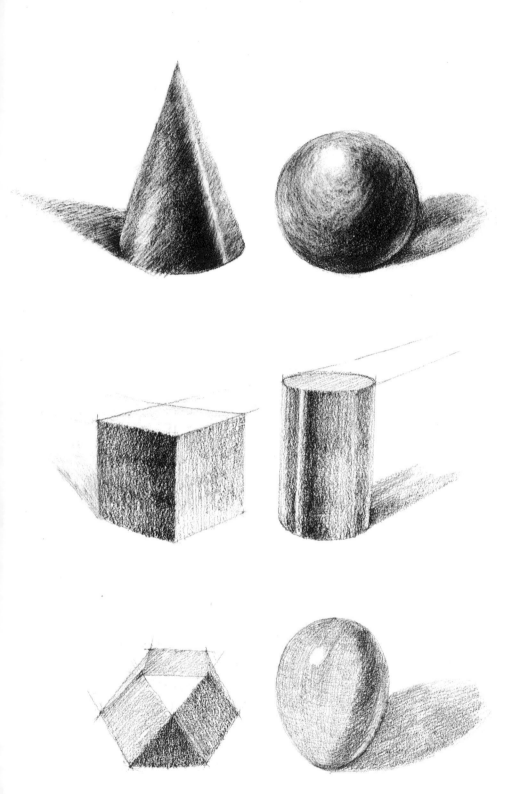

I used grade B and 4B lead pencils on rough-textured paper to draw these geometric forms. Figures a and b indicate the full range of tones that can be achieved with pencil; c and d show five tones; and e and f only four tones. Drawing geometric forms will give you practice in controlling the direction of your pencil strokes, placing values accurately to describe form, and indicating the correct perspective through the use of light, shadow, and reflected light.

diagonal strokes over your original hatching.

As you add shading, remember that lines drawn across the form suggest softness, curved lines suggest fullness, vertical lines suggest hardness, and lines drawn in all directions create the effects of merged tones, atmosphere, density, and mystery.

In order to keep shading lines under control and to give them force, always allow them to follow one particular direction, preferably from right to left. Also, always allow the direction of the head or the angle at which it is held to dictate the flow of your lines.

There are some excellent examples of pencil, chalk, and pen and ink techniques in the work of the old masters, particularly that of Michelangelo, Tiepolo, and Rubens, and a close study of such work would be time well spent.

Drawing Geometric Forms

I cannot emphasize too strongly the importance of tonal values in creating the illusion of three-dimensional form on a two-dimensional surface. Particularly in mastering the art of drawing a child's head, the overall form and the complications of form within form represented by the features can be grasped only by an intensive study of the use of light and shade.

You may find it useful to familiarize yourself with the basic geometric forms and the effects of light and shade upon them before you begin to draw the human head and figure. Study the sketches nearby, which include the form of an egg (because the human head is based on this shape), and practice using tonal values to suggest the six forms.

Notice also that many other factors contribute to the accurate description of form: the direction of your strokes, the proper use of perspective with regard to each plane or surface, and the direction

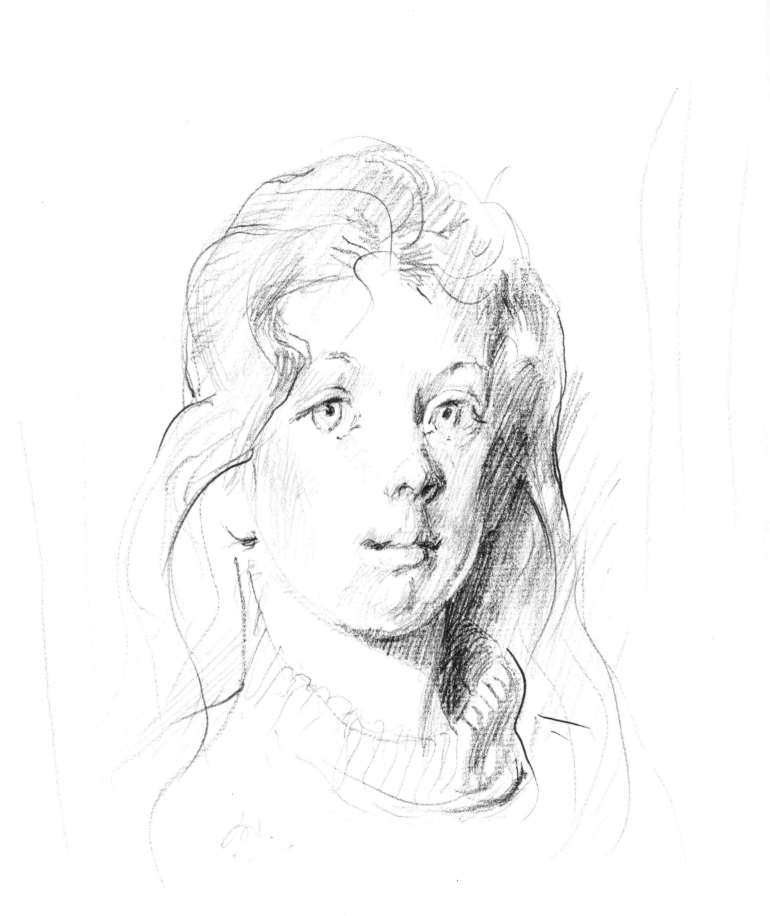

I used a 4B lead pencil for this sketch; the result is airy, subtle, and delicate. When using pencil, I usually have to exercise great restraint in order to maintain a delicate quality.

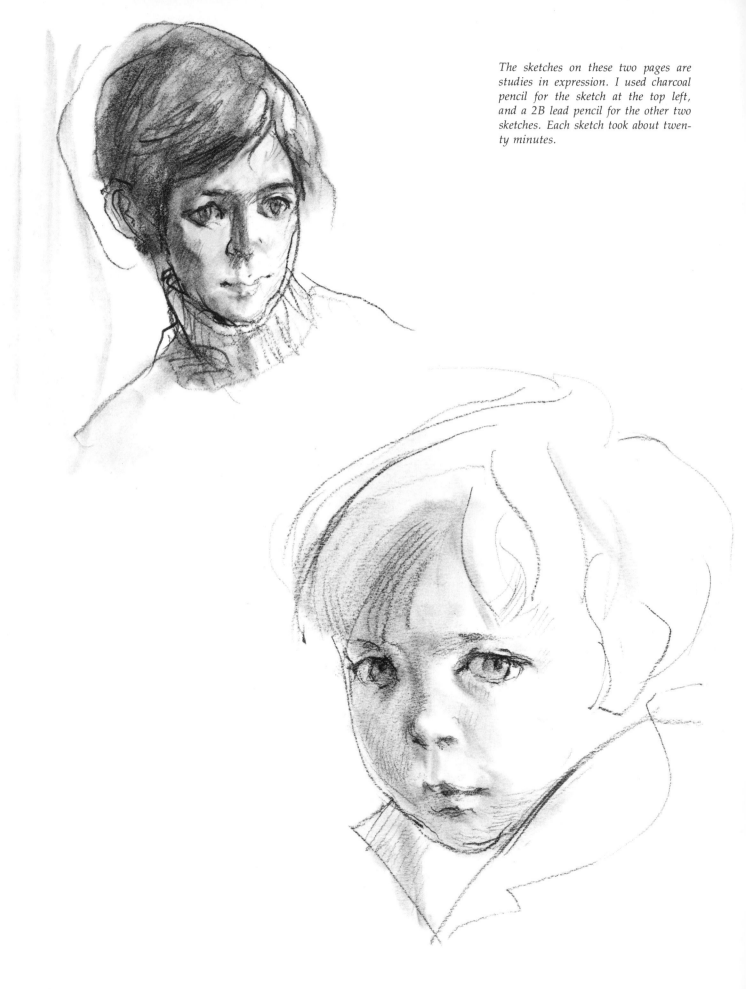

The sketches on these two pages are studies in expression. I used charcoal pencil for the sketch at the top left, and a 2B lead pencil for the other two sketches. Each sketch took about twenty minutes.

of the light and its subsequent effect on shadows and reflected light. At a later stage, when you have gained mastery over structure, you will find that such practice in drawing the basic geometric forms was well worthwhile.

Drawing the Head

Begin by quickly drawing the general round shape of the head—about half life-size or less for a pencil or charcoal drawing and usually life-size if your sketch precedes a pastel, watercolor, or oil painting. In the early stages you will probably feel a strong urge to develop a likeness right away, but avoid this temptation and go for structure and a solid impression instead.

Determine the angle at which you are going to draw the head and lightly place your vertical axis line down the center of the round form. Indicate the horizontal axis in the center of the head with a light line, then draw the eyes in lightly along a line that falls somewhat below this axis. (In an adult's head, of course, the eyes are located at the exact center of the head or slightly above.) The distance between these two horizontal proportional guidelines will vary according to the degree of foreshortening created by the angle of the head.

Until you gain sufficient skill and confidence in indicating these proportions, axial lines will be necessary. You are attempting to draw the most difficult subject an artist is challenged by, and ignoring such rules will inevitably cause frustration and wasted time and material. Also, from the very beginning, try to avoid using a rubber eraser, and get into the habit of allowing your working hand to draw with a circular motion so that you will gain a strong feeling for the roundness of the form as you draw.

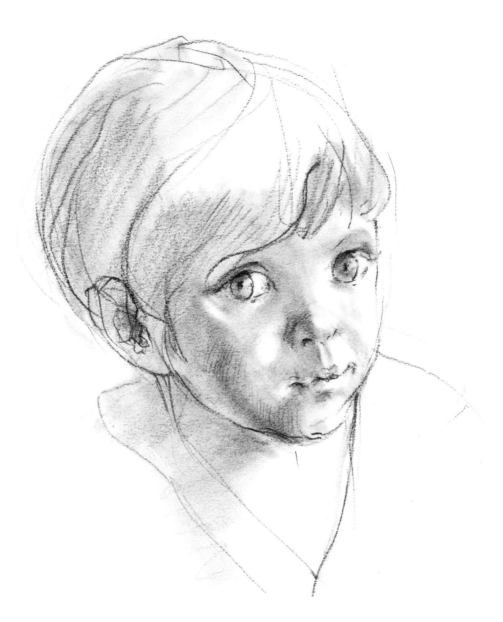

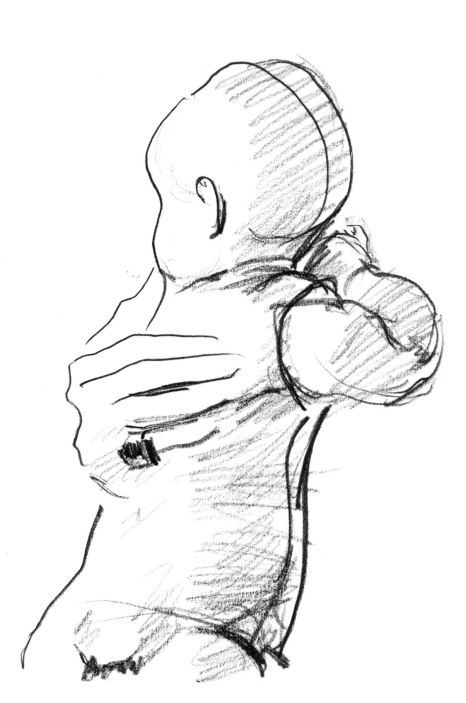

Using Sketches and Studies

An artist who works from life must possess a keen sense of observation and the ability to work fast and be visually analytical. By making detail drawings and shorthand notes, I insure that the anatomy and tonal values are correct and properly related to the major work at hand. I sometimes pin these sketches above my paper or canvas in order to have them constantly in front of me while I work.

Sketches and studies are often useful as shorthand notes on features—the nose, the expression of the mouth, the attitude of the hand or foot, or the fall of the hair. Hands in particular require a great deal of very careful study, and you may have to make many sketches of hands before you decide on a final pose.

It is wise to have a sketchbook handy because natural and spontaneous gestures are fleeting, and you may regret not having had the necessary materials on hand to capture an attractive pose or attitude. You should therefore have a fairly large sketch pad, about 14″ × 17″, and several smaller sketchbooks to carry around with you as well as to keep near your studio easel.

Sketches and studies are also invaluable in giving you extra time away from your sitter to think and meditate, thereby enhancing the coordination between thought and execution. In most of my work, I spend more time thinking about the portrait while I am away from the easel than when I am poised before it in the heat and tension of painting.

When you use sketches and studies for future reference, you must make sure that tone, anatomy, and movement are reasonably accurate. And obviously, such preliminary work must be done under the same lighting conditions as those to be used for the finished portrait.

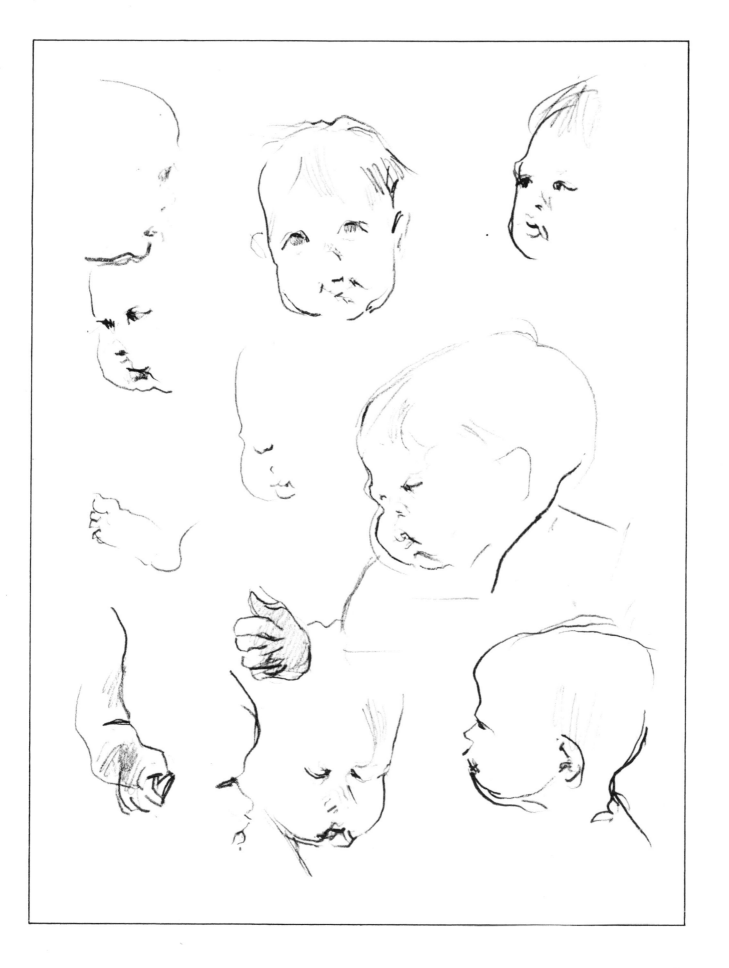

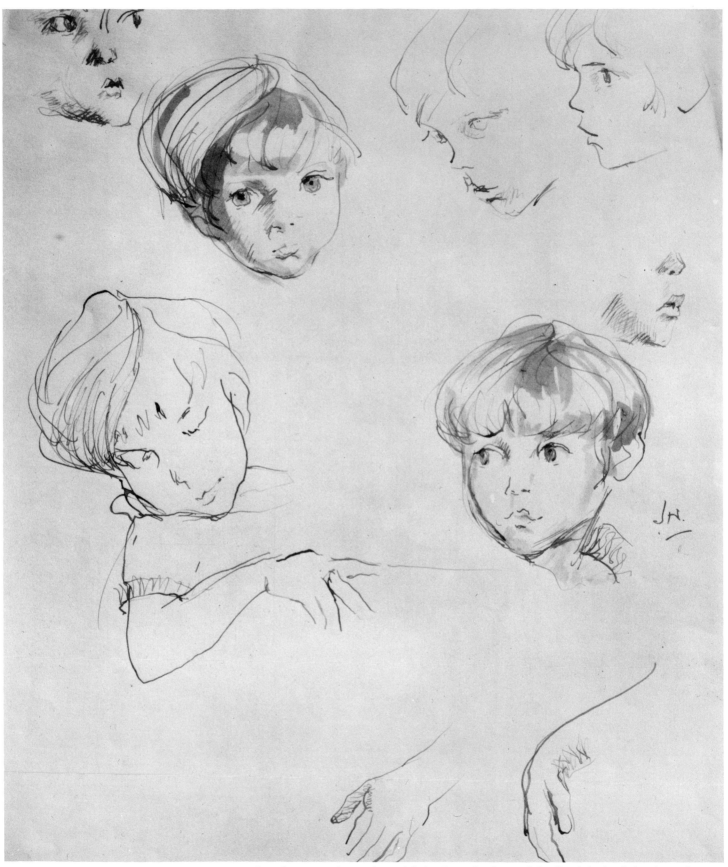

I used a pen and raw sienna ink for these sketches and details of the head, hands, and features of the subject of a finished portrait.

Points to Keep in Mind

In concluding this chapter, I would like to recapitulate the few essential points the child portraitist must store in his subconscious mind and use whenever he is faced with the challenge of producing a convincing likeness:

Nothing is static in a child; everything grows from day to day, if not from moment to moment, and speed is therefore vital.

Do not be too concerned with accuracy; no one retains a perfect photographic memory of what he sees. Aim instead for character and spirit. A hard, tight drawing is a dead one!

Nothing is fully formed in a child; softness and looseness are preferable to solidity and hardness.

Draw lightly and move from one quick impression to another, rather than trying to overwork a single study to dreary perfection.

Practice quick sketching as often as you can, and try every medium until you find one that particularly suits your own temperament.

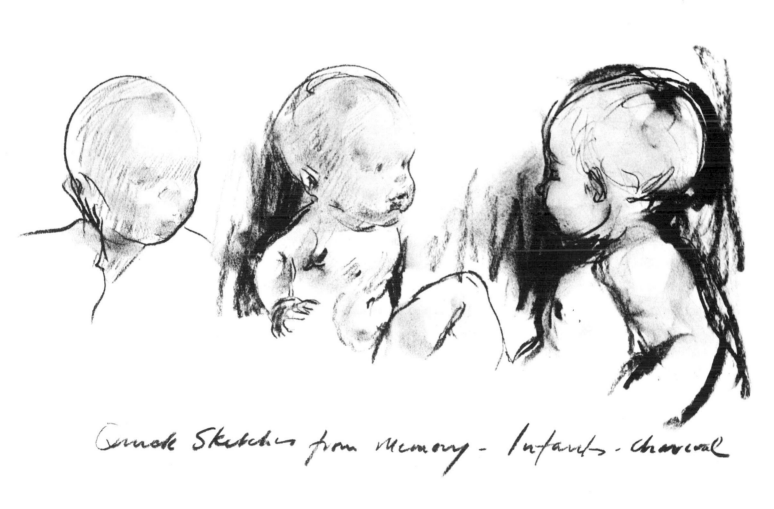

Quick Sketches from memory - Infants - Charcoal

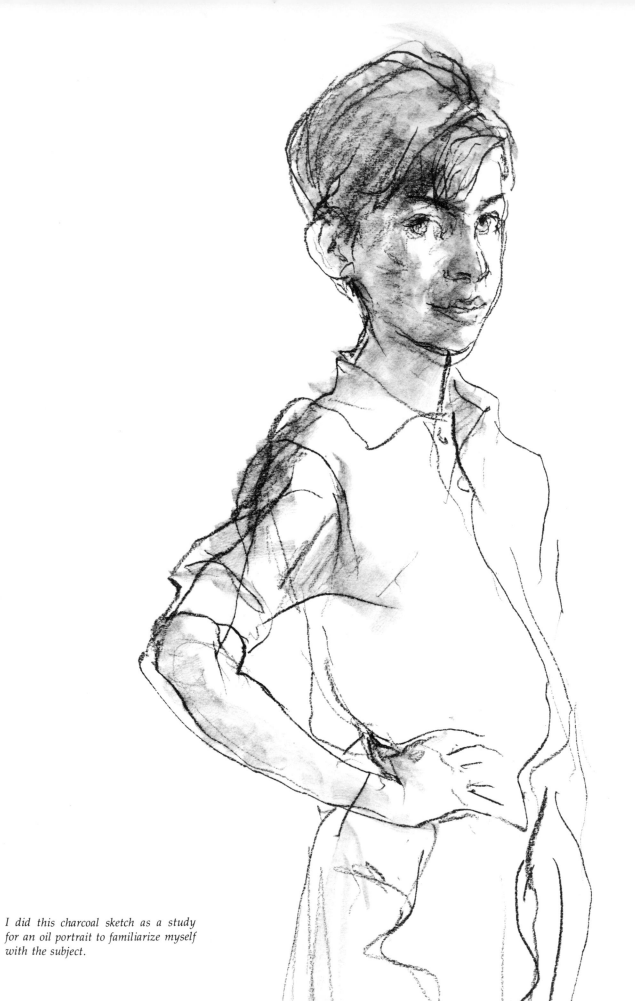

I did this charcoal sketch as a study for an oil portrait to familiarize myself with the subject.

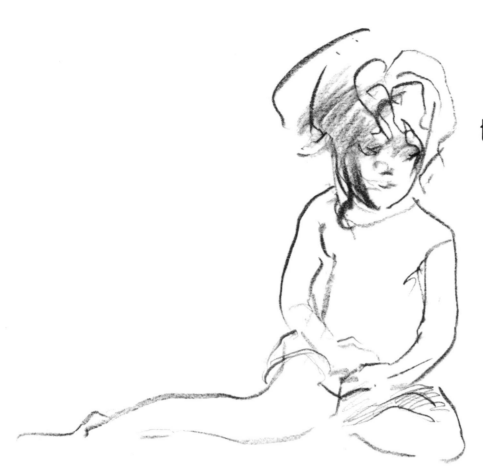

Chapter 5
Planning
the Portrait

A portrait can be many things: it can be photographic, dramatic, romantic, symbolic, allegorical, impressionistic, expressionistic, or even abstract; yes, even abstract—think of Picasso or Picabia. Which of these many approaches you use will depend largely on who and what you are. Before you begin to assess yourself as an artist it will help if you get to know a bit about yourself as a person, about your attitude to life and people and about your convictions.

I'm sure that most of us will agree that since a work of art must be subjective to a great extent and must therefore contain something of the creator, it will naturally express his personality if not his character. If the painting is purely a product of skill and industry, this will be evident in the facile and superficial result; it will be lifeless or soulless. To produce a sensitive portrait, then, you must be sensitive to the world and the

people around you.

Edmund Burke, the eighteenth-century philosopher, said in his *A Philosophical Inquiry into the Origins of Ideas on the Sublime and the Beautiful:* "There should be an individual feeling in art which would manifest itself in quiet pleasure over the Beautiful; defined as the smooth, soft in colour, the small in size and the exaltation over the sublime." The latter he defined as "the dark, the rough and the mysterious."

I cannot really see myself enjoying writing this book if I were simply to tell you how to paint the likeness of a child's face with mechanical skill. I shall consequently ignore the direct photographic likeness. Color photography is of a high order today, and it is a waste of creative effort to try to compete with it. To do so would be very pedestrian. Parents who pay a high fee for a portrait deserve more.

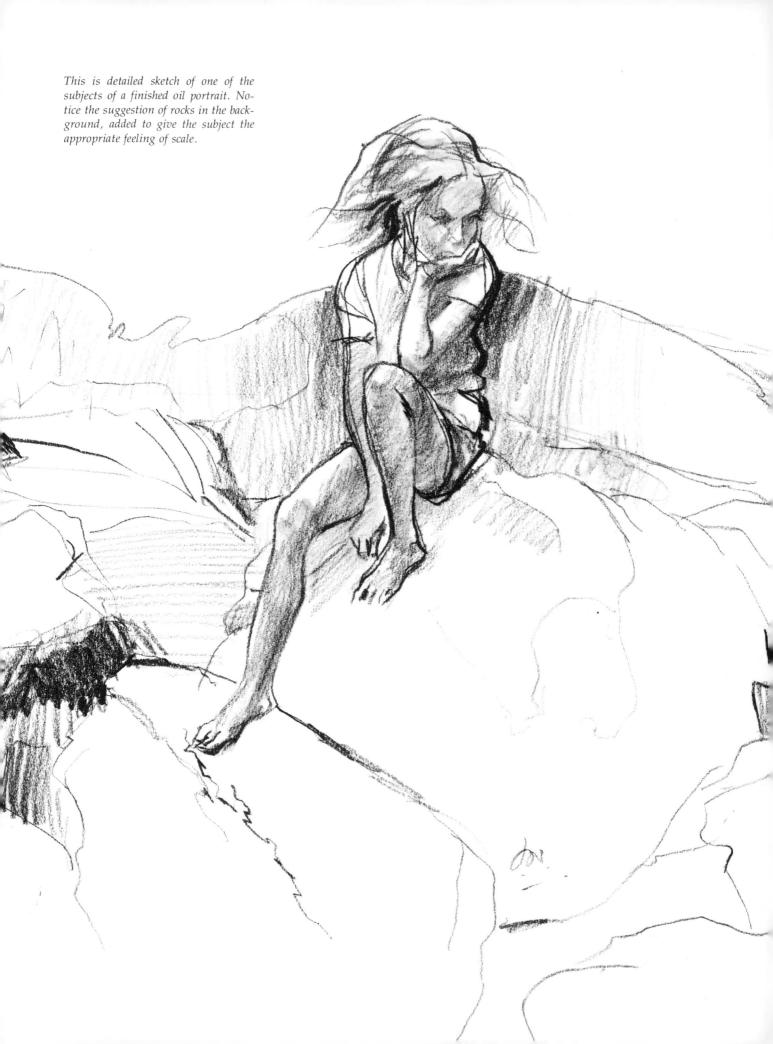

This is detailed sketch of one of the subjects of a finished oil portrait. Notice the suggestion of rocks in the background, added to give the subject the appropriate feeling of scale.

Styles of Portraiture

Your first conception of the portrait will of course depend on the personality of the child and the setting in which the painting will eventually hang. Generally, a composition with a dark background with the light concentrated in a small area provides drama. Rembrandt was a master of this technique, and so was Velázquez. However, although a dramatic portrait is always striking, it is somewhat out of place today. Children seem to be more mercurial now and are seldom held in the spotlight of high drama, except when it concerns their parents' lives.

Likewise, the romantic mood—the enchanting bower or Elysian landscape—obviously does not match our age and lifestyle. There are many fond mothers who no doubt would like their daughters to be painted like *Pinkie*, by Sir Thomas Lawrence or like Gainsborough's daughters. However, enchanting as these paintings are, they would be out of place in the settings of today's homes. Besides, a large number of girls, particularly little ones, are quite happy simply wearing jeans and rarely appreciate dressing up in a party dress or like a Degas-type "petite danseuse."

In short, apart from the long list of styles mentioned at the beginning of this chapter, it seems that the two most common styles for children's portraits today lie in the direction of either the impressionistic or the expressionistic, and occasionally the realistic. The work of Renoir, Manet, Degas, Mary Cassatt, and John Singer Sargent provides us with examples of impressionistic portraits. Edvard Munch, Nolde, and Kokoschka provide us with examples more in the realm of expressionism.

It is you who will finally have to decide on a style that really suits your temperament and skill. If you find it difficult to decide, you may eventually have to resort to thumbnail sketches to help you visualize the finished portrait. Later you might develop one or two of those into larger color sketches. And I suggest that you also go to the great masters for inspiration!

Size of the Portrait

The size of the portrait is generally dictated by the medium you use, the place where the portrait is to hang, the painting time available, and of course the pocketbook of the person who commissions it.

Today's townhouses and apartments have limited space for large portraits—and do not forget the additional dimensions of the frame! A 25" × 30" canvas is ample for a portrait of a child under five years of age; for children above that age you may need a 28" × 32", 30" × 40", or even 36 " × 42" painting surface. For two children or more you will have to start thinking in terms of 40" × 48" or 42" × 50", depending on the number of children. I have painted family-group portraits as large as 72" × 84", but paintings this size need careful planning.

For large oil portraits you will need high-quality, heavy stretchers with two central crossbars to support the canvas adequately, a heavy studio easel, and lots of space—15' × 12' at least—to work in. A large canvas must be viewed from quite a distance in order to be seen in focus, and you will need plenty of room to step away from your work.

I work with the scale of 5½" to 7", maximum, for a child's head in a group portrait. The canons of proportion for a standing figure allow that the body should be five to six and a half times the length of the head; a seated figure should be three to four times the length of the head. The size of the canvas you need can be worked out from

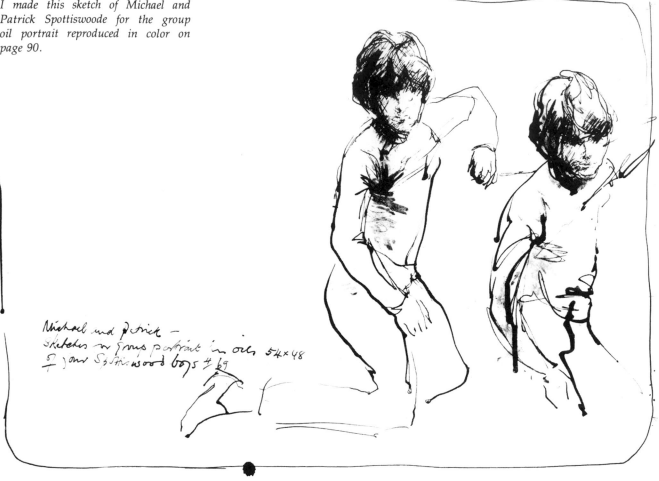

I made this sketch of Michael and Patrick Spottiswoode for the group oil portrait reproduced in color on page 90.

these measurements, with an allowance for additional space above and below the figures, which may be one head-length or more depending on how far forward or back you wish to place your figures. It is wise to make a pencil sketch to scale—1″ equals 1′ of canvas—before you start calculating the dimensions of the final canvas.

Choosing a Medium

You will find that children may be divided into roughly three types from the painter's point of view: those who obviously, because of their coloring and features, are a must for a striking oil portrait; others who will make good pastel or watercolor portraits and nothing more; those who are best attempted as finished drawings. Especially in the larger sizes, the

choice of medium is also influenced by the size requirements of the portrait, but the final decision will depend primarily on your own skills and your preference for a particular medium. You must *feel* the rightness or wrongness of a medium, rather than trying to rationalize its suitability. Here are some suggestions that you may wish to keep in mind as you choose your medium:

Drawing. The very delicate and sensitive face lends itself more to a good drawing than to a strong or vivid oil; fine lines and subtle tones will be all that is necessary to describe such a face.

Pastel. Pastel provides an easy medium for just a simple, straight-forward likeness, to be used more as a record than as a painting. Because of the difficulties of work-

ing in pastel, this fragile medium is not practical for large paintings such as group portraits. Also, at least in Great Britain, pastel paper is limited in size to 19" × 22", therefore limiting the size of the head in a portrait to about 4" to 5" for a three-quarter-length figure and about 5" to 7" for just the head or head and shoulders.

Watercolor. Lively and spontaneous portraits can be created in this medium. However, as is the case with pastel paper, watercolor paper is rather limited in size, as are brushes (in Great Britain). Also, because of the awkwardness of handling the water, an Imperial-size sheet of watercolor paper is about the maximum that can be handled conveniently. Due to the fluidity of the water, the artist is invariably compelled to work on horizontal rather than vertical surfaces, making it more difficult to use a large painting surface.

Oil. For a group portrait, oil is obviously the best choice of medium since size is the governing factor. It is difficult to manipulate or even to find very large sheets of drawing and pastel paper, so canvas is the natural surface to use for a very large painting. Remember also that in an oil portrait a life-size or nearly life-size figure is necessary to do justice to your subject.

Color Scheme

I always begin a portrait by considering the color scheme. I usually let the child's eyes, hair, or clothes be the key as I think out a palette for the portrait. I often remind myself that the sitter is enveloped in space of a particular color or character, and this must be clearly reflected in the figure and clothing. In order to produce a harmonious painting in terms of color, this reciprocal relationship between the colors in the figure and those in the background must be observed very carefully.

Of course, the complexion also plays a large part in the decision, and if it is to be an outdoor portrait, the intense lights and shadows created by the sunlight will require a palette of rather strong color. Sometimes I even take into consideration the room where the portrait is going to hang, although the artist obivously must not allow the interior decorator's mind to take over in this area. The painter's real *feeling* about a child is naturally more important than the room, and this feeling should be the deciding factor.

Most parents find it difficult to visualize a color scheme, so you will have to use your color sense, experience, and imagination in planning it. If you are in doubt, paint a small oil sketch as near as possible to your conception of the finished portrait; you will find this is a good way of getting parents to join you in your decision-making process.

Remember also that it is not necessary to aim for purely natural or realistic color. Let your imagination run free, and if you feel like adding lots of blue in the black of a child's hair, do so! There is no absolute or pure black—and don't forget that the background will reflect color that may not be obvious in the hair itself.

You will find it quite surprising how many people fail to notice the arbitrary use of color in the hair when the painting is finished and hung. The overall impression, if successful, will tend to camouflage, if not conceal, any liberties you may have taken with flesh tones and hair. If you study the portraits reproduced in color in this book, you will find many examples of the free yet appropriate use of color.

A painter should be bold in his choice of color, and we do not have far to go to look in the museums of the world to find this point illustrated in the realm of portraiture, particularly in paintings

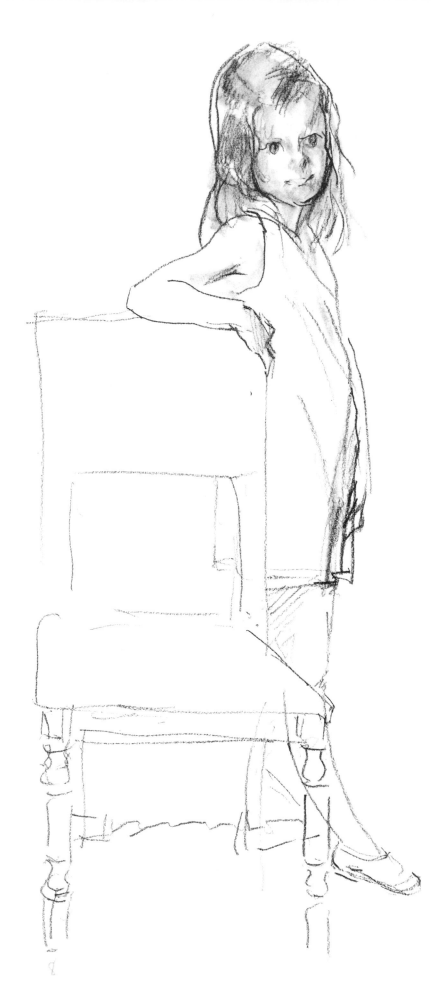

done since the advent of the impressionists. Aim to be poetic and exciting in your use of paint, rather than timid and unadventurous.

Background

Needless to say, consideration of the background in a portrait is vital. I generally try to keep the background very simple so that it will not compete with the central figure or figures in the painting. A child's personality is not powerful enough to warrant a fussy or busy background.

I always try to decide upon a background color complementary to the sitter—that is, one that will bring out the particular qualities of the child's complexion. For example, when painting a fair child, I use a cool, predominantly blue-green background. This can be either tinted paper if I am painting a pastel or watercolor portrait, or a coating of toned-down viridian green if I am using oil on canvas.

Remember too that the background does not necessarily have to be painted. You will notice in some of the examples of my work in this book that I avoid using a background as such; I have painted many group portraits of children using the bare white paper or canvas as my background in terms of color.

The great advantage of using a white or natural painting surface as the background is that the painting will go with almost any color scheme. Also, if the painting is large, the light background will keep it from becoming a heavy picture and thereby dominating everything around it.

Of course, this approach requires careful planning and good draftsmanship. I often proceed as if I were doing a large drawing. I use charcoal to lightly sketch in the composition and either dust off the surface layers or fix the sketch with a fixative spray. Then I go over the outlines with a brush and paint, usually using ultra-

marine blue because this color relates perfectly to the bare painting surface and ties the painting together.

I keep my lines loose and free and sometimes leave one or more inaccurate lines in the finished portrait as my "signature." I try to paint only a minimum number of areas as masses of tone, so that the large white spaces will relate well to these few masses rather than appearing disjointed.

If you have the nerve, of course, you may simply go at the white surface with a brush loaded with pigment and lots of turpentine!

Choosing the Right Pose

Since no two children are really alike, it is obvious that there are postures which come naturally to some while being a strain for others; yet incorrect posture is a fairly common reason that many portraits lack interest and fall far short of perfection.

There is nothing worse than showing a lack of imagination when posing a sitter, so try to avoid the banal and the repetitive, and always try to avoid the formal pose. For instance, some subjects look better in a standing pose; others fall naturally into a comfortable posture when seated. Since they are loose and supple, children should not be made to sit rigid and upright in the manner of a Victorian governess.

I have painted boys seated astride a chair, with the back of the chair toward me; in this position the sitter's arms automatically fold across the top of the chair back. I have also placed children on the floor on a pile of cushions.

John Singer Sargent painted a most charming portrait of four girls, the Boit children, which now hangs in the Boston Museum of Fine Arts. In this painting, one of the girls is seated on the floor and the other three are standing. Their personalities are played off against one another and a giant Chinese

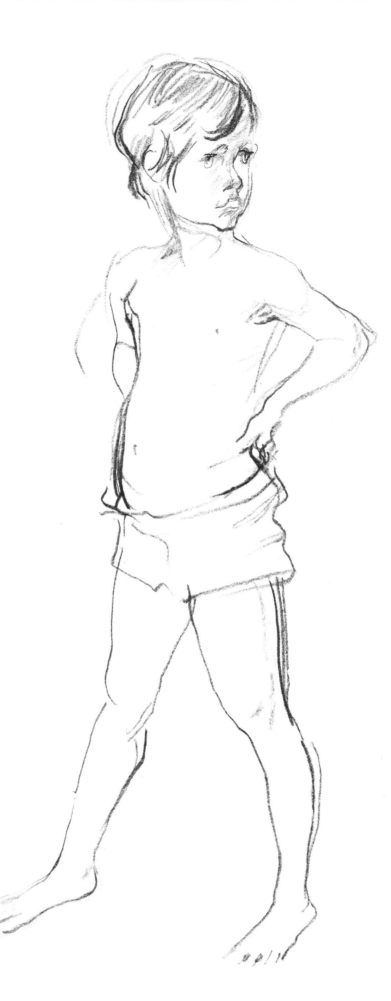

porcelain vase in the background gives the painting height and elegant contrast. Degas and Renoir also used unconventional approaches in their arrangement of children in group portraits.

It is only by trial and error that you will find the right pose for each of your subjects, and with experience you will soon be able to sense the right as opposed to the wrong one.

Clothing: Formal or Informal?

The first thing to discuss when planning a portrait is whether it is to be a formal one, with the sitter perhaps wearing a party dress, or an informal one, with the sitter in jeans or even a bathingsuit. I once painted a group of three boys wearing similar torn-off shorts and striped "T" shirts, with bare feet! Their Dalmatian helped complete the portrait as he lay at their feet and gazed up at them. A sweater or an open shirt or blouse also provides informal attire for children.

Girls look good in something pretty but simple. The choice depends of course on their ages; after eight or nine, girls become self-conscious and are more concerned with what they are wearing. All this is a matter of taste and you will have to discuss the matter with the sitter's parents.

Remember too that children's faces speak for themselves and do not need ostentatious trappings. I once arrived to paint two little boys of three and five in Oyster Bay, Long Island, and found them enjoying a game of "cowboys and Indians." I thought it might be fun to paint them in their costumes. Later, however, I decided against this approach and ended up by painting them in clean rompers, adding the touch of "cowboys and Indians" by painting shadows dressed in these outfits in the background!

I have also enjoyed portraying children in bathingsuits when by the beach, and on occasion, even in the nude! The portraits reproduced throughout this book illustrate the kinds of clothing appropriate for children's portrait paintings.

Drapery

Until a few generations ago, art students were strictly trained in the fine art of rendering drapery, and there are many great portraits in which the cloth of the costume —satin brocade, for instance—illustrates how much attention was given to this subject. The old masters generally set their best pupils to the important task of painting elaborate robes and hangings.

Of course, a lot can be learned from studying the folds and textures of muted velvet, shiny satin, or even cotton, as well as the way they fall. When doing a formal portrait, I often make separate studies of the child's clothing, preferably in charcoal, and work from these when I am away from the sitter.

But the mastery of the form beneath the cloth is as important as painting the outside shape correctly. Leonardo da Vinci is our finest example and inspiration in the study of form. The movement of the body, the extension of the limbs, and so on naturally dictate where the folds occur in a garment. Fortunately or unfortunately, however you may look at it, we can easily avoid the subject of drapery today.

Including Animals

As I mentioned briefly in an earlier chapter, animals and pets are very welcome additons to children's portraits, provided you are capable of portraying them convincingly and quickly. The most ambitious aim in this category is the equestrian portrait of a child. But remember, even if you feel like

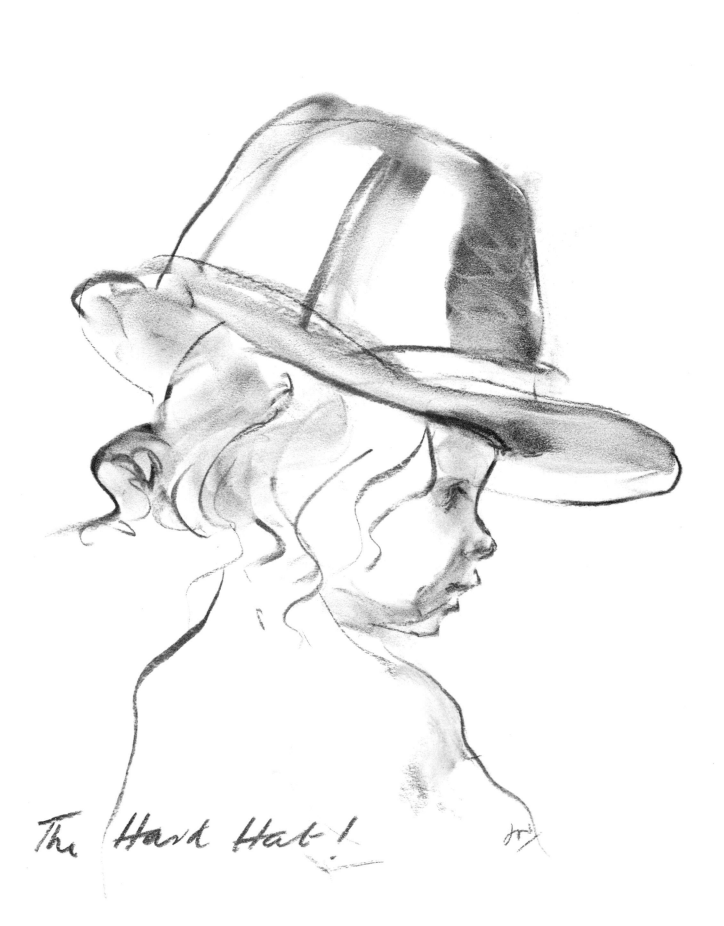

The Hard Hat!

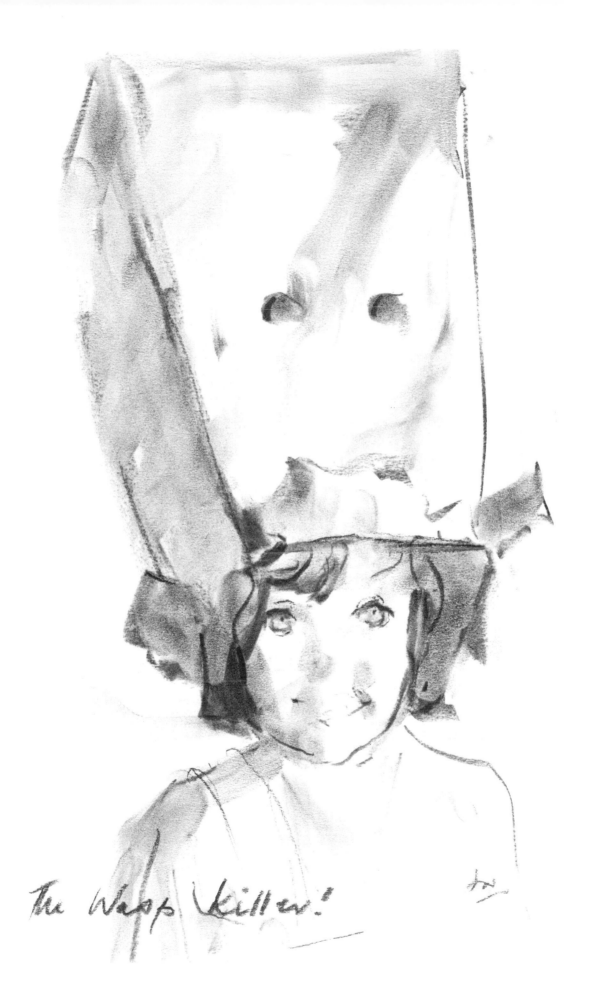

The Wasp Killer!

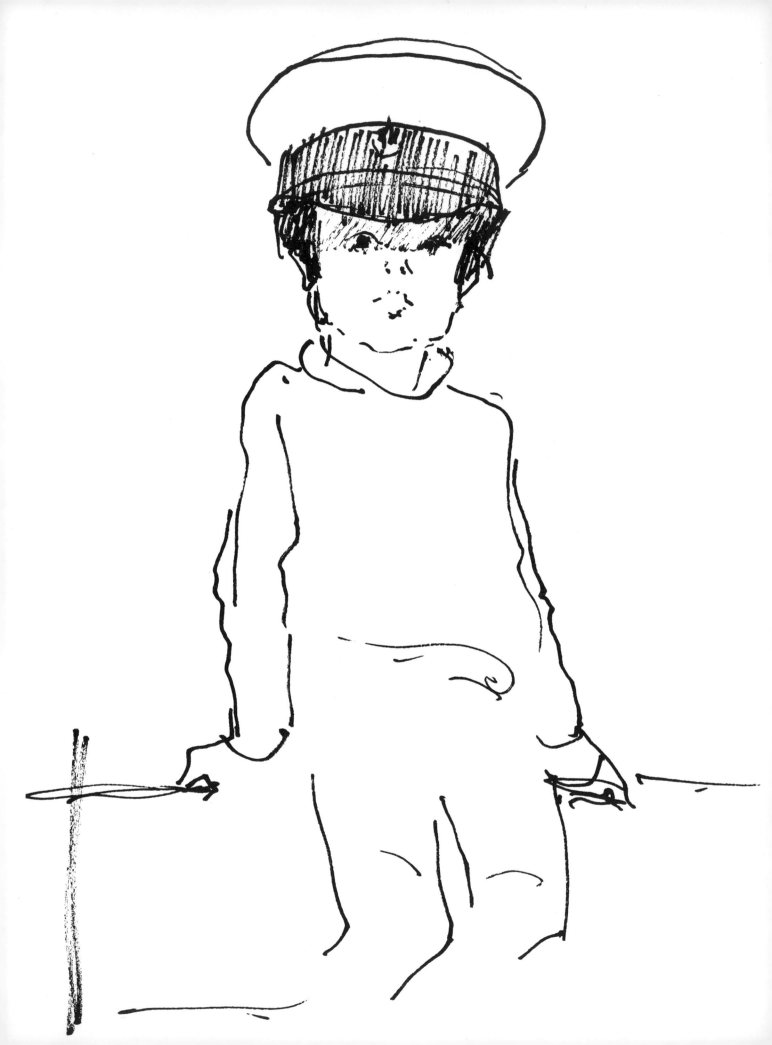

a Velázquez painting the young Prince Don Baltasar Carlos mounted, the parents of your subject will want as good a likeness of the pony as of their child!

Moving on to the more domesticated creatures, cats and dogs, particularly the latter, have played a large part in children's portraits throughout history. If there is a dog in the household it is not unusual for the child's parents to suggest including him in the portrait, especially if he and the children are inseparable. Several studies in action and repose will be necessary before you can gain confidence in making an accurate likeness of the animal. It is important not to allow the dog to eclipse the child in your composition, and to see that the flowing lines of the dog are compatible with the shapes in the rest of the portrait.

Cats, with their graceful bodies, also make splendid subjects. It is not easy to capture cats on canvas, however, and they will also require careful study. On one occasion I included a rabbit in a group portrait, but I suggest that you try to avoid making this sort of feature too sentimental or too conspicuous.

Props

I have used a variety of props—from chairs to boats—in my portraits of children. Indoor portraits can obviously include chairs and other items of furniture that enhance the composition. In the examples of my paintings reproduced throughout this book, you will notice that I have used boats and rocks in the backgrounds of outdoor group portraits.

Obviously, you must make careful studies of the structures of boats and rocks and other props, so that you can maintain an element of authenticity in your painting when you use them. Also, if you decide to put an object such as a boat in your painting, be

sure to plan its scale carefully or you may end up with all boat and no children!

Where to Paint the Portrait

If you have a studio in the same city or town where the children you are going to paint live, then it is best to arrange the sittings in your studio. This is the ideal place for an artist. He is well oriented to his environment, he knows his source of light well whether it is natural or artificial, he will naturally be relaxed enough to create good work, and he can obviously spread his paints and brushes around him without fear of damaging the furnishings.

If you do not have a studio, then you should paint your subject in his or her own surroundings. And of course, if you have an out-of-town commission you will have to provide yourself with portable equipment and allow some time before the sittings to adjust to your new and temporary surroundings.

The most convenient way to paint a portrait with an outdoor background is to sketch the background in pencil or oil and then work indoors, with the light coming from the same direction as it did in the outdoor studies.

Preparing to Paint

I would like to pass on to you the procedure I go through when I am about to start a painting. First, I clear my mind of distracting thoughts and meditate quietly if I can. Then I think about all the elements that are important, in the following order of priority: design, form, color, tone, and texture.

A good portrait naturally requires careful consideration, and these elements, plus ample preparation in the form of sketches and notes—made ahead of time or even during the execution of the portrait—help to maintain order and unity in your thoughts and work.

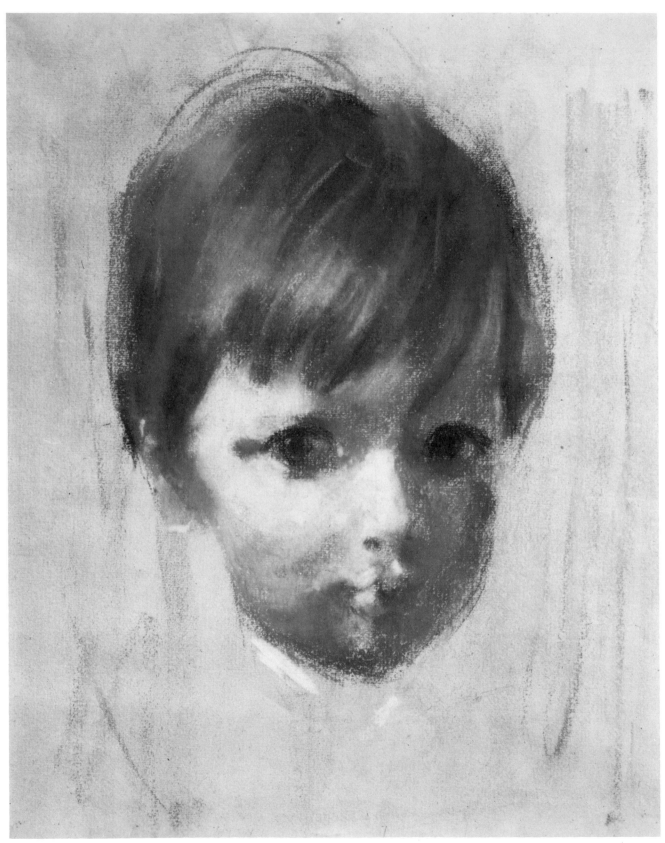

The Head of a Little Boy. *Pastel on paper, 14" × 18". Collection Mrs. M. Lineaweaver, New York. This pastel portrait, done without detail or a full development of the features, captures the spirit of innocence typical of small children. The sitting lasted no more than thirty minutes.*

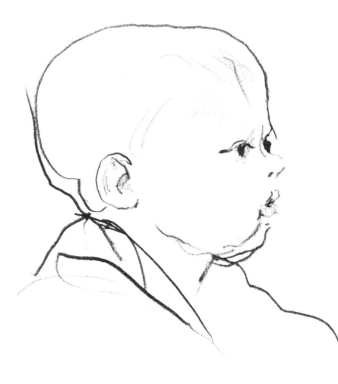

Chapter 6
Developing
a Likeness

In accepting a fee for a portrait, the painter is naturally obliged to satisfy his client that he has made a fairly good representation of the child he has portrayed. The delicate question often arises as to who is the final judge of what is a fairly good representation. If you are painting someone only for yourself you may ignore this question and give more attention to the purely artistic or expressive aspects of portraiture, or you may even compromise with something halfway between the two.

What Is a Likeness?

A likeness may be a purely physical one, in which all the features are accurately depicted, the proportions and relationships of one feature to another are correct, and even the gesture is typical of the person painted. A likeness may also be a character study in which the subject is perfectly represented except for certain exaggerations in the nose, eyes, mouth, and so on, similar to a subtle caricature.

You can obtain a convincing likeness in spite of these slight distortions if you first study and analyze the personality of the sitter very carefully. In the case of children's portraits, however, this type of representation defeats the purpose of the painting, which is often meant to be a record of that particular child at a certain age. The innocence and charm of the child's face will not be there if you take such liberties in painting it.

Sometimes, of course, a very convincing likeness happens even though there are slight inaccuracies as a result of the artist's feeling about the personality of the child. In my own work, I always try to "sense" the child's personality and to achieve a good likeness without slavishly copying what I see in front of me. I try to analyze what makes one particular child different from another.

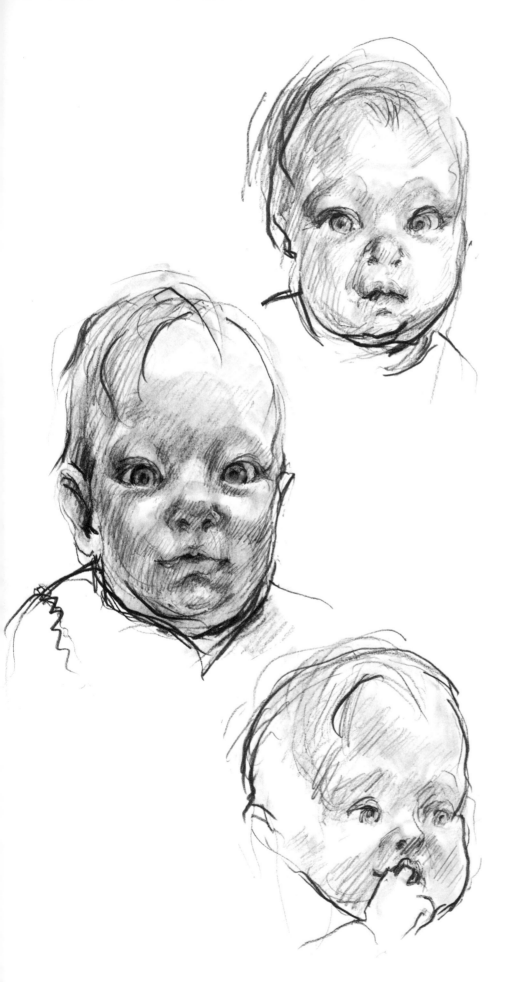

Likeness will be an arbitrary subject as long as we all think, feel, and react to one another differently. In one family, the father, mother, grandfather, grandmother, and friends will all see the child differently, and this will complicate the subject even further.

Ultimately, it is you, the painter, who must take a firm stand when there is doubt or a difference of opinion. Your training, talent, experience, and of course objectivity will be put to the test. You will have to make an unbiased assessment of your own work, as well as the constructive criticism of the parents, as you either improve or accept what is nearest to a good likeness.

Character, Personality, and Soul

Here you are treading on dangerous ground, and only your knowledge and experience will lead to a perfect understanding of what these three are about. Character is obviously something you can discover only after knowing the subject for a period of time. This is a much abused word. The painter need not go into character too deeply where children are concerned, because in most cases, it will not yet have been formed or will be only partially developed.

It is therefore really the personality, rather than the character, that is obvious to the outsider who has come to paint a child in a few sittings. Whether the child is lively or dull is part of his personality; I can generally tell after a few minutes of talking to or playing with a child whether or not I will have to work hard to put "life" into the portrait. The artist naturally prefers a lively child who gives him something in return and does not take too much out of him.

By soul in the context of a child's portrait, I mean the feeling of depth and vibrant life in the child's face. Your perception of soul depends a lot on how you react to children and on how sympathetic you are to their ways. Without real empathy, it will be difficult to breathe life or interest into a child's face as you paint it.

Using Mechanical Aids

By mechanical aids, I mean primarily the camera, or photographs. At an early period in my career, I decided that I would discipline myself to totally eschew the use of the camera. Drawing has always been one of my interests, and I was determined that if I were going to paint portraits I would have to become a sound draftsman. I reasoned, if painters painted good portraits before the invention of the camera, why could I not also try?

Mechanical aids of this nature tend to make a portrait turn out impersonal, cold, and lacking any true human quality. The only piece of equipment I use—to check the truth or accuracy of my own perception—is a hand mirror, as mentioned earlier in this book. The mirror helps me get a new, reverse image of what I am doing instantly, and I can immediately correct any faulty drawing or foreshortening.

So, as far as my own work is concerned, the camera and photographs are definitely out. The only case in which photographs are necessary is, obviously, in painting posthumous portraits. I know that many portrait painters do use photographs as aids to developing a likeness, and I think in most cases this is evident in their work.

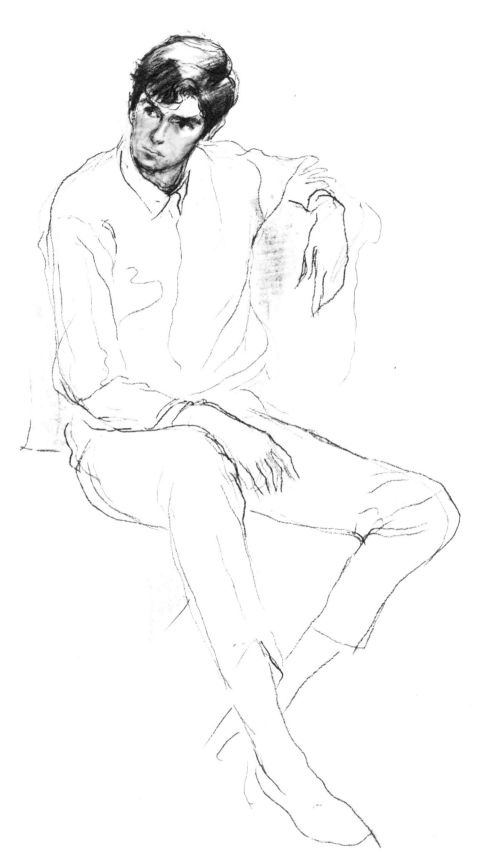

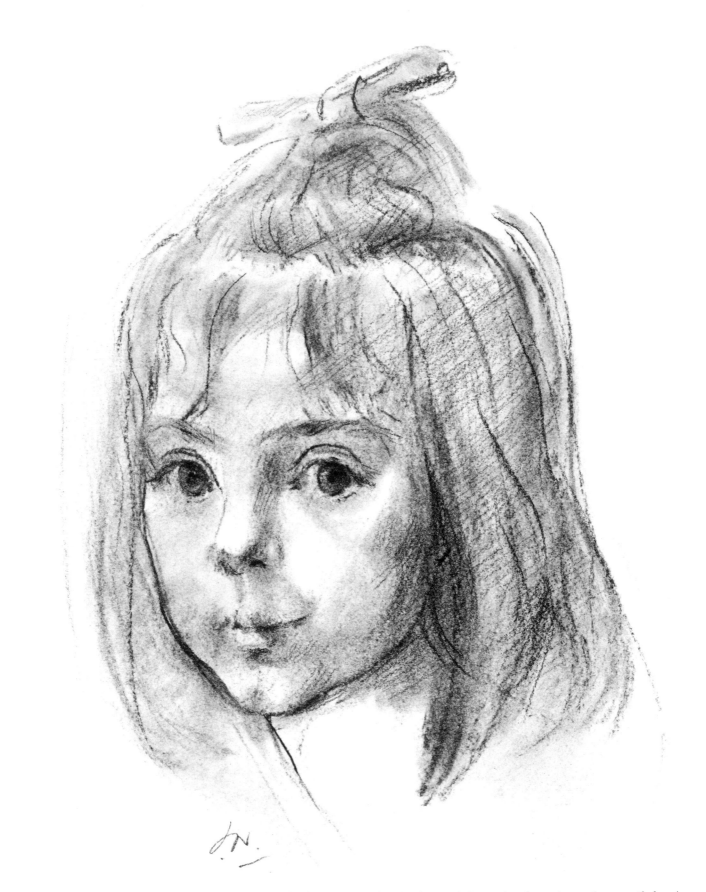

I completed this portrait drawing in one sitting, using charcoal on rather smooth drawing paper. I find that when I work fast and furiously I produce the best results; if I fail to concentrate, the work becomes heavy and labored.

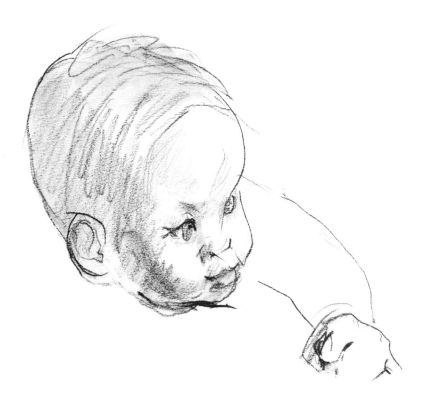

Chapter 7
Finished
Portrait
Drawings

If you have decided that a finished drawing is most suitable for capturing the likeness and character of a particular child, your next step will be to settle on size and medium—that is, to decide whether you will use charcoal, carbon pencil, lead pencil, or Conté crayon. The method of completing the finished portrait drawing is basically the same as that for sketches and studies described in Chapter 4; keep in mind the geometric forms, as well as the use of line, discussed in that chapter.

Size of the Drawing

I suggest that the maximum size for a lead pencil, carbon pencil, or crayon drawing should be no more than half to two-thirds life-size, or between 4" and 5" for the head. If you decide to use charcoal, you may go for a slightly larger head, say 5" to 6". About two-thirds the size of your actual drawing surface should be used as

space above and below the head; it is always best to use a larger sheet of paper than you actually need, in order to give yourself room for changes.

Drawing the Head
from Several Angles

Drawing two or more attitudes of the same head in one portrait is always stimulating for the artist. Since most of us have so many different expressions, this is always a pleasing way to draw a child—but it is also difficult. You will have to allow space for several heads on your drawing paper, and besides drawing the features in a variety of foreshortened positions you will also have to deal with composition when you use this approach. (For a more complete discussion of composition, see Chapter 8.)

Try to draw the head looking into the paper rather than out of it, in order to lead the viewer's eye

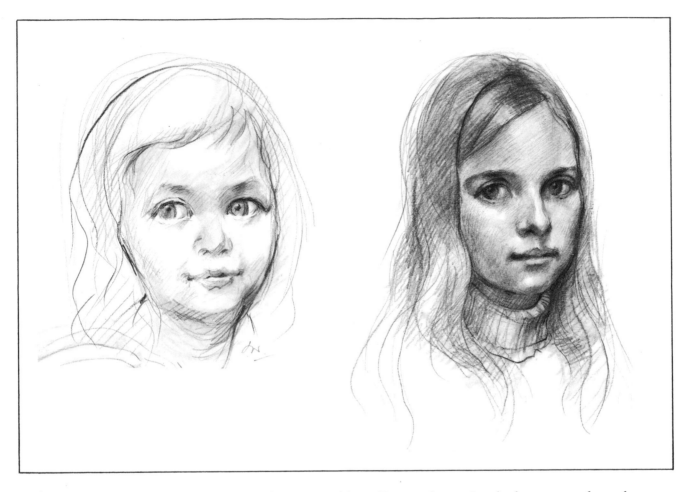

Above are two approaches to the finished portrait drawing. In the drawing on the right I used carbon pencil to obtain darker tones. This drawing looks overworked as a result of my attempts to obtain a good likeness. The drawing on the left was more successful, with its light tones and freer quality.

Nadia and Natasha Brooks-Baker. *(opposite) Oil on canvas, 30" × 36". I did this portrait as an academic, or formal, exercise in blue. In fact, I used four blues—permanent, Winsor, cerulean, and ultramarine blue—with touches of viridian green in the background. The blues tended to dominate the painting, so I had to paint the faces quite pink or they would have appeared ghostly. I used geranium lake, alizarin crimson, cadmium yellow pale, and yellow ochre for the flesh tones. I added a touch of cadmium red for the lips and for Natasha's red hair ribbon in order to relieve the overall blue of the background.*

into the composition. If you do have the head turned toward the edge of the paper, then place the eyes so that they look either out at the viewer or toward the center of the painting.

After you have made your first drawing of the head in one position, make a quick mental study of the paper and decide where you should place your next drawing so that it will be in a harmonious relationship to the first, and so on. Try to create rhythm as you place each different pose of the same head, and keep in mind that variety is also essential.

Drawing the Hands
When competently and sensitively drawn, the head of a child is often a thing of beauty in itself. The movement of the head in relation to the neck and of the eyes in relation to the rest of the head all give the portrait movement, create

visual pleasure, and produce esthetic satisfaction in drawing it.

The addition of hands to such a portrait will increase its interest on the whole and will also supply an additional touch of character. Of course, including the hands will increase your work and further tax your skill, because hands are very difficult to draw with feeling and expression. Try to keep the lighting on the hands simple but strong, as their structure is not easy to define.

Hands may be drawn in repose or doing something appropriate to a child of the particular age you are drawing. The arrangement of the hands in relation to the head and shoulders is also important and requires much thought. You should try out different poses and decide on the one that looks most natural. Here again, it is essential to take into account the additional length of paper needed.

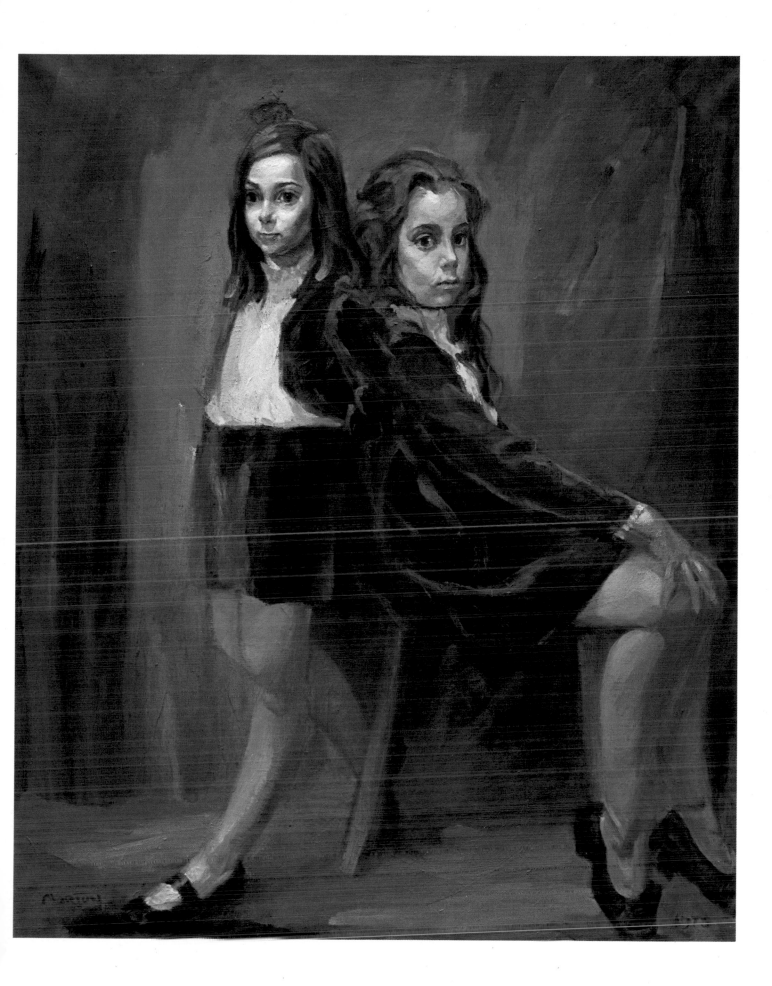

89

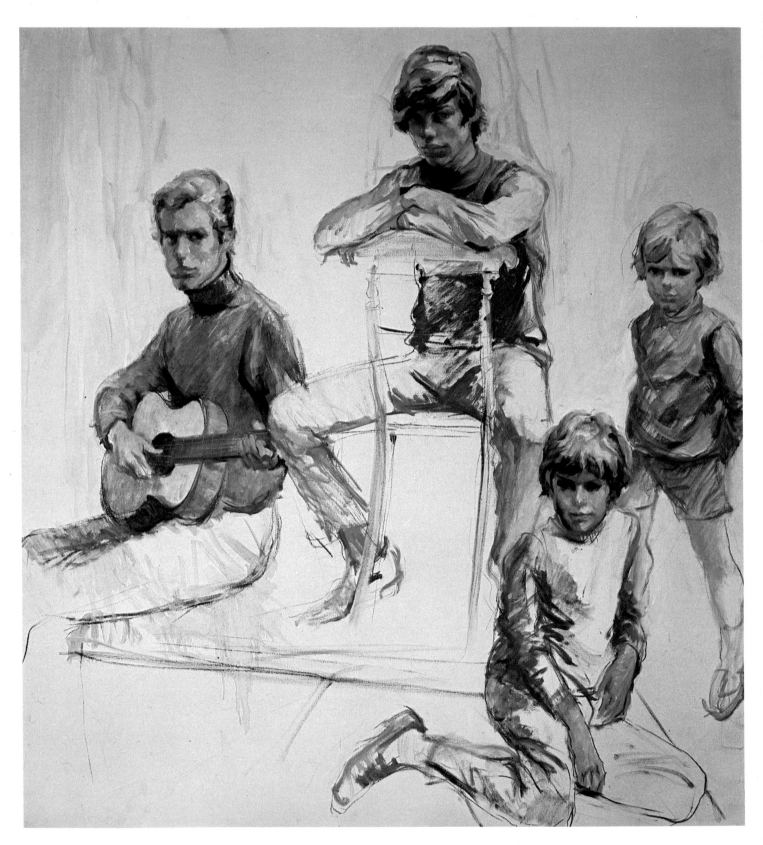

Nigel, Michael, Patrick, and Jonathan Spottiswoode. *Oil on canvas, 58" × 64".*
Collection Mr. and Mrs. Derek Spottiswoode, London, England. Painting these four
brothers became an absorbing and challenging commission. After making several sketches,
I created this composition and decided to keep the whole color scheme dominated by blue.
Ultramarine blue, cadmium orange, and white were the only colors I used in the painting.

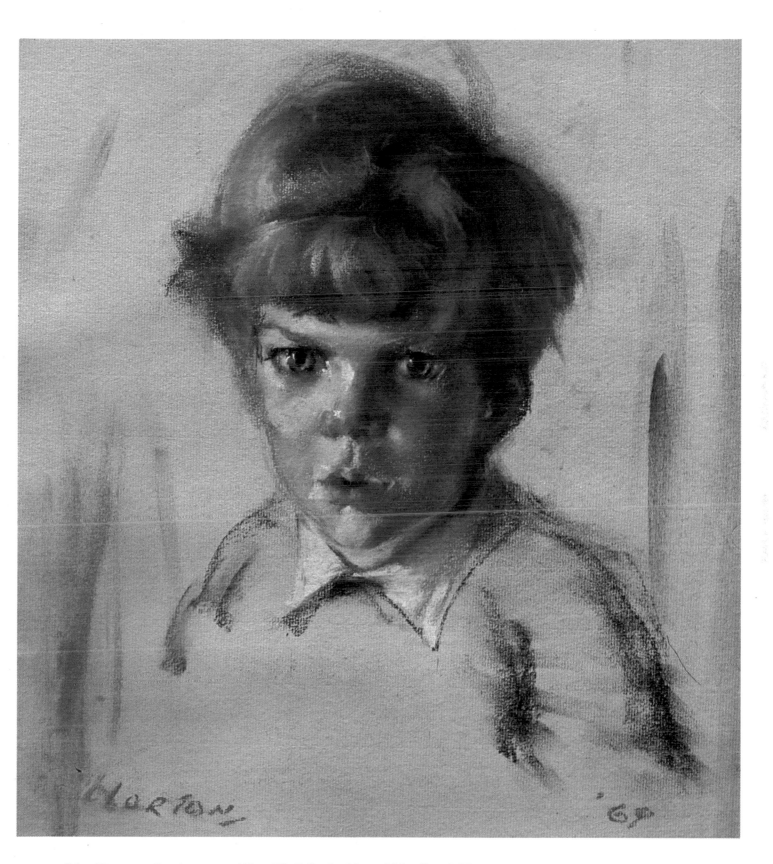

John Kinsman. *Pastel on paper, 19" × 22". Collection Mr. and Mrs. Francis Kinsman, Essex, England. Pastel is just about the best medium for capturing likenesses of very young children; it is well suited to expressing the softness of their facial tones and hair. It is also very convenient to use pastel when time is of the essence.*

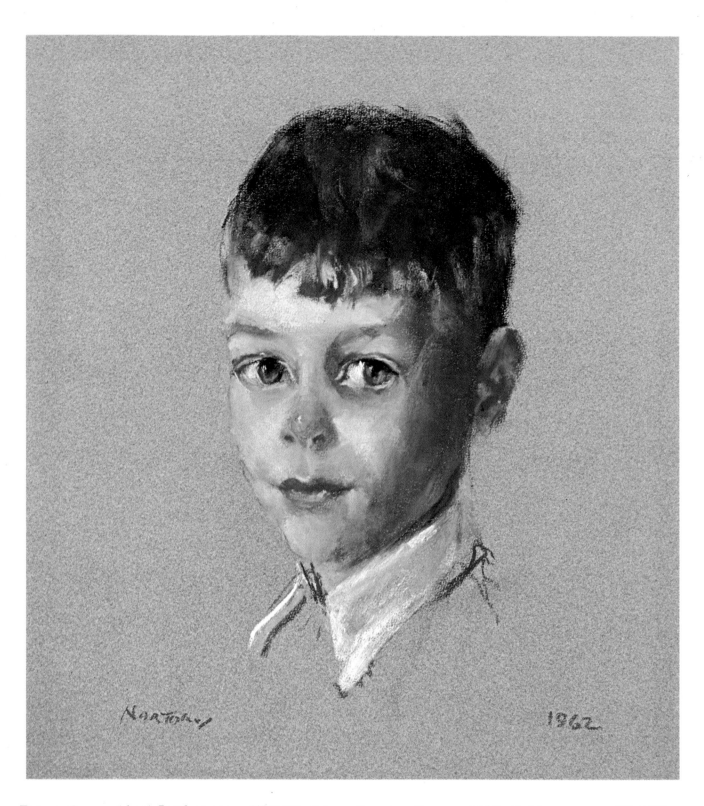

Tommy Cooper. *(above) Pastel on paper, 19″ × 22″. Collection Mr. and Mrs. Paul Cooper, Surrey, England. Because it seemed better suited to Tommy's strong coloring, I used a darker and warmer shade of paper here than I used for the portrait of Sussane. When painting a head in pastel, I find that just the collar of a shirt, blouse, or sweater is all that is necessary. Too much clothing detracts from the face, and folds of cloth make the portrait look "fussy." Children need the simplest treatment.*

Sussane Cooper. *(right) Pastel on paper, 19″ × 22″. Collection Mr. and Mrs. Paul Cooper, Surrey, England. I painted this on gray Ingres paper. Sussane's look of serene interest well describes the keen and patient sitter she was. Subjects like her are a joy to paint.*

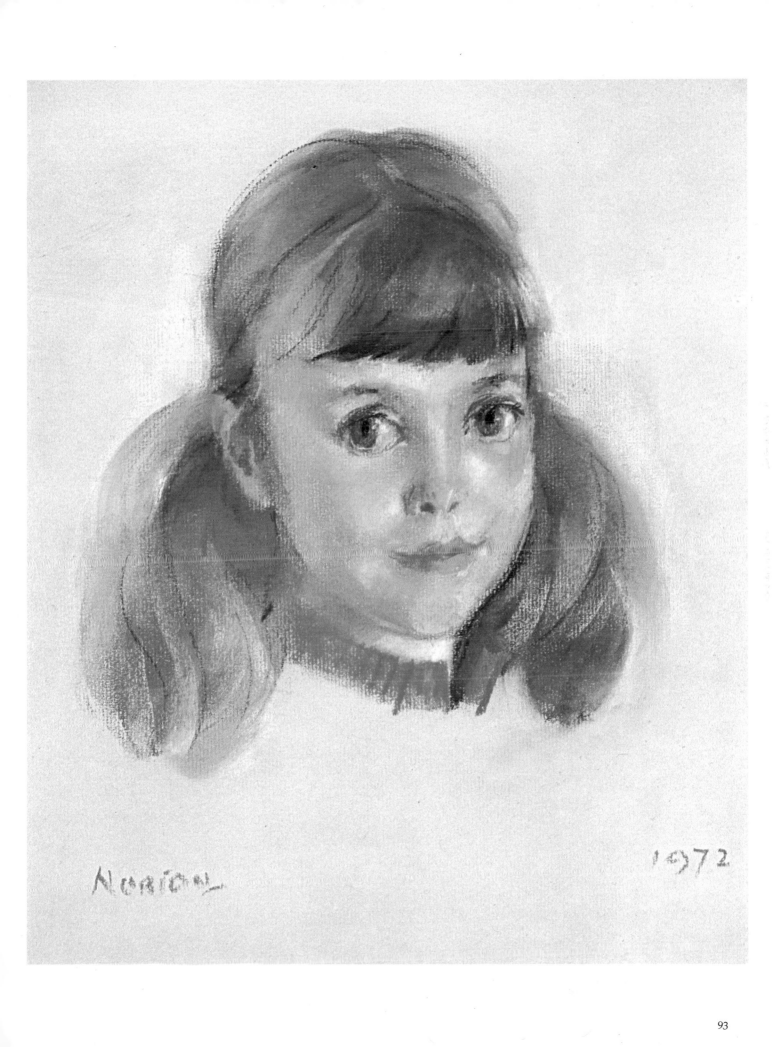

Norton 1972

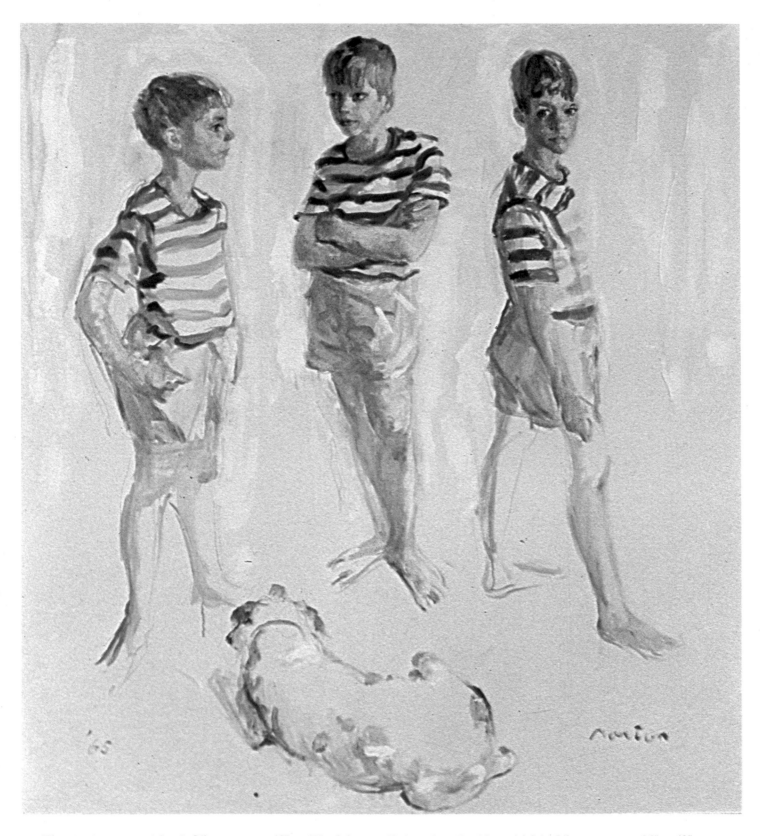

The Rapley Boys. (above) Oil on canvas, 40" × 48". Collection Mrs. Anne Rapley, New Haven, Connecticut. This commission provided me with three very cooperative boys who were quite willing to be painted barefoot. I emphasized the striped "T" shirts by painting all three subjects in the same attire and added the Dalmatian with its contrasting spots!

Christopher Buckley. (right) Oil on canvas, 36" × 42". Collection Mr. and Mrs. William F. Buckley, Jr., Stamford, Connecticut. As you can see, the predominant color here is cerulean blue. I used this as well as ultramarine blue, cadmium orange, and titanium white for the flesh tones. The high-back chair made an excellent background for Christopher's head.

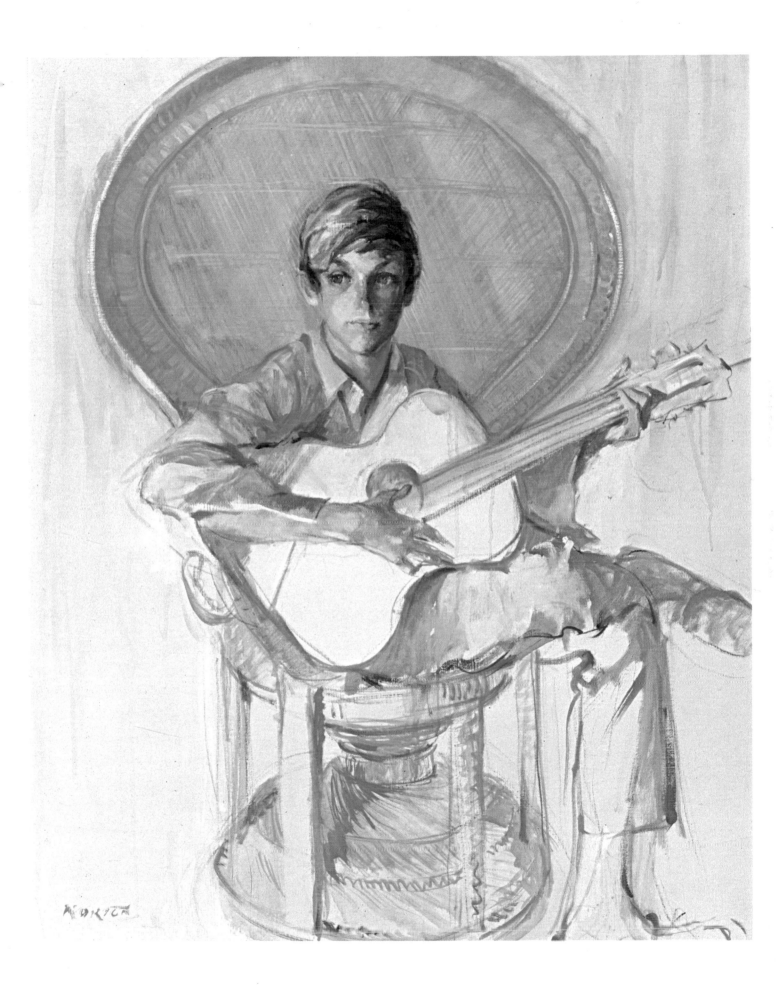

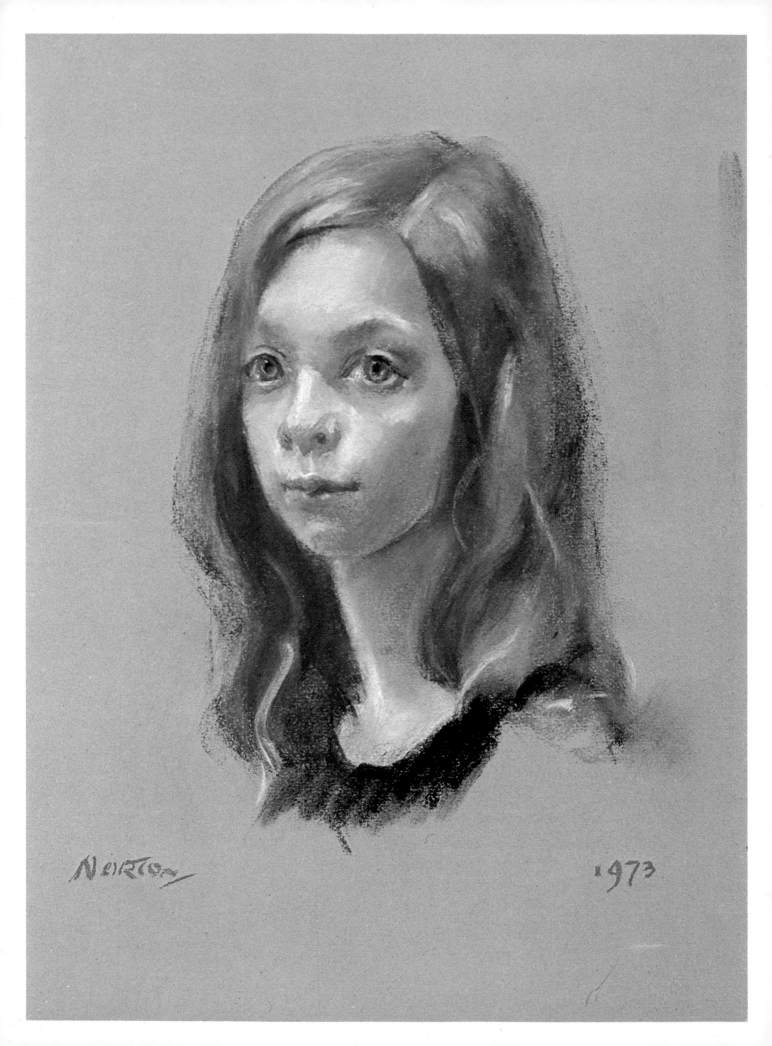

Norton 1973

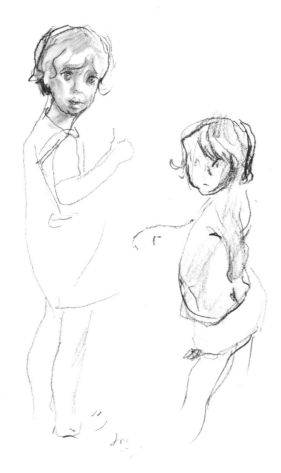

Chapter 8
Color and Composition

Both of these elements are extremely important in producing a pleasing, successful painting. Therefore, before I begin to discuss painting actual finished portraits, I would like to describe some of the basic principles, or ideas, behind both color and composition and how to use them.

Color Theory

The theory or science of color is one of the most important elements in the field of picture-making. In his *Treatise on Painting*, Leonardo da Vinci wrote about color: "The first of all simple colors is white, although philosophers will not acknowledge either white or black to be colors; because the first is the cause or receiver of colors, and the other totally deprived of them. But as painters cannot do without either we shall place them amongst the others; and according to this order of things, white will be the first, yel-

low the second, green the third, blue the fourth, red the fifth, black the sixth. We shall set down white for the representation of light, without which no color can be seen, yellow for the earth, green for water, blue for air, red for fire and black for total darkness."

It was nearly a century later that Sir Isaac Newton, physicist and mystic, formed his color circle and related the colors to the seven planets and the seven notes in the musical scale: red for C, orange for D, yellow for E, green for F, blue for G, indigo for A, and violet for B. Newton was followed by other theorists on color, the long list of whom includes Le Blon, Goethe, Chevreul, Church, Munsell, and Ostwald.

Basically, colors appear different under different conditions and obviously undergo positive changes depending on the kind and source of light acting on them. For example, colors viewed in daylight

Carolyn Wroughton. *(opposite) Pastel on paper, 19" × 22". Collection Mr. and Mrs. Philip Wroughton, London and Berkshire, England. I used lilac-gray Ingres paper and painted this sensitive face in cool pinks and grays to show the translucent quality of the skin tones. The touch of black introduced a suggestion of the leotard worn by this young ballet student and also served to accent the delicate structure of the head and neck.*

contain varying degrees of blue, while colors viewed in artificial light appear more yellow. This is why lighting conditions are a serious consideration in painting.

The whole question of color is a vast and complicated subject, particularly when you begin to think about the psychological connotations of colors as well. For those who wish to do further reading on color theory, I have listed several titles in the Bibliography at the end of this book.

Color Terminology

I suggest that you glance at the color wheels nearby, as these illustrate the various ways in which colors are considered to be related to one another. Also, you may find the following terms and color characteristics helpful as you plan your paintings:

Hue. The actual name of the color, such as red or blue.

Tint. The result of adding white to a color. For example, if you add increasing amounts of white to pure ultramarine blue, you will have lighter and lighter tints of ultramarine blue.

Shade. When you add increasing amounts of black to a pure color, you will have darker and darker shades of that color.

Primary Colors. Red, blue, and yellow are called primary colors because they cannot be duplicated by mixing together any other colors. However, even the primary colors are not entirely pure. The experiments of color technologists have shown, for example, that it is not yet possible to produce an absolutely pure red; most reds contain varying amounts of yellow or blue. The purest colors are those seen when a prism breaks up the white light of the sun.

When primary colors are mixed together, they produce a neutral,

In this standard color wheel, the primaries (1) are yellow, red, and blue; the secondaries (2) are green, purple, and orange; and the tertiaries (3) are the innumerable tones obtained by mixing together two of the secondaries.

gray color. In fact, if you mixed together all the pigments on your palette, they would neutralize one another and form a gray mass—or in more significant artists' terms, a mess!

Chromatic Intensity. This means simply the degree of brightness of a color. The intensity of a color can be reduced by the addition of either white or black; white will weaken and lighten the color while black will lower its tonal value.

Warm and Cool Colors. The eye normally sees more warm colors than cool ones. Generally, the warm colors such as red and yellow are considered dynamic and of greater chromatic intensity than the cool colors such as blue and green. Warm colors, particularly red, tend to vibrate. They also appear to advance and thereby dominate a painting, while the cool colors seem to recede and can be used to cool a painting considerably.

Tonal Values. As I said in an earlier chapter, the value of a color is its degree of lightness or darkness. Tonal values are extremely important in describing form. However, a change of color, rather than a change of tonal value, can often be used with telling effect. In other words, if I want to describe a change of plane in a delicate face that is half in shadow, I often use a different color, rather than simply a lower value of the light flesh tone, to indicate the area in shadow.

Color Harmony

Since the success of a finished painting depends on the skillful and tasteful use of color, you should keep in mind that color harmony can be created in many ways. One way is to use strongly contrasting values of the same color; another is to use colors adjacent to each other on the color

Colors in highlight tend to move toward yellow; colors in shadow tend to move toward violet.

This color and tone triangle illustrates that white tints a color; that black shades a color; and that the tonal values between white and black consist of various shades of gray.

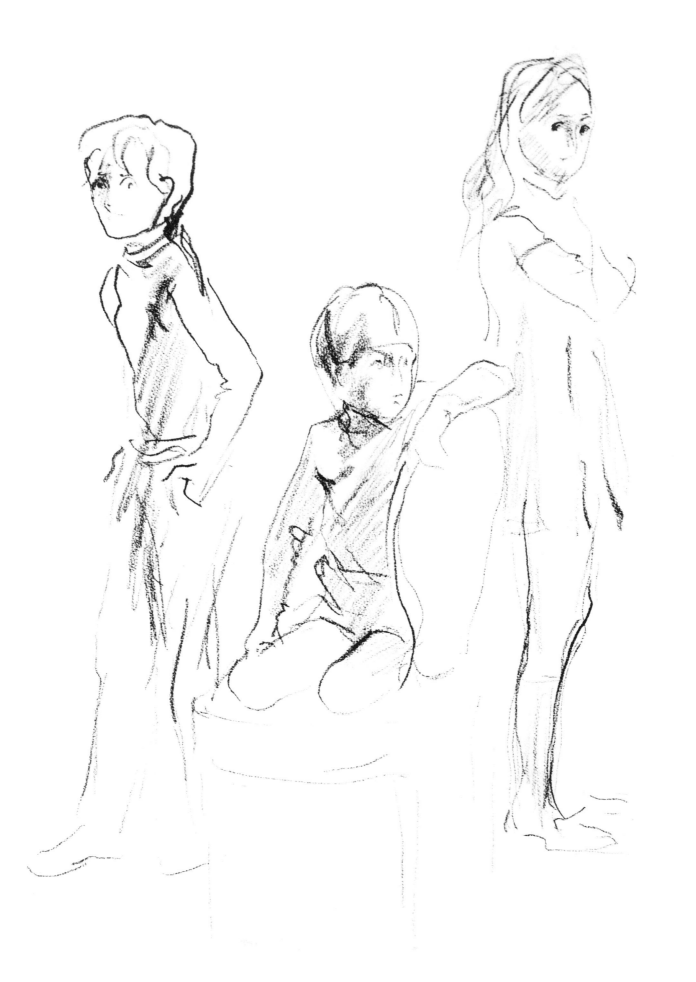

The charcoal pencil studies on these two pages helped me visualize the compositions of the finished oil portraits which followed them.

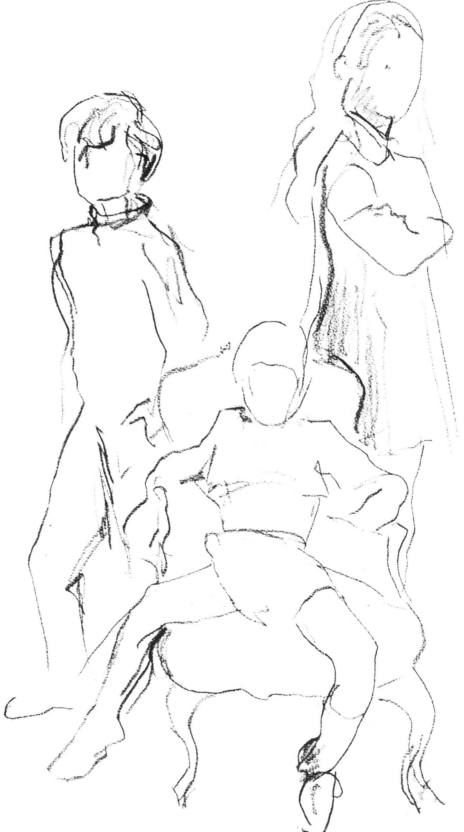

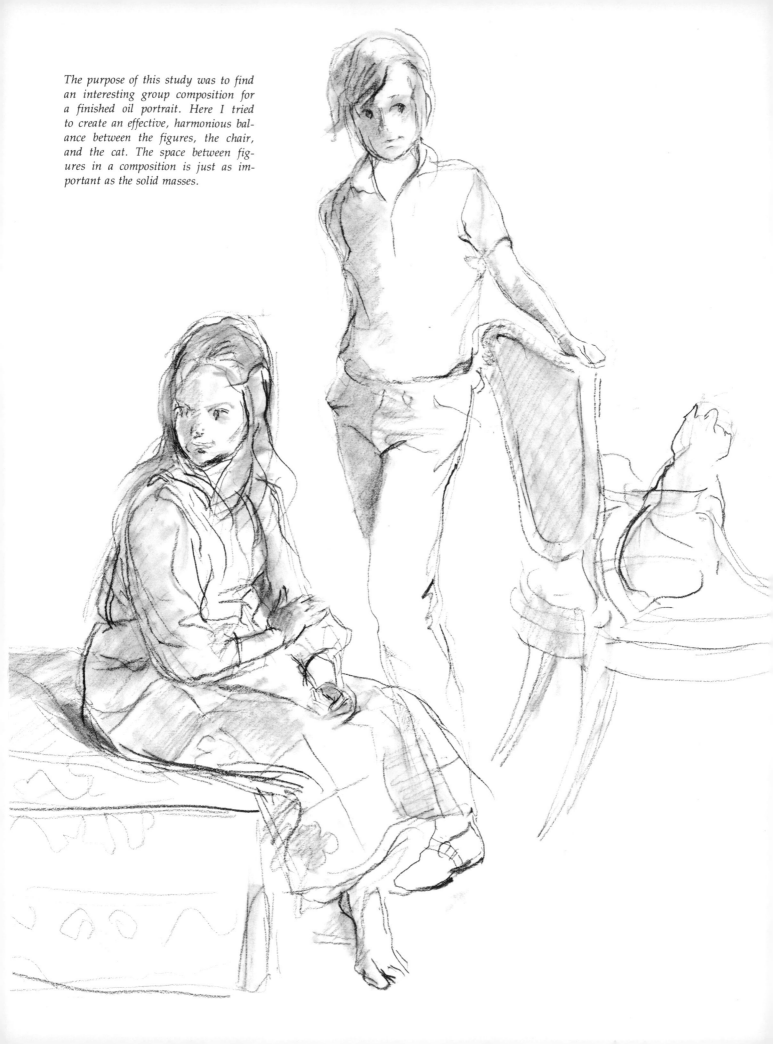

The purpose of this study was to find an interesting group composition for a finished oil portrait. Here I tried to create an effective, harmonious balance between the figures, the chair, and the cat. The space between figures in a composition is just as important as the solid masses.

wheel. It is also possible to use triads—that is, three colors on the color wheel that form the corners of a triangle—as well as to use simply one dominant color.

However, it is most important to let your own personal "color feeling" dictate your use of color. In my own work, as you may have noticed, I use a good deal of blue. To a great extent, the painter's choice of color is influenced by his psyche!

Composition

Composition always has been, and still is, the foundation of a good painting. Composition means designing or putting together the elements of a painting to create a harmonious and dynamic whole within the framework of a two-dimensional surface. In painting, the whole is more important than any one part, and each individual element is therefore vital. Form, space, color, value, and texture, as well as their effects, must all be taken into consideration.

Since drawing and painting deal basically with space and form, these are the first elements to be considered. Space and form can be manipulated to make the composition either flat and two-dimensional or three-dimensional, as most conventional portraits are.

The simplest way to deal with space and form is to master the art of perspective, to make use of the principle of the diminishing line of sight, and to create an illusion of space.

Composition must be dynamic —that is, it must have a feeling of perpetual thrust. Composition always plays a key role in my work. I try to lead the eye of the viewer from one element, shape, or color to another, to keep the eye traveling around the whole painting, and finally to lead it back to each part in turn.

Rhythm, balance, and harmony are elements that should be taken into account throughout the composition. Just as the human body provides all these forces, the blank spaces around it must likewise do their part by providing thrust and counterthrust to give the painting life.

The Japanese Zen painters observed in their philosophy that ". . . it is the blank white spaces in the art of sumi é that are important, they provide the note of cosmic space without which living bodies are nothingness."

Studies for Composition

When you use sketches for the purpose of composition, the object of the exercise is to explore every possibility of movement and gesture that the human form is capable of, endeavoring at the same time to keep these movements as natural and spontaneous as possible. A posture or movement that seems unnatural to the anatomical or muscular system, not to mention the nervous system, of your subject would look ludicrous, impossible, or unreal.

Aim for continuous connecting lines of vision, contrast blank spaces with masses of tone, look for contrast of line and tone while trying to visualize a pleasing composition. Search for rhythm in the figure while you draw, and allow a convex curve to flow into a concave curve and so forth.

One of the most visually satisfying geometric forms is the pyramid. With its attendant triangles, angles, and flat surfaces, the pyramid provides innumerable ideas for building well-structured paintings; when sketching or searching for poses, keep this form in mind. For example, notice the way a hand rests on a hip, the angle of the head in relation to the shoulders, the spread of the feet, the meeting of the hands, and the little triangles suggested by each hand itself.

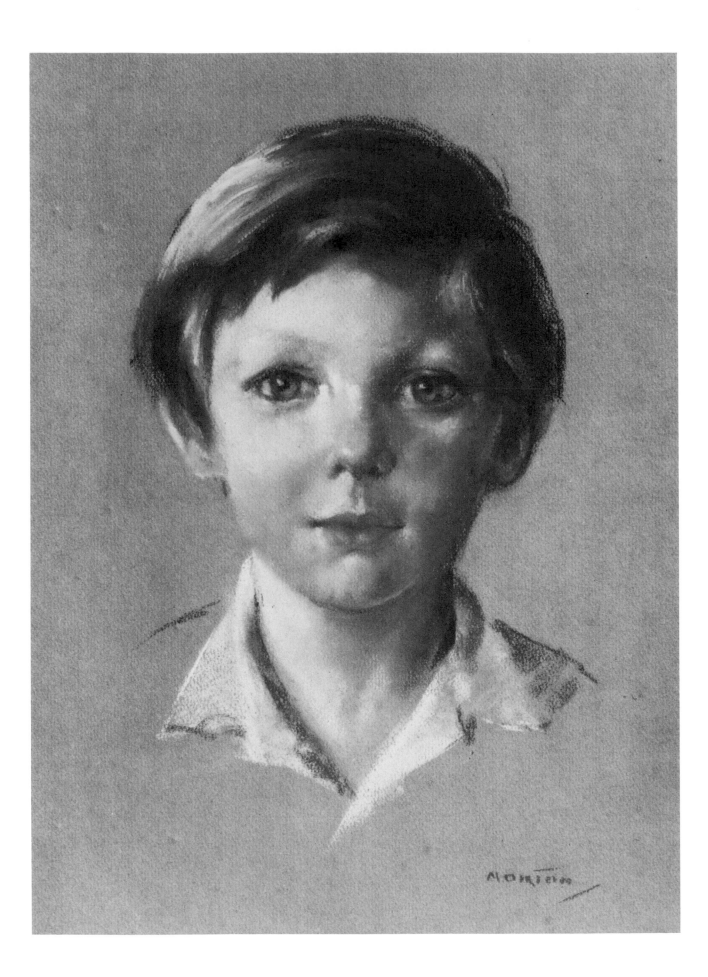

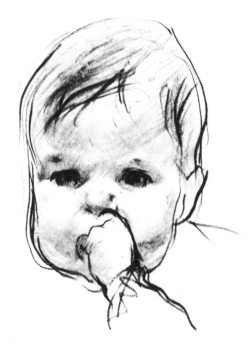

Chapter 9
Pastel Portraits

I am always astonished by the intensity, purity, and permanence of the important seventeenth- and eighteenth-century pastel portraits and studies I have found in museums in Europe. Earlier still, in the sixteenth century, Holbein the Younger is one of the first painters mentioned as having used the medium when it was limited to the earth colors compressed as sticks of chalk. In his monograph on Holbein, Ford Maddox Heuffer says the painter used "pastel" to draw his great studies for portraits of Henry VIII, Sir Thomas Moore, and Erasmus, to name but a few of his illustrious sitters.

But another painter, a woman, Rosalba Carriera, was the one who really introduced pastels as we now know them, with a large range of colors. She came to Paris from Venice with her mother and sister in 1720 and started a vogue of painting portraits in pastel. She was also a friend of Madame Vigée-LeBrun, the famous court painter and friend of the tragic Queen Marie Antoinette.

Another French painter and perhaps a better known pastelist than Rosalba Carriera was Maurice-Quentin de La Tour. When I visited the Musée Lecuyer in St. Quentin, located about a hundred miles northeast of Paris, I was captivated by the range and richness of his lively portraits of royalty and the famous people of his time, including Louis XV, Madame Pompadour, and Jean-Jacques Rousseau. The town of St. Quentin, where La Tour was born in 1704 is justly proud of him and advertises the fact on large signs visible miles before you enter its limits—a moving tribute to a painter.

Pastel Materials

The advantage of using pastel is that you can invariably provide

John Harpur, (opposite) Pastel on paper, 19" × 22". Colection Mr. and Mrs. B. V. C. Harpur, Surrey, England. This is one of my early pastel drawings, whose subject had a direct, boyish face. I completed this portrait in two sittings.

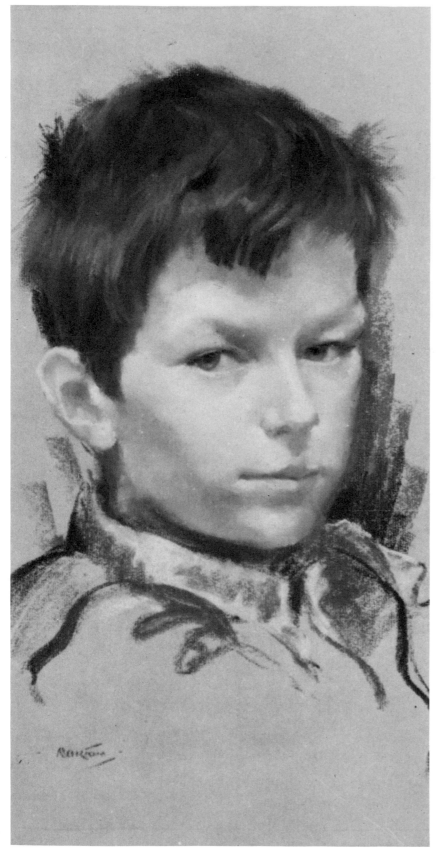

Diarmid Cammell. *Pastel on paper, 19" × 22". Collection Mrs. Charles Cammell. In this pastel portrait, I tried to capture the intelligent, observant, and thoughtful expression on the sitter's face.*

yourself with a comparatively full range of ready-mixed colors, conveniently packed and set out ready to use for painting active, mobile children. I try to carry the appropriate colors in my hand as I work, so that there will be no delay while I look for a color and thus miss a facial expression at the right moment. The following is a description of the pastels and other materials I carry with me when I paint a portrait in pastel:

Pastels. The substance of a pastel stick is generally finely ground pigment mixed with chalk and clay and rolled under pressure. In the highest quality pastel, clay is the only binding agent, and pastel is generally considered a dry medium. The pigments used in pastels are the same as those used in oil and watercolor paints.

I have tried pastels from almost every country that makes them— France, Holland, Germany, the United States, and the United Kingdom—and have found the type best suited to my style and temperament is that made by George Rowney & Company Limited of London. These pastels are soft, have permanence and intensity in the lower values, and are supplied in a full range of over 350 colors, tints, and shades. Although this type of pastel is very fragile, the broken bits can also be used conveniently. When I travel I carry a box of nearly 100 colors with me, but I try to keep as full a range as possible in my studio.

Pastel Painting Supports. As mentioned in an earlier chapter, in Great Britain it is difficult to obtain pastel paper in the very large sizes suitable for group portraits. Although they are available in the United States, rolls of pastel paper 36" wide are now scarce in Great Britain. However, the standard sizes in which pastel paper is available are well suited to painting the head alone.

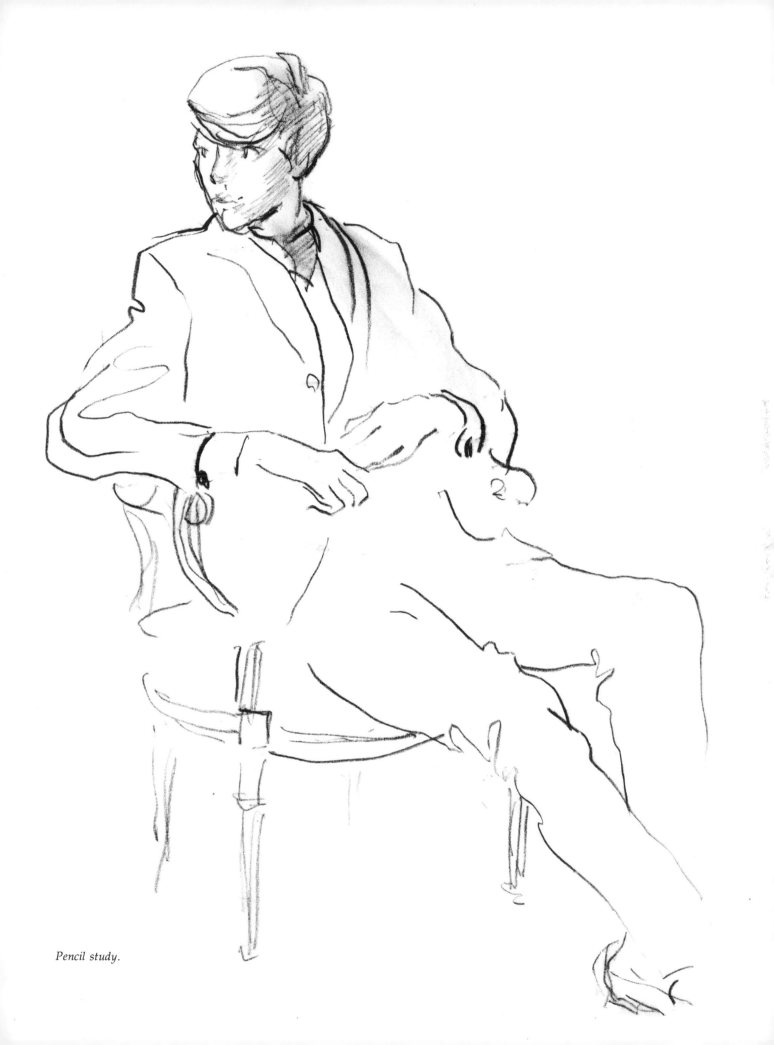

Pencil study.

Large sheets of brown wrapping paper are also quite workable, but these are used mainly for cartoons done for murals or even for oil portraits. Pastel can be used on illustration boards (drawing paper pre-mounted on a stiff backing) as well as on canvas—Picasso has done this—but the rough canvas surface makes it difficult to add the details necessary in portraits.

Pastel papers are available in a wide range of tints. When painting a head in pastel with a minimum number of sittings, time is of the essence. I therefore keep an assortment of tints plus white in stock, from which I choose the most suitable or flattering shade for my particular subject. The paper serves as the background for my pastel portraits and it must therefore be a pleasing color in order to enhance the colors and values in the portrait itself. I suggest that you experiment with the various colors so that your familiarity with them will make your work easier when you choose paper for each new portrait.

Turpentine. If you use pastel on canvas or board, you can make the colors permanent by using the "finger and cloth" technique. After you have applied a color to a particular area, dip a cloth in turpentine and rub the color into the painting surface. This is also a useful way of painting a mural with dry colors that must be preserved.

Brushes. When I apply too much pastel to a particular area, I use a small paintbrush or toothbrush to remove it.

Erasers. I use only a kneaded eraser, and I rarely use that. Erasers tend to rub the color into the paper, and it is necessary to remove as much of the pigment as possible with a facial tissue before erasing.

Mirror. A painting aid that will help you make quick corrections in drawing and foreshortening is a small hand mirror. It will provide you with a reverse view of what you are doing, and since your eye will not have adjusted to this view, you will instantly see any errors.

Paper Napkins. I carry a box of paper napkins to keep my hands and work clean.

Tissue Paper. I do not use a fixative to protect my pastel paintings, because fixatives tend to kill the brilliance of pastel colors, particularly the lights. As a result of this, I have to handle my work carefully; I protect it by covering it with tissue paper and placing it in a portfolio until it is framed, which I try to do as soon as possible.

Dust Sheet. If you are working on a carpeted floor, it might be wise to put down a dust sheet—a sheet of plastic, an inexpensive plastic tablecloth, or even a covering of newspapers—to protect the surface of the carpet. Fine pastel dust will fall as you work; this is difficult to remove and quite annoying, particularly to the owner of a fine new carpet!

Pastel Techniques

There are at least two schools of pastel technique: the soft, blended touch of La Tour and Chardin provides a luminous quality; the other method is to apply the pastel in strokes, using different colors beside and on top of one another, like the Impressionists Degas, Toulouse-Lautrec, and Mary Cassatt. The second technique was used mainly for studies, although these artists have left us finished masterpieces as well.

Picasso has also provided us with a large and beautiful pastel painting of a woman in a blue hat, which now hangs in the Tate Gallery in London. This was done on canvas, and a hard type of pastel

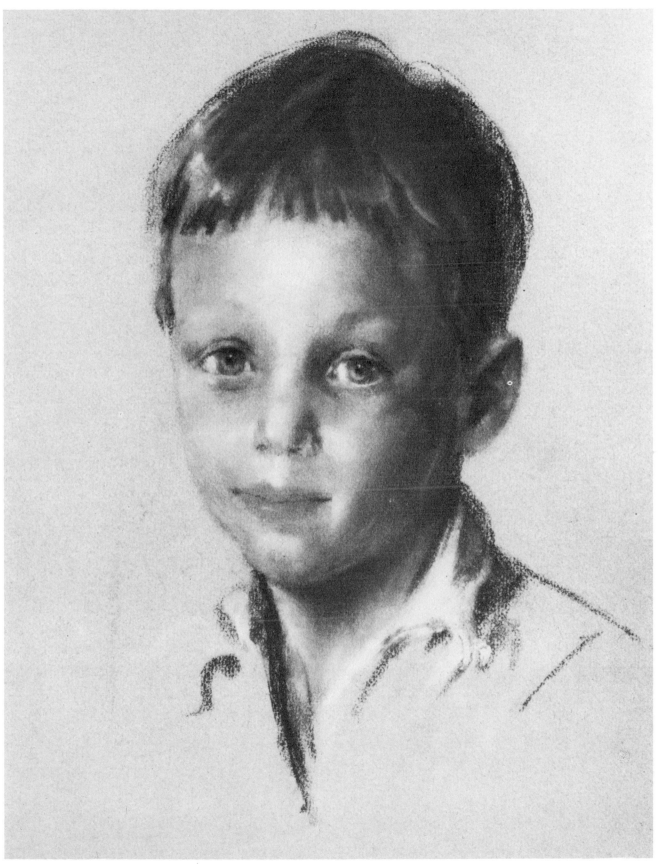

Study of a Boy. *Pastel on paper, 19" × 22". The strong contrasts of light and shade on the shirt collar add life to the portrait and give the subject a boyish look.*

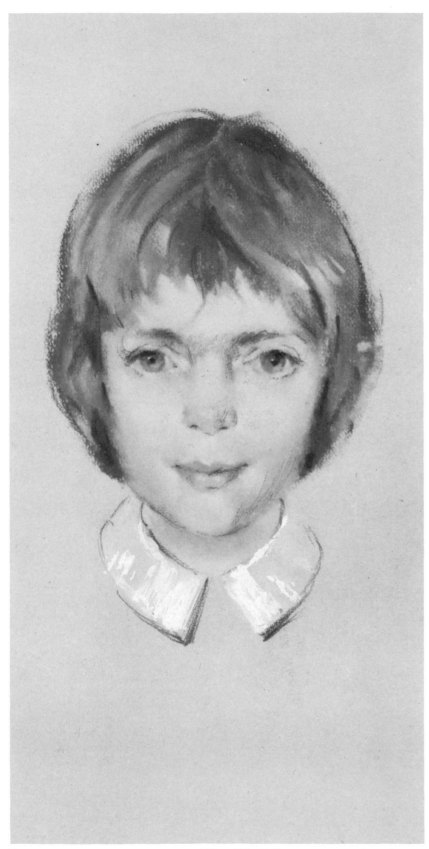

Rosemary Wall. *Pastel on paper, 19" × 22". Collection Mrs. Robert Sinclair Thomson, Glasgow, Scotland. This child's face was ideal for a pastel portrait. I used soft hues on gray paper.*

must have been used in order to withstand the "bite," or coarse texture, of the canvas.

Light Source

Be sure at each successive sitting that you use the same light source. To facilitate the arduous task of painting the head, particularly a child's head, see that your lighting is strong enough to cast clearly defined shadows, and if possible complementary to the bone structure and character of the face.

Edges

If you prefer the soft effect in pastel, you can rub the color into the paper as you work on each area of the head, allowing your finger to follow the form of the head. You should also blend your colors where necessary and sharpen edges to emphasize accents or changes of plane.

This process of working an edge into the background in one area and then contrasting the soft edge with a well defined, hard edge is called "losing and finding." Lost (soft) and found (hard) edges are important in giving your work a three-dimensional effect, in making it look like a solid object surrounded by space.

Skin and Hair Colors

When choosing colors for skin tones, a handy guideline is to use bluish green for the dark tones of a fair child and a green with more yellow in it for the warm shadow areas on the face of a sallow child. The same rule applies to choosing pinks for the light areas: use cool pinks for fair skin and warm pinks for darker skin.

If you are painting a child with very fair, almost translucent skin, I suggest you use white pastel paper (I use Ingre pastel paper, made by Canson-Montgolfier of France). The white of the paper will allow the colors to display their true brilliance.

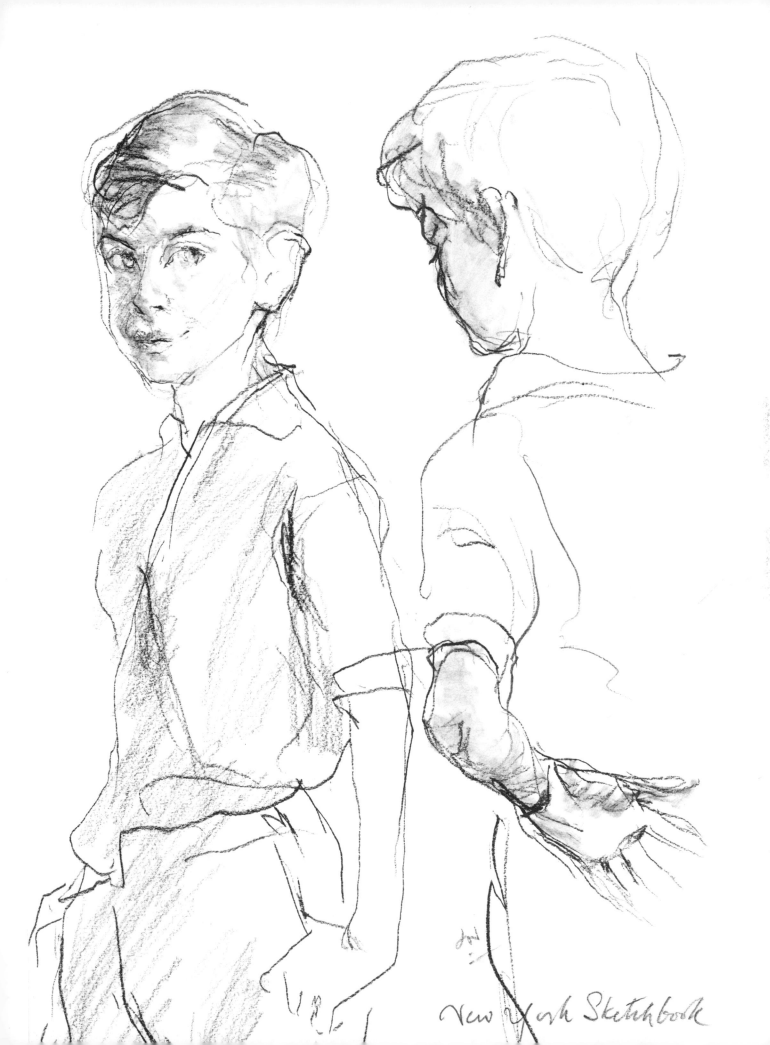

New York Sketchbook

When painting the hair, use the same rule of mixing warm and cool colors: use warm for the shadow areas and cool for the light areas.

Shoulders and Hands

Remember to use the same colors for the hands that you use for the face. Consider also the scale of the hands; the portrait will give the impression of a deformed subject if the hands are out of proportion to the head or shoulders.

Preliminary Work

Since pastel colors are dry, they reflect more light than fluid mediums such as oil. It is therefore possible to achieve effects of great brilliance of color and contrast of tone with pastel. However, a lot of forethought and careful planning are necessary in order to create the desired effects. Consequently, small color sketches done in the early stages of painting, before the final work is attempted, will prevent subsequent frustrations. You might also try using charcoal to lightly block in the final portrait. Then fix the charcoal drawing and apply color over it.

Painting the Head in Pastel

Pastel is a deceptive medium. It looks easy to use, but it can get out of control and leave you with a messy, muddy result. When painting children in pastel, ensure that your work remains fluid by moving around the whole head as you work. Keep your colors fresh and crisp and related in harmony, and keep in mind the shape of the head, the flow of the hair, and the direction of the light as you paint. To see examples of excellent pastel portraits of children, I suggest you study the work of the famous pastelists, particularly Mary Cassatt.

A full-color, step-by-step demonstration of painting a pastel portrait begins on page 114. The following is a description of the procedure I generally follow when painting a portrait in pastel:

Beginning Stage. From my supply of paper, I choose a suitable color, usually either a warm or cool gray, depending on the complexion of the subject. This provides an appropriately middle-tone background. After sketching in the outline of the head with a dark color, preferably one complementary to the paper, I rub in the dark tones using a suitable blue or green. This procedure is the same as that used in oil painting, except that I use the side of the pastel stick to apply broad strokes of color.

This "rubbing in" of the dark masses against the lighter background is important and will be the key to subsequent colors and values as the portrait develops. This first color must relate to the tones in the living head, so it is wise to try out a few colors on the edge of the drawing paper before beginning the actual painting, thus preparing a harmonious color scheme or palette.

Next I paint in a blob of pale color, which represents the lightest light, or highest value. I generally add this on the forehead if the subject is in overhead lighting—remember "the head is an egg"!

Finishing Stage. With the three basic tones—light, middle, and dark—established, I proceed to develop the portrait. I paint the hairline first, then overpaint the pale skin tones on top of it. To avoid sharp edges where the skin and hair meet, I use gentle strokes and soften the color with my finger where necessary. Once again, I try to be bold, direct, and simple in my treatment of the face and hair. I try to work with masses and add deft touches of detail only at the very end. Remember—an overworked portrait is a dead one!

Louise Bunge. *(opposite) Pastel on paper, 19" × 22". Collection Mr. and Mrs. Walter Bunge, Hertfordshire, England. I painted this portrait about ten years ago, completing it in two sittings.*

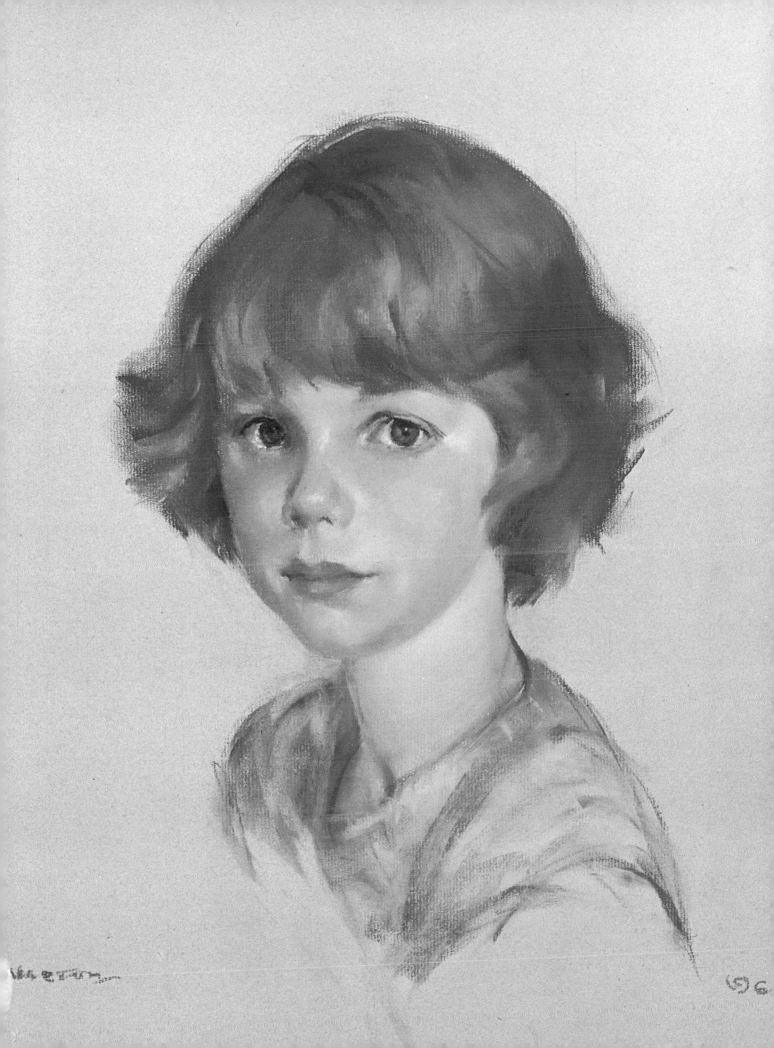

**Demonstration:
Painting a Pastel Portrait**

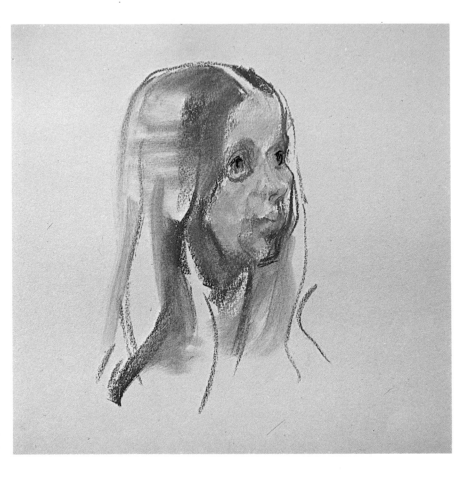

Pastel Portrait: Step 1. *I sketch in the head, using a sepia pastel stick on neutral gray Ingres paper. I make sure that the proportions are correct in relation to the actual head and that the size of the drawn head relates well to the size of the paper.*

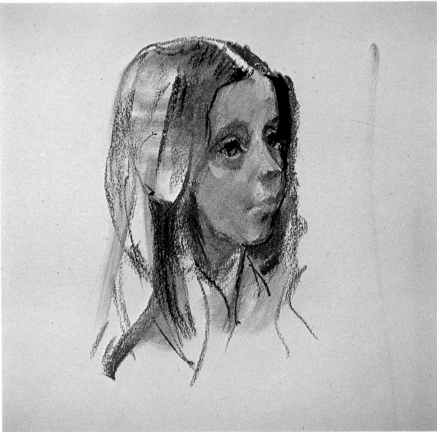

Pastel Portrait: Step 2. *Having laid in the broad masses, I further develop the eyes, nose, and the contours of the head. I use a sepia pastel stick to add the dark values to the portrait. At this stage, the paper itself still provides the highest values.*

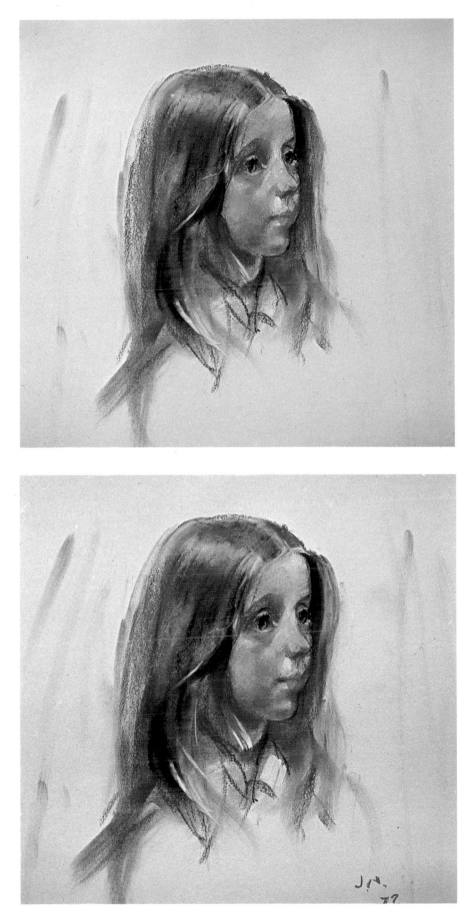

Pastel Portrait: Step 3. *After a break of five to ten minutes, I continue to model the features and hair, moving all around the head as I work. Less of the paper is now exposed, and I add half-tones, especially in the hair. It is now nearly fifty minutes since I began painting.*

Katherine Ward-Thomas. *Pastel on paper, 19" × 22". Collection Mr. and Mrs. Michael Ward-Thomas, London, England. Here I add the finishing touches to the eyes, mouth, hair, and general expression. Meanwhile, I try to maintain that wonderful feeling of remote innocence and "Alice-in-Wonderland" charm projected by this lovely face. The whole sitting has taken approximately seventy-five minutes.*

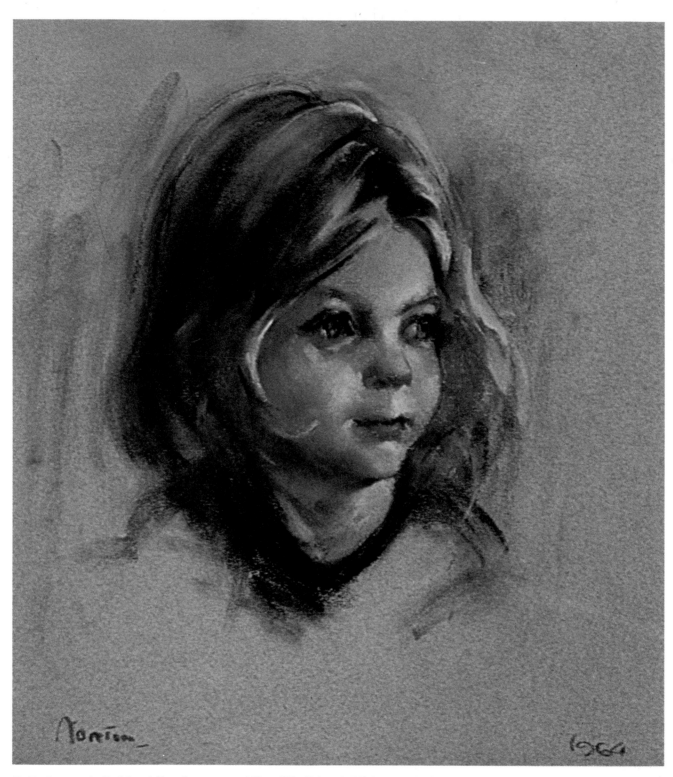

Belinda Marshall. (above) *Pastel on paper, 19" × 22". Collection Mr. and Mrs. Michael Marshall, Cambridge, England. This very soft, little-girlish face is surrounded by rich blond hair. I used cool, lilac-gray Ingres paper to complement her lovely coloring. Five years old when I painted her, Belinda was a delightful subject.*

Katherine and Sarah Chetwynd. (right) *Pastel on paper, 20" × 30". Collection Mr. and Mrs. Richard Chetwynd, London, England. The main problem I encountered in this painting was how to place the two young girls together on so small a support. I painted the older girl seated and gave the younger sister slight movement as she stood immediately behind and to the right. Notice that I laid color into the background and used a variety of hues to give the portrait "life." I used white 70 lb. drawing paper.*

116

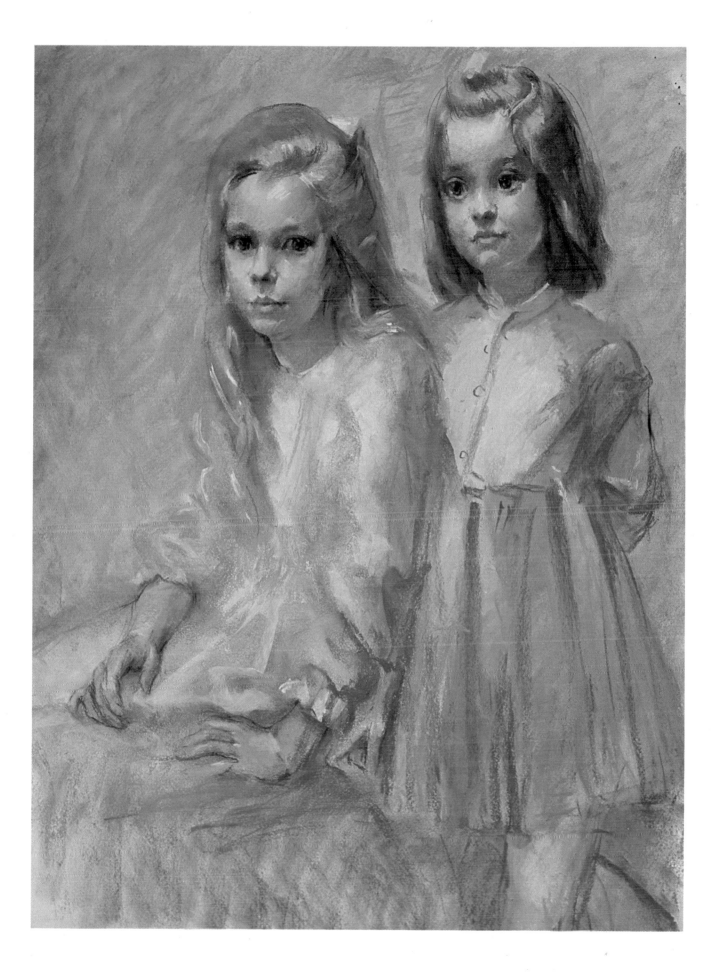

Demonstration:
Painting a Watercolor Portrait

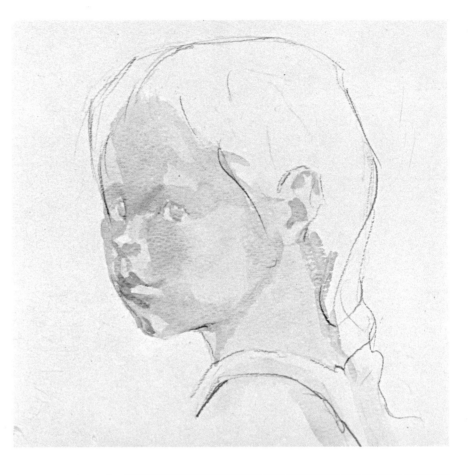

Watercolor Portrait: Step 1. *I sketch the head lightly in pencil. After wetting the paper and allowing it to become almost dry, I use a very pale wash of cerulean blue to paint the whites of the eyes. When this dries I use a deeper wash of the same color to paint the irises, leaving a tiny white spot as the highlight in each pupil. Highlights such as this can also be scratched out of a dry wash with a sharp razor blade. When the eyes are dry I apply a pale wash of cadmium red over the face and neck and mix in a little cadmium yellow pale on the forehead and neck. I add very pale washes of undiluted red to the fleshy areas of the cheeks and lips. When these washes dry, I use a stronger red wash to paint the closer cheek, carefully drawing the form and using the wet-and-dry technique to blend this wash into lighter areas of the previous wash.*

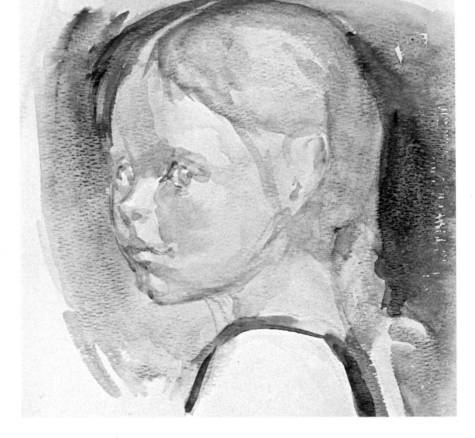

Watercolor Portrait: Step 2. *I wet the background with clean water, and as it dries I wash in some chromium green, cerulean blue, and ultramarine blue. I think quickly and try to ensure that the pale colors in the background are adjacent to the dark tones in the face and vice versa. While these washes dry I paint in the hair using washes of cadmium yellow pale, cerulean blue, chromium green, modeling the head as I proceed. While the hair is drying I continue to model the face, using delicate mixtures of red and blue where necessary—for example, under the tip of the nose, under the chin, and in the hollows of the eyes.*

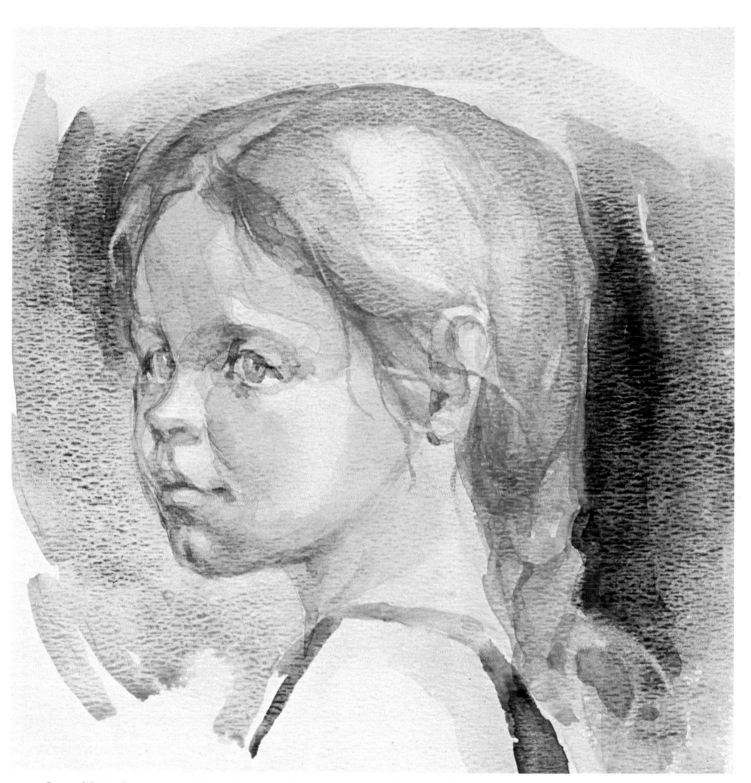

Lucy. *Watercolor on paper, 10″ × 12″. The middle and light tones are now established, and I proceed to darken some of them. I continue to model the face carefully to achieve an accurate description of the features and expression. I give the model a rest while I make a final analysis of the proportions, foreshortening, and so on. Then I put in all the necessary details, taking care not to overdo them. I use a damp brush to carefully soften some hard edges as well as to "remove" some highlights and smooth out the rough texture of the paper in several areas to create "life" in the background and hair. I use a razor blade to scratch out some strands of hair. Finally, I add accents to the face and background and some finishing touches to the dress.*

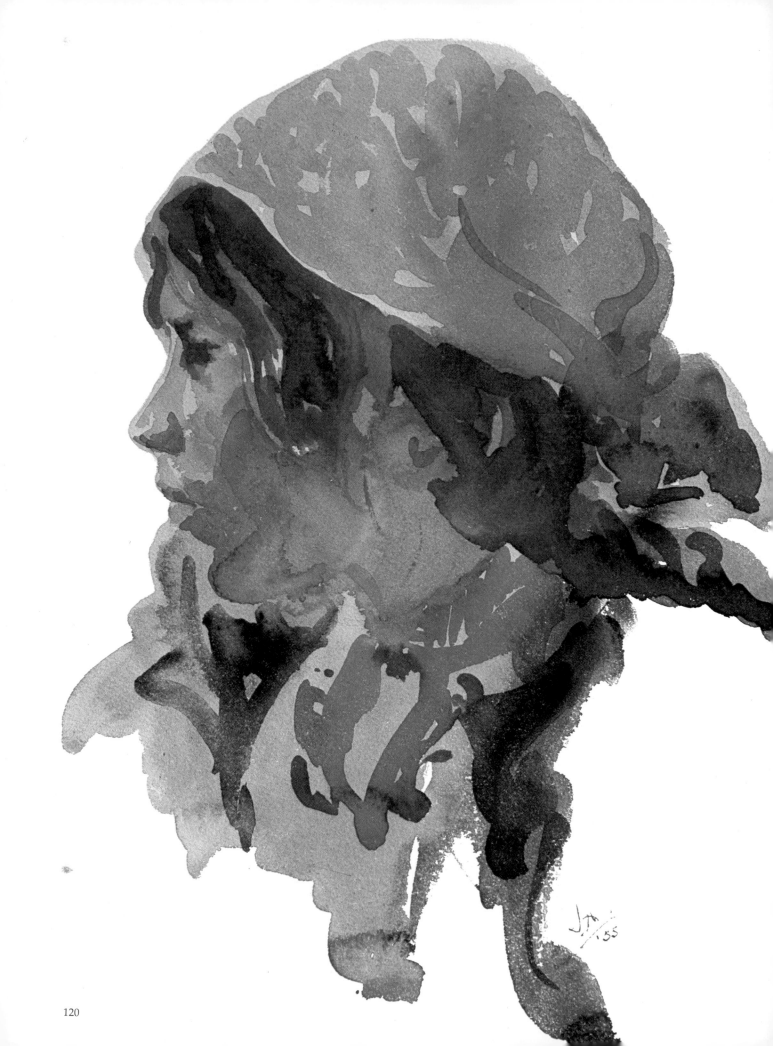

120

Chapter 10
Watercolor Portraits

Despite the fact that watercolor has been used largely as a landscape medium, it has also been used to produce many portraits, particularly in the highly specialized field of miniature portraits. Apart from landscapes and portraits, many watercolor masterpieces of street scenes and seascapes have expanded the wide range of subjects that can be painted in watercolor.

Having been brought up in the traditional English manner, I have developed a taste for watercolor, which I have come to believe is essentially an English painting medium. Thomas Girtin and William Mallord Turner were the greatest eighteenth- and nineteenth-century exponents of the medium, and I doubt that they have ever really been surpassed.

Girtin was the first to avoid following an arbitrary painting procedure and soon departed from the old method of first painting the lights and shadows in monochrome and then applying local color over this. He developed the techniques of losing and finding darks and lights and of mixing warm colors with cool colors, directly on the painting surface. By eliminating the necessity for a preliminary drawing or outline, these techniques enabled him to draw, using a brush fully loaded with undiluted color, and then to soften the edges or lines of the drawing to create the painting itself. To paint smaller details, he was ready to drop in strokes and patches of color in areas where he needed them with telling effect.

Turner, especially in his later years, became truly ethereal in his use of the medium. He has left us a great and inspiring collection of watercolors that are not only poetic but almost philosophical, if it is possible to say that about a painting.

Bedouin Girl–Beirut. *(opposite) Watercolor on paper, 9" × 12". I painted this portrait on a street in Beirut, using yellow ochre, crimson lake, and Prussian blue. When I ran out of water, a Lebanese boy rushed to fetch some water from a nearby gutter. Fortunately the water was clear, but the work was so far along that I could not be very discriminating, anyway! This painting took only about forty-five minutes; since I did it outdoors, the washes dried quickly.*

In addition to drawing with a pen and ink, I used watercolor painting techniques to apply ink washes with a brush.

122

As we have come to understand it through the work of these great masters and purists, the essence of watercolor painting is simply color and water—plenty of color and plenty of water. This is the traditional and pure method according to the English school of watercolor painting, which uses the medium as it is—transparent. The French use an opaque mixture of watercolor and white paint and call it gouache.

The difference between the two techniques is that transparent watercolor makes it possible to use the white of the paper for the highest lights, while gouache requires the use of opaque white pigment to achieve the effects of light. Also, since watercolor is transparent, a toned paper may be used to provide a middle or slightly lower key background on which to lay washes. In this chapter, I shall briefly describe my own approach to the delightful medium. (A full-color, step-by-step demonstration of painting a portrait in watercolor begins on page 118.)

Watercolor Materials

I have found that the following watercolor materials suit my technique and are all I require when I paint a watercolor portrait:

Watercolor Pigments. One of the most important points to consider when buying watercolor pigments is that some pigments interact chemically with others to such a degree that they disintegrate when mixed or blended on the paper. At other times, particles of pigment settle on the surface of the paper to create more texture than you may want, although such texture can often be used to advantage.

Watercolor pigments are available in ½" square cakes or in tubes; the tubes are more convenient for large or quickly done work. The colors I keep on hand and use most often are:

Alizarin crimson

Cadmium red

Indian red

Ultramarine blue

Cobalt blue

Cerulean blue

Winsor blue

Viridian green

Cadmium green

Cadmium yellow

Cadmium yellow lemon

Yellow ochre

Sepia

Raw umber

Ivory black

Payne's gray

If I am painting flowers, I increase my palette to include rose madder and carmine.

Watercolor Painting Supports. Watercolor papers are available in a variety of textures as well as in a variety of tints. The smoothest paper is called hot-pressed; moderately rough paper is called cold-pressed; the most coarsely textured paper is called simply rough. Watercolor paper is also available pre-mounted on a sturdy backing such as heavy cardboard, referred to as watercolor boards. These boards generally have smooth, absorbent surfaces that dry quickly and give areas of color rather hard edges.

Drawing Board. When you use watercolor paper you will need to support it by securing it to a drawing board, which should be at least 1" larger than the paper on all sides.

Cellophane (Scotch) Tape. I use this to attach my paper to my drawing board. (You could also use masking tape.)

Brushes. I keep on hand a wide selection of sable brushes, from number 00 to number 12; two or three large squirrel hair brushes; an oxhair and a large hog hair (bristle) brush for creating special effects.

Knives and Razor Blades. When very sharp, these can be used to scratch out sharp highlights, as well as to add definition and texture to the hair.

Cleaning Materials. I always have a large natural sponge handy, as well as lots of blotting paper and clean rags or paper towels.

Watercolor Techniques

There are two basic approaches to watercolor painting: one is the direct approach, in which there is no preliminary drawing and a brush of the appropriate size is used to both draw and paint at the same time; the other is the slower approach, in which the subject is first drawn lightly but carefully and the final painting is then applied over the sketch.

I often start a direct watercolor portrait by making pencil sketches and then do the final portrait in one sitting, working fast and furiously. I painted the Bedouin girl's head (reproduced on page 120) using this approach. I did the painting on a street in Beirut, using water from the gutter that—fortunately—happened to be clean at the time! This method requires that there be absolutely no interruptions and demands intense concentration.

When I use the slower approach, I use a charcoal or a soft lead pencil. When I use pencil, I use the inside of a fresh slice of soft bread to remove the surface layers of graphite. (The bread removes the graphite without damaging the paper beneath.) If I use charcoal, I draw very lightly, dust off the sketch with a handkerchief, and spray it with fixative before I begin to paint.

The preliminary drawing should be used only when strong, dark colors are to follow; the sketch lines will show through light, transparent colors. Although it is possible to achieve a great degree

Watercolor palette.

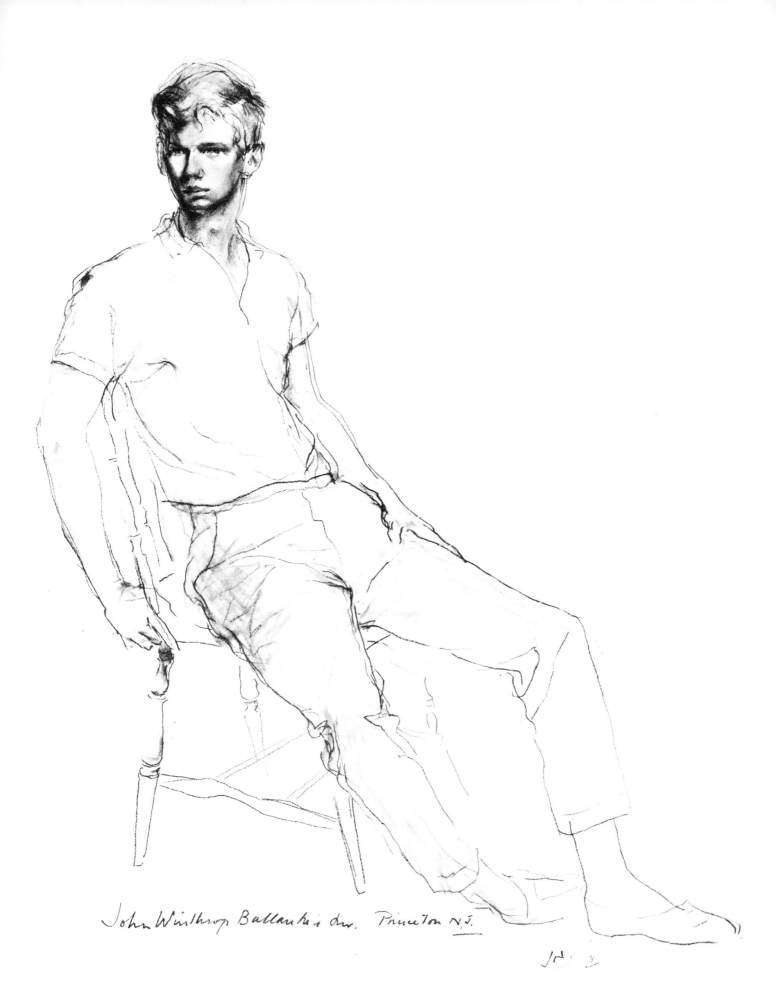

John Winthrop Ballantine Jr. Princeton N.J.

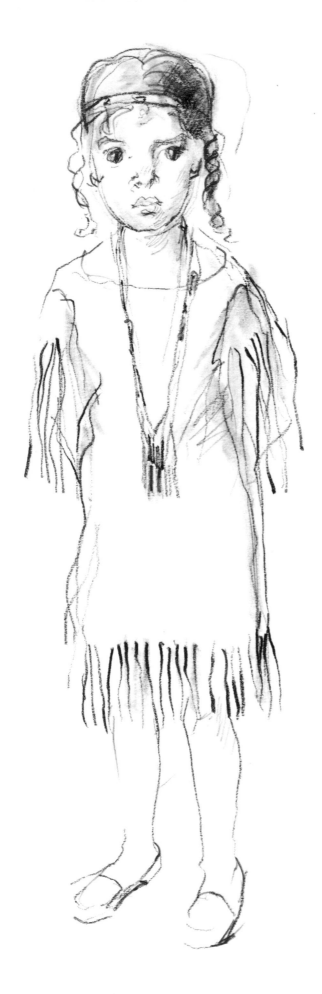

of accuracy using this technique, I doubt that the results have the same amount of "life" as those of the more chancy, instantaneous approach.

In addition to these two basic approaches, you can use a variety of watercolor painting techniques, depending on the painting time available and the effects you wish to create.

For example, if I do not have much time to complete a watercolor portrait, I use the "semi-wet" technique—that is, I keep the paper wet as I apply colors. I first soak the paper well, then lay it on the drawing board with a double thickness of blotting paper under it to absorb surplus water, and use cellophane (Scotch) tape to fasten the paper to the board. If it is a very warm day or if the studio is warm, the rapid evaporation of the water causes the color to dry quickly, and I then have to rewet the paper as I paint.

When I have more painting time, I use the "dry" technique. I begin by soaking the paper, then I stretch it as taut as possible, tape it to the drawing board, and allow it to dry. As I paint, I wait for each color wash to dry before I add the next one. Applying washes to dry paper in this manner creates harder edges in the painting.

You can create a variety of textures, depending on whether you use hot-pressed, cold-pressed, or rough paper. You can also vary the textures in one painting by wiping the surface of rough paper with a rag or sponge, by drawing a loaded brush lightly across the surface of rough paper, and by stippling (holding a large or small loaded brush in a vertical position and dabbing on small spots of color). As I mentioned earlier, you can also use a sharp knife or razor blade to scratch out textures and highlights.

To create interesting color effects, you can lay transparent

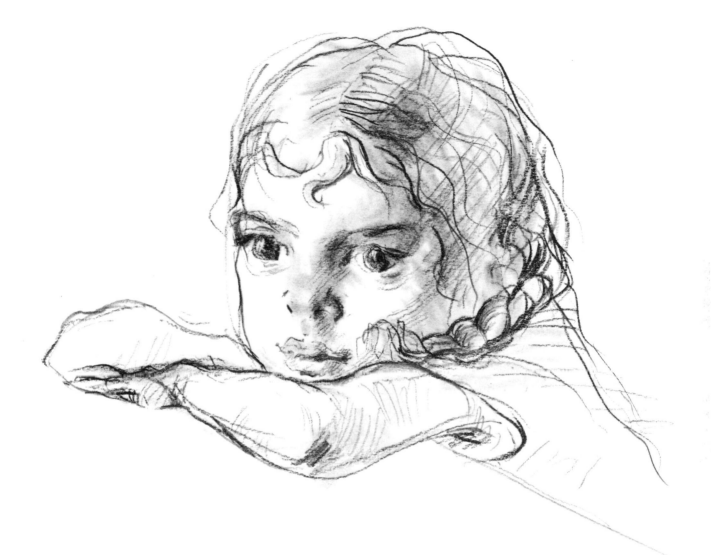

The two pencil sketches on this and the opposite page are studies of a Shinnecock Indian girl, which I drew on Long Island.

washes of different colors or of stronger tones of the same color one on top of another. And if you use tinted paper, the result will obviously be much lower in key than it would be on white paper.

Regardless of the approach and techniques you use, you should remember the procedure for applying watercolor. Whereas in oil painting the light tones are painted over the dark, watercolor requires the reverse treatment. The lights are painted in first and are followed by a build-up of dark tones, which are applied in one wash after another until the desired tone is achieved.

Painting Time

In the direct watercolor approach, time is all important; speed is the governing factor. But in order to paint a successful portrait using this method, two things are necessary: a complete knowledge and understanding of what you are going to do, and complete preparation not only of mind but also of materials.

To do a serious watercolor portrait using the direct method, I have to be relaxed and free from the fear of interruptions. I take my telephone off the hook, lock the front door, collect all my paints, brushes, palette, lots of jars of water, blotting paper, and so on, put on a record, and paint!

There is a charming tale of a Taoist painter in the great tradition of Chinese watercolor painting: he enters his attic studio by a ladder through the floor, draws the ladder up after him, sweeps the floor of his studio, arranges his materials and tools, meditates on Tao or Confucius, and paints!

All things being equal, this approach enables me to paint a reasonably good watercolor in under an hour. The slower method, which involves drawing the whole head in lightly and waiting for each subsequent wash

to dry, should take about two hours.

Size of the Watercolor Portrait

I have found that a head a bit smaller than life-size, or about 6" in height, is the largest that can be painted conveniently in watercolor. A head of this size requires a sheet of watercolor paper about 12" × 15" or slightly larger. If I decide to paint the shoulders as well as the head—which I rarely do when using watercolor—I use a larger sheet, roughly 15" × 18", and paint the head about half life-size.

Subordinating Likeness to Effect

When discussing a portrait commission, I always preface my opinions with the well-known question that has been asked for ages: "Do you want a work of art or just a record?" Of course it would be marvellous to achieve both—that is, a good likeness *and* an exciting work of art—but this is rare. Lesser mortals have to choose!

As far as my own taste goes, I opt for the lively and spontaneous watercolor portrait. I find that I quickly tire of the studied likeness, which invariably looks dead. A well-painted likeness may sometimes be technically pleasing, but I feel my client is entitled to more when paying for a portrait. So in my case, the answer is that I invariably subordinate likeness to a bold and stimulating portrait. On the other hand, many painters try to get away with bad work by saying they have been spontaneous, when in fact their results are shoddy because of lack of training.

Subordinate likeness to effect if you wish, but do not be indifferent to likeness if you are being paid. It is very important to master the techniques of watercolor painting, so that you can store them in the back of the mind and then let your feeling dominate the result.

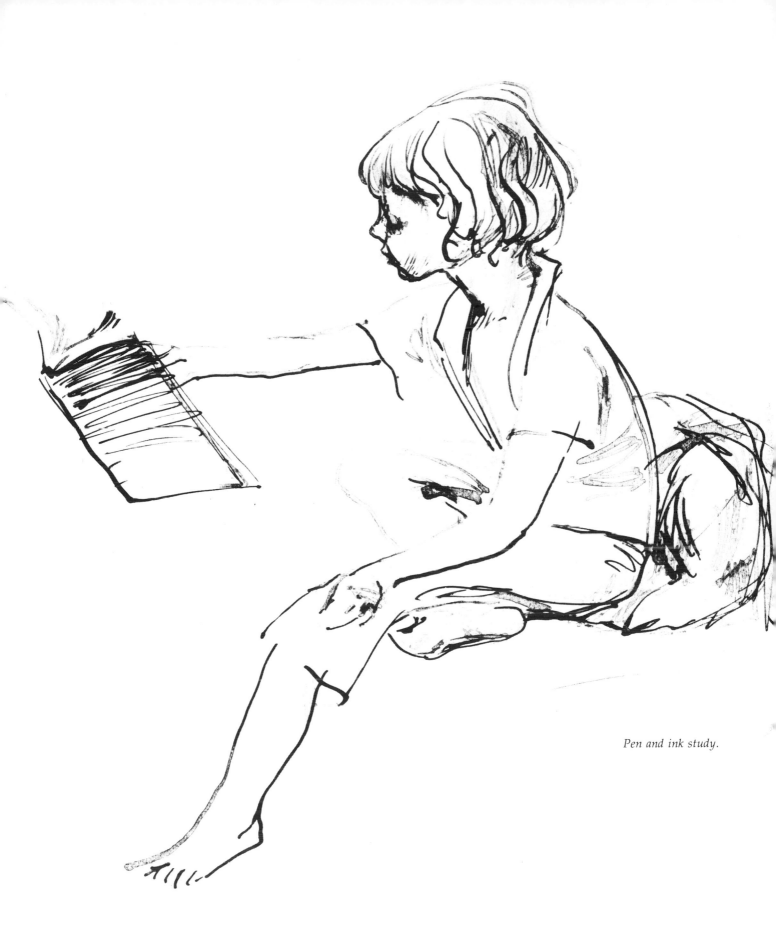

Pen and ink study.

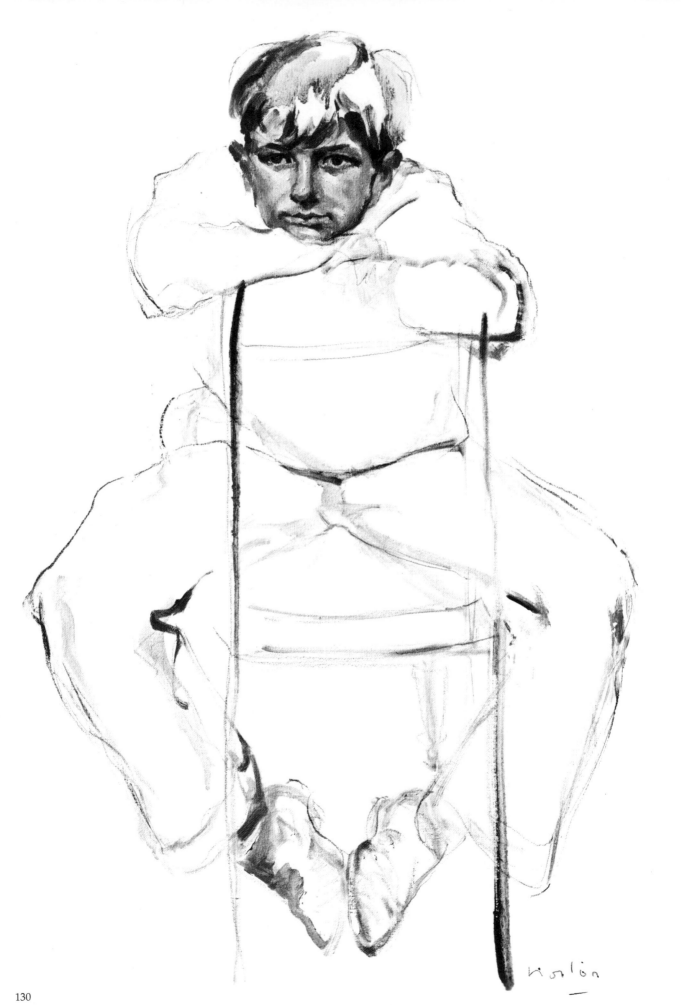

Chapter 11
Oil Portrait Sketches

The sketch is generally understood to be a rough draft, a quick impression or shorthand note of detail for future reference. Because of their potential for spontaneity and expression, I use sketches both as preliminary work for finished portraits and as paintings by themselves.

The individuality of the artist makes his sketch obviously different from another's sketch of the same subject, particularly in the case of oil sketches. For example, whereas one painter will go for color, another will be influenced more by form and mass. Therefore, in a portrait sketch whose painting time is quite short, the structure, tonal values, and suggestions of local color are more important than the details and finishing work. The whole object of the sketch is to obtain a good and spontaneous impression, and too much attention to detail will kill the freshness of the work.

A good example of the quick oil impression that comes to mind is the one of the poet Vernon Lee painted by John Singer Sargent in the 1920s and now hanging in the Tate Gallery in London. Everything in the sketch looks fluid and alive, as if the painter were afraid to stop and study what he was doing for fear of missing a memorable expression.

What to Aim For

Since you are attempting an oil sketch rather than a portrait, you should aim for simplicity and dispense with an overall suggestion of clothing. If I am painting just the head, I merely paint the collar and a bit of the shoulders, particularly the shoulder nearest my point of view, and add just a few folds of cloth under the arm to give it weight.

As I strive for a fairly convincing likeness, I light the subject so that the facial planes are distinct

Timothy Simond. *(opposite) Oil on canvas, 30″ × 40″. Collection Mr. and Mrs. Kyrle Simond, London, England. In this oil sketch, I concentrated on the subject's face; I included his arms and legs and the suggestion of the chair simply as a framework and support for the head. I treated the painting as a large "brush drawing" by leaving the canvas bare.*

and simple, providing me with bold masses. I try to create a strongly lighted effect with most of the light coming from above, as this type of lighting creates well-defined shadows and clearly defines the features.

To make the result of about an hour's highly concentrated work completely successful, I try to keep in mind the expression of my sitter, as well as to sustain a freshness of color and a vitality of brushstroke. If I am painting a three-quarter length sketch or a full figure, I also concentrate on gesture and rhythm throughout the canvas.

Time Factor

The controlling factor in painting an oil sketch is time, as indeed it must be for a sketch in any medium. I therefore do my thinking *before* I put paint to canvas and usually allot myself a maximum actual painting time of one hour for a head study and two hours with a break in between for a full figure with hands.

Since the purpose behind a sketch is to start the artist's more complex creative processes working, I sometimes do more than one sketch to stimulate my imagination. This requires two or maybe three separate sittings.

Size of the Oil Sketch

For a child's head alone, which I usually paint life-size, I select a 12″ × 16″ medium-grained pre-stretched canvas or a pre-mounted canvas panel; for a three-quarter length seated portrait, an 18″ × 24″ canvas is large enough. Since the head of a small child is barely 7″ long, there is an allowance of approximately 4″ to 5″ at the top of the 18″ × 24″ canvas, while the 12″ × 16″ canvas allows space for a full head and shoulders.

Oil Sketching Materials

Since the materials I use for sketching in oil are fewer and

simpler than those I use for painting a finished oil portrait, I will save a detailed discussion of these materials for Chapter 12. All that is necessary to mention here is that I use sable brushes numbers 4 through 8 and hog hair (bristle) brushes numbers 6 through 12 for painting oil sketches. These are generally sufficient for painting the head and background on a small canvas.

In the following sections on mixing flesh tones and painting the sketch, I will describe the colors I use for sketching in oil.

Mixing Flesh Tones

In painting terminology, the distinctions between warm and cool colors can often be confusing. Basically, the reds are considered warm, the blues cool, and the yellows warmer than the greens. However, some reds such as carmine tint and rose madder contain a small degree of blue and are therefore cooler than reds such as the cadmium.

In painting flesh tones, the secret of creating a lifelike illusion is correctly using the interplay of warm and cool colors. Areas of flesh near the bone are cool in relation to the purely fleshy areas, which appear warmer. Then again, fleshy areas that receive full light are cooler than fleshy areas in half light.

Skin tones are also affected by reflected light from the background and clothing. The area under the chin, which is also flesh, will be cool when it contains blue or green reflections from a white shirt collar beneath; it will be a warmer color when it contains reflections from a vivid yellow sweater. All such conditions and possibilities must be taken into account and studied very carefully when dealing with flesh tones.

For very fair complexions, I use cool colors: rose madder for the pinks and reds; crimson for the very dark details; cobalt blue and cad-

mium yellow pale or viridian green (sparingly) for the cool greens. For warmer complexions, I use hotter colors such as cadmium red medium or light, ultramarine blue, and cadmium yellow; for even darker skins I use yellow ochre.

As far as possible, I avoid using pure black at all and manage by substituting a mixture of whichever red and blue I am using. Titanium white is the white pigment I use most frequently in painting flesh tones, as it is a brilliant white and has great opacity.

Preparing for the Sketch

Since you will have to work quickly when painting the actual sketch, you should go through the preliminaries of organizing your sitter and arranging the most suitable pose before you begin, meanwhile talking to the child to make him or her feel at home and relaxed. Do not hesitate to spend as much time as possible deciding on the right pose and analyzing the sitter's features. Decide beforehand, for instance, whether the eyes or the nose should receive full recognition.

I usually put on a record that appeals to the child at his particular stage of development; music helps to warm the atmosphere and distracts the sitter sufficiently to prevent him from becoming bored. Mixing colors also helps greatly to interest and distract the child. As I lay out brushes and tubes of paint and begin mixing colors, I keep up a running conversation about the range of hues and their similarity to other things more familiar to a child, such as ice cream and toothpaste!

While arranging my tools and equipment, I think simultaneously about the background color and flesh tones, as well as the color of the clothing to be included, and squeeze out the paints on my palette accordingly. I then mix as many tones as I need for the head and background, still maintaining that feeling of entertainment necessary when painting children.

Within the space of barely ten to fifteen minutes, I have organized the pose, colors, and lighting and am ready to paint with fury!

Painting the Oil Sketch

When painting sketches it is important to remember that hesitation in applying paint to canvas is something to be avoided. Even if it is sometimes wrong or inaccurate in regard to likeness, the bold approach is more appealing than the meticulous, belabored handling of pigment or pencil that identifies characterless work. You are really painting an illusion, for that is what a portrait is. The real is the living thing; the painted creation an illusion, a two-dimensional simulated effect of three-dimensional solid matter.

A full-color, step-by-step demonstration of painting an oil portrait sketch begins on page 138. The following is a description of my general procedure for painting an oil sketch:

Beginning Stage. I begin by sketching in the head or head and figure, using ultramarine blue or sepia diluted with lots of turpentine, and keeping this very tentative outline free and loose. Immediately after this I paint in the background that surrounds the head, again keeping the paint thin and rubbing it into the grain of the canvas.

At this stage, I use the flat side of a number 12 brush and do not worry too much about the brushstrokes. In these first applications of paint to canvas, remember to keep your paint thin, to apply it in the form of a scumble, and to rub it well into the canvas. Scumbling actually means painting one color over another, still wet, color without completely obliterating the first layer of paint, whereas glazing requires that the first application of paint be dry before another is

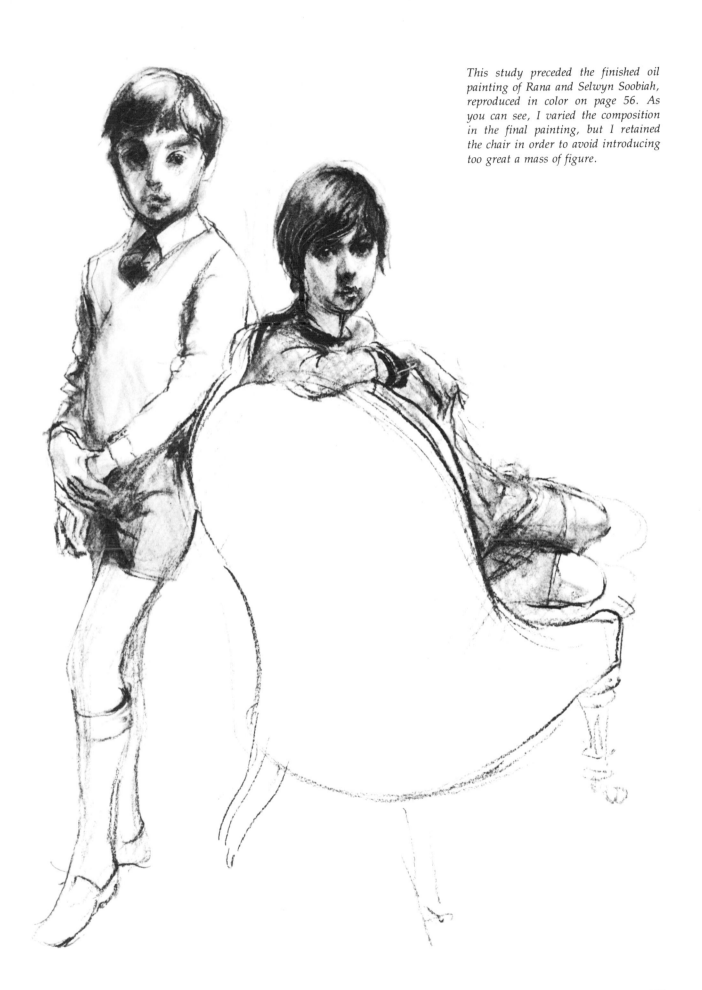

This study preceded the finished oil painting of Rana and Selwyn Soobiah, reproduced in color on page 56. As you can see, I varied the composition in the final painting, but I retained the chair in order to avoid introducing too great a mass of figure.

added. However, by "scumble" here, I mean that you should apply the paint as a thin, semitransparent layer on top of the canvas itself.

Next I select about a number 8 or 9 hog hair (bristle) brush and paint in the main masses, keeping the shapes of these masses rather square and their sizes carefully related to one another in proportion. This technique is really "drawing," using a brush loaded with paint. Don't worry about likeness at this stage. Just draw with care and feeling; likeness will follow. It is *most* important to be accurate in the placement of your main masses at this stage; otherwise your work will be formless and will hardly give you the impression of solid matter.

I also pay great attention to tone as I paint in the masses. I make certain that the tone of the background is equal to the middle tone of the head.

After I paint in the middle-tone masses, I paint in the light masses as accurately as possible and complete this beginning stage by applying the darkest darks. I then put down my palette and give the sitter a five-minute break while I study the head very carefully to make sure the masses of light, dark, and middle tones all relate to one another in terms of proportion and value.

Finishing Stage. With the masses of the head now blocked in, I begin to block in the eyes as two fairly accurately placed blobs of color. This step is important: the distance between these two blobs will be my yardstick for the rest of the head, my key to accuracy in the overall proportions.

I keep searching for the sides of the triangle formed by the eyes and the tip of the nose. It always helps to keep the very elementary geometric forms—pyramids, triangles, spheres, cubes, and cylinders—in mind as you place the features. The whole science of painting, and par-ticularly of portraiture, is based on the relationship of space and matter. Form and the play of light upon it are related to this and must be kept in the back of your mind as you proceed.

Think logically as you work. For instance, when I paint the mouth I start with a vague shape and build it up slowly, using repeated strokes and painting the underneath surfaces first. I start with the lower lip, the corner farthest from my view, then paint the cast shadow of the upper lip. I finish by painting the corners of the upper lip to suggest whatever expression I wish to convey. As you know, the corners of the mouth turn down when expressing dejection and up when expressing elation.

As you add your finishing brushwork, allow your full brush to slide gently over the stroke that preceded it. Paint as if you found each form and then lost it again. This process of losing and finding form in your brushwork produces a three-dimensional effect by blending the surface of one shape into another or into the background.

Words about Sketches

In conclusion to this chapter, I would like to quote two great masters in the fields of painting and literature. The first is Goethe, who said: ". . . the work of the master can always be detected in the small and unaffected sketches rather than in the more elaborate and finished executions."

It may be a long way to becoming a master, but it is nevertheless useful to remember that "unaffected sketches," rather than weak, belabored daubs, show the character of the artist.

To be more topical, Jean Cocteau said of that twentieth-century giant, Picasso: ". . . he takes it as dogma that the well done is over done, an inelegance of the spirit, and strove always to retain the freshness of the first sketch."

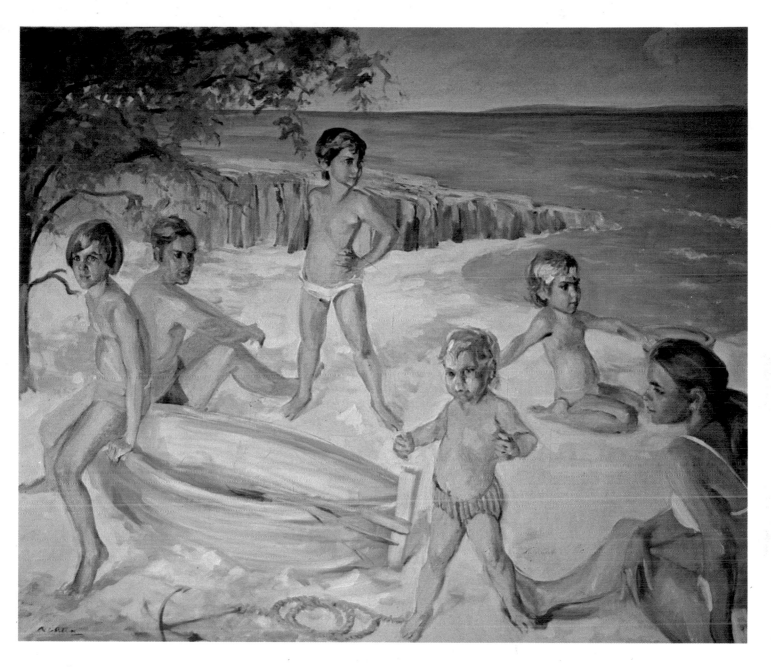

The Family of Mr. and Mrs. Duncan Burke. *Oil on canvas, 64" × 58". Collection Mr. and Mrs. Duncan Burke, Darien, Connecticut. I collected several pencil sketches and a small oil sketch before I tackled this large canvas. The background of blue sea and pink rocks made the color scheme most important; I had to carefully consider the relationship between the background colors and the flesh tones of the six figures.*

Demonstration:
Painting an Oil Sketch

Oil Sketch: Step 1. *I sketch and block in the main masses, using a brush loaded with a mixture of sepia, a little titanium white, and turpentine, on a 20" × 25" canvas board. Notice that I place the figure of this young girl to the right of center.*

Oil Sketch: Step 2. *At this stage I introduce a little yellow ochre and crimson lake for the tones in the face and hair. I add a touch of viridian green mixed with yellow for the cool areas of the face and put a squiggle of green on the sweater just to fill up the canvas and reduce the stark white of the background.*

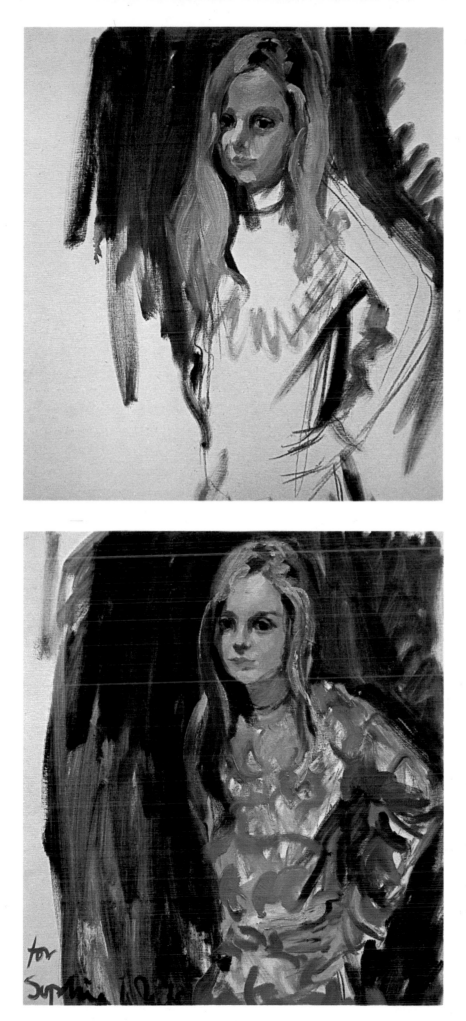

Oil Sketch: Step 3. *I further develop the tones in the face and hair as I work around the whole head. So far, the sketch has taken about forty minutes.*

Sophia White. *Oil on canvas board, 20" × 25". Collection Mrs. Michael White, London, England. In this final stage I roughly fill in the color of Sophia's stylish sweater and the complementary green background. Using cadmium red, alizarin crimson, yellow ochre, cadmium yellow, and viridian green, I add a few finishing touches to the face and hair to make everything fluid. I have made no great attempt to develop a likeness; in the short space of barely an hour, which this sketch took, a good likeness is rarely achieved.*

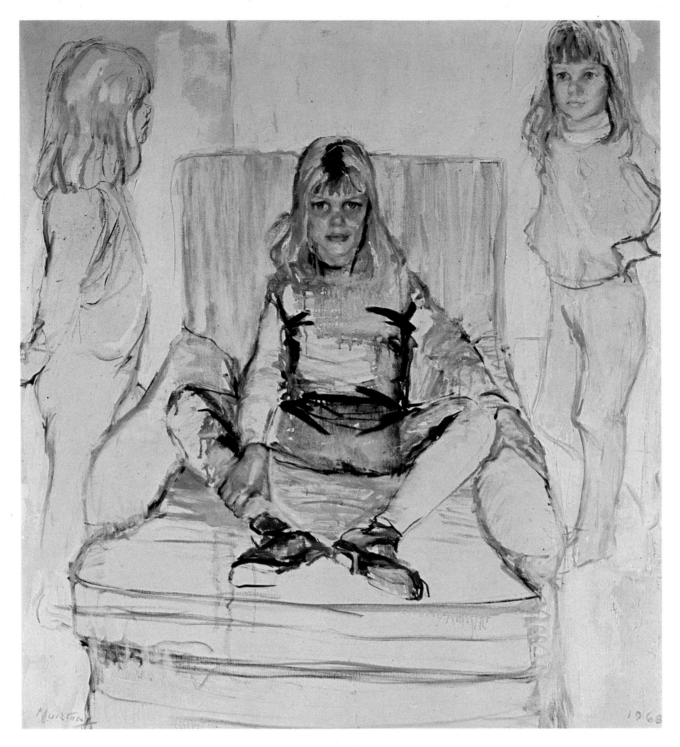

Amanda Nevill. *Oil on canvas, 42" × 48". Collection the Honorable Robin and Mrs. Nevill, Audley End, England. This portrait was destined to hang in a distinguished English country house. The problem, therefore, was to paint this very lively child in a manner formal enough for its hanging space. In the last analysis, I decided in favor of the child's vivacity and depicted three aspects of her personality—two of them merely suggested.*

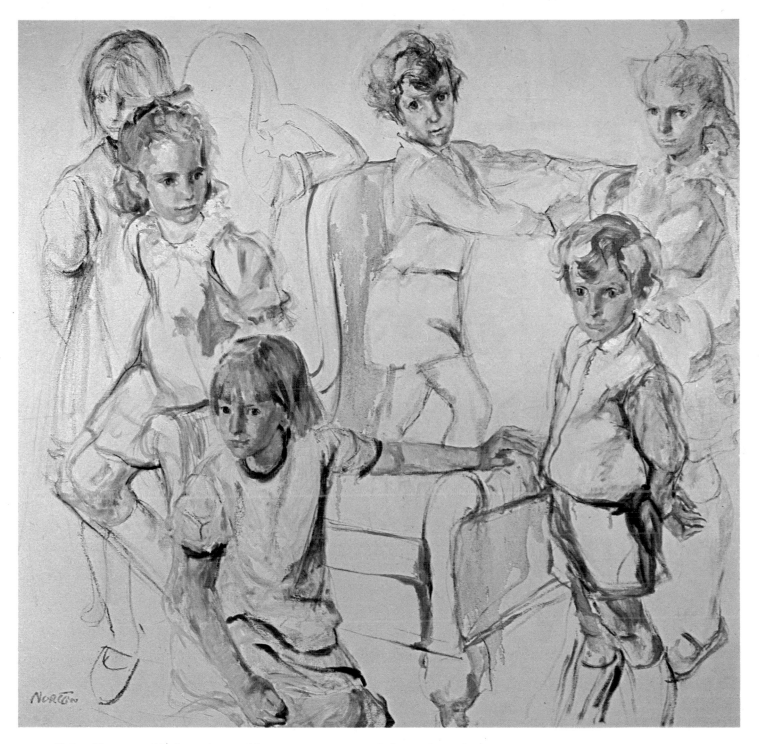

Claire, Nancy, and Nelson Hume. *Oil on canvas, 48" × 42". Collection Dr. and Mrs. Michael Hume, Boston, Massachusetts. This is one of my first group portraits, with a double likeness of each child. I painted it when the Hume family visited London some years ago, and the portrait still remains a favorite of mine.*

Demonstration:
Painting an Oil Portrait

Oil Portrait: Step 1. *I use ultramarine blue diluted with turpentine to lightly sketch in the figure on the bare white canvas.*

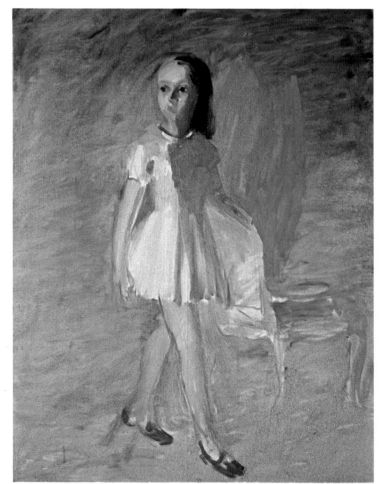

Oil Portrait: Step 2. *I rub ultramarine blue mixed with titanium white into the background and add some areas of viridian green, diluting each color with turpentine. I use cadmium red, cadmium yellow pale, and white to suggest the flesh tones, then rub in touches of ultramarine blue and viridian green. I paint the pink dress with a mixture of cadmium red and white and suggest the red shoes. I also rub ultramarine blue, viridian green, yellow ochre, and crimson lake into the hair to accent the pale tones of the face.*

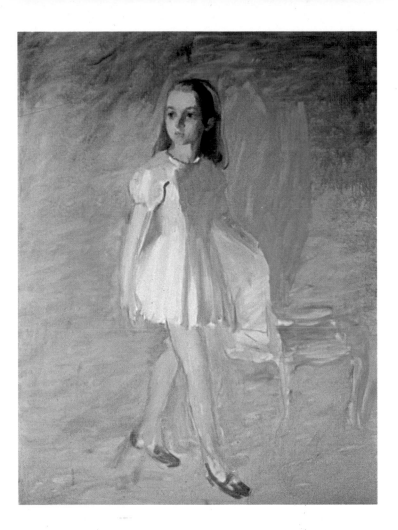

Oil Portrait: Step 3. *I have to avoid using too much paint while I try to preserve a feeling of overall softness and freshness. I begin seriously to develop a likeness, to which I have not given much thought until now because color was more important in the early stages.*

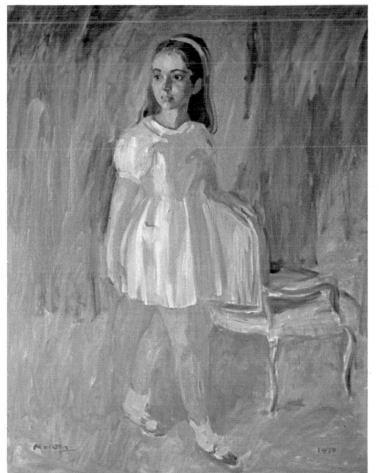

Elizabeth Uzielli. *Oil on canvas, 36" × 42". Collection Mrs. Anne Uzielli, New York, New York. As the sitter becomes bored with posing, I try to perfect the likeness. The battle between painting the blue and green world of an "enchanted forest" and developing a likeness to please fond parents is tough. I try to achieve both with these final touches.*

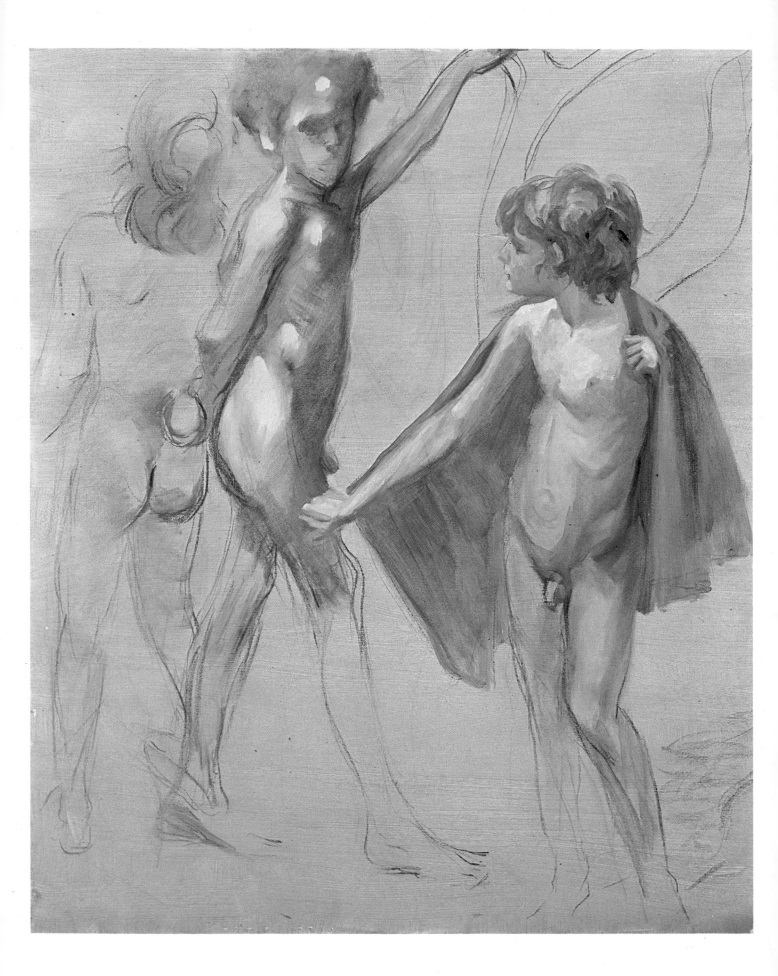

Chapter 12
Finished Oil Portraits

I assume that you will read Chapters 4 and 5 before you attempt to paint a finished oil portrait, and that you will be prepared, mentally at least, for the finished work. Since your skill and imagination will be judged by the finished portrait, all the early preparation will prove to be worth the effort.

It is always important to have a clear picture in your mind's eye of how you are going to paint something. I try at all cost to avoid facing my sitter with a blank mind and, even worse, a blank expression. Instead, I try to face the subject of my portrait with a purposeful expression in order to give him or her confidence.

Having decided beforehand whether I am going to do just a simple, straightforward likeness using little imagination or invention or, at the opposite end of the scale, to paint a penetrating and elaborate creation, I will have won half the battle when I stand before the virgin white canvas. My preliminary studies and sketches will have guided the whole creative process toward the final decision; no time will have been wasted in doing any of them if the result is successful.

Oil Painting Materials

Many books have been written on oil painting materials and their development and uses throughout history. I have included the titles of several books on oil painting materials and techniques in the Bibliography at the end of this book. Here, I will describe the oil painting materials I use, as well as some of their characteristics, advantages, and disadvantages:

Oil Pigments. These are divided into three groups: organic, mineral, and synthetic. The following description of some of the oil colors I use will give you an idea of how complex the manufacture of such pigments is today, how far removed from

Puck, Oberon, and Bottom. *(opposite) Oil on canvas, 34" × 37". My approach to this painting was technically quite different from the freer, alla prima sketches and quick portraits elsewhere in this book. I carefully sketched in the nude boys, using charcoal directly on the canvas, then glazed the sketch with a transparent yellow ochre glaze and added the lights and darks.*

Giorgio Vasari's description of grinding the colors fine in a mortar and pestle.

Alizarin crimson is a deep, rich red originally made from the madder root that grows extensively in France. Because of its high cost it is now manufactured synthetically. This color loses its permanence when mixed with earth colors such as yellow ochre, the siennas, and the umbers.

Cadmium yellow is precipitated cadmium sulphide combined with an acid solution of a stable cadmium salt and hydrogen sulphide gas.

Cadmium red is made by adding selenium to cadmium yellow.

Chrome yellow is a useful color. It is a lead chromate made by adding nitrate to a solution of alkali di-

chromate. When chemically pure, this color is permanent; when mixed with colors of organic origin such as the madder pigments, it takes on a greenish hue.

Yellow ochre is a natural earth pigment consisting of silica and clay. It owes its color to iron oxide.

Cerulean blue is a useful pigment that consists of a cobaltous stannate. It has limited tinting strength but is the only blue that does not contain a violet hue.

Cobalt blue, perhaps the bluest pigment, is produced by calcining (burning) a mixture of cobalt oxide and aluminum hydrate to form aluminate. This pigment is very stable and is unaffected by sunlight. Since cobalt blue is one of the most costly artists' colors, it

is sometimes adulterated by the addition of ultramarine blue.

Ultramarine blue is another important color on the artist's palette. It is made artificially by compounding soda, silica, alumina, and sulphur.

Vermillion is red mercuric sulphide. In its natural state, it is the mineral cinnebar, the principal ore of the metal mercury, and was known to the Greeks and Romans in this state.

Emerald green is copper aceto-arsenite and is one of the most brilliant inorganic pigments.

Titanium white is the whitest of the white pigments and has the greatest hiding power, or opacity, of any of the whites. Its chemical name is titanium dioxide and it is derived from the ore ilmenite. This pigment is one of the important contributions of modern technology to the science of color chemistry.

White lead, or flake white, is the most common white pigment, but this color tends to yellow with age.

Ivory black is actually made by charring waste cuttings of ivory and then grinding, washing, and drying the black residue. It is the most intense black, as opposed to lamp black, for instance, which is amorphous carbon and is slightly bluish.

In addition to these pigments there are several others which I use rarely and sparingly. These include sepia, which is a dense, warm, dark color, and crimson lake, which is a very strong, intense color. I also use touches of viridian green to add "life" to a painting.

I did these two charcoal drawings as studies for oil portraits. It is sometimes interesting to omit the tone or shading in the hair, as I did in the drawing on the left. The drawing on the right illustrates another quality —the grace of the upturned head, accentuated here by the classic oval face and the dark tones of the hair.

It may seem that I have "waxed technical" in this brief description of pigments, but I am sure you will grasp the reason why. If you are going to the trouble of painting a portrait, which not only requires skill and patience but is also expensive in time and money, you do not want to end up with pigments that will change color or quality with time.

The museums in many parts of the world are full of paintings that are a long way from their original state because of the chemical reaction of one pigment to another. Sir Joshua Reynolds, the first president of the Royal Academy, has left us portraits that have suffered the consequences of his use of pigments that contained bitumen; all the fine, warm brown areas in these paintings are now a lifeless black.

Canvas. I exercise great care in my choice of canvas. My approach to applying paint, the textures it is possible to create, and the absorption or rejection of pigment by the painting surface are all determined by the quality of the canvas used. Since the cost of a portrait is high, it is only fair to the client to give him a painting done with the best materials. I therefore always choose a high-quality Belgian or French linen canvas made from flax. The tooth, or grain, of such a canvas is neither too fine nor too coarse for my style of portraiture.

Remember that the quality of the priming on the canvas is also important. Since canvas in its raw state is porous and therefore absorbs color, it must be sized (coated with a water-base synthetic resin) and given a coat of white primer (kaolin, chalk, or zinc white) to make it less absorbent. The priming on the surface of the canvas determines whether each tone will retain its original quality; the more absorbent the canvas, the less chance there is of retaining the original quality of the paint applied. The cheaper grades of canvas are usually given two coats of primer, while the higher qualities receive three or more coats.

Each manufacturer has his own grading system and reference numbers for the many qualities of canvas available. Your choice of canvas will, of course, depend on your own techniques and requirements.

Gesso. This is made from gypsum or kaolin and is a useful material to have around the studio. You can use it in thin coats to prime raw canvas or canvas panels, and you can apply thick coats to build up texture on the painting surface itself before you begin to paint.

Mediums. The medium I use most often with oil pigments is turpentine, preferably the synthetic variety because the type made from distilled wood becomes somewhat tacky. I often add linseed oil to the paint when I want a rich quality and slower drying time. When I begin the final sitting of a portrait, I make sure that my mixing palette and the dippers I use to mix the paint and medium are clean; otherwise, fresh colors may look muddy.

Brushes. These are naturally as important as pigments, and it is therefore necessary to pay careful attention to the selection of brushes that will give you the right degree of "spring" and will hold the correct quantity of paint. Cheap brushes seldom produce good work or last very long, and it is vital not to be "penny wise" in buying brushes. When you select your brushes, examine the ferrules—the metal collars that fasten the bristles to the wooden handles—to make sure they are not loose.

Caring for your brushes is just as important as selecting them; you can prolong their "lives" by washing them properly after each use.

For painting children's portraits, I keep a large stock of brushes that

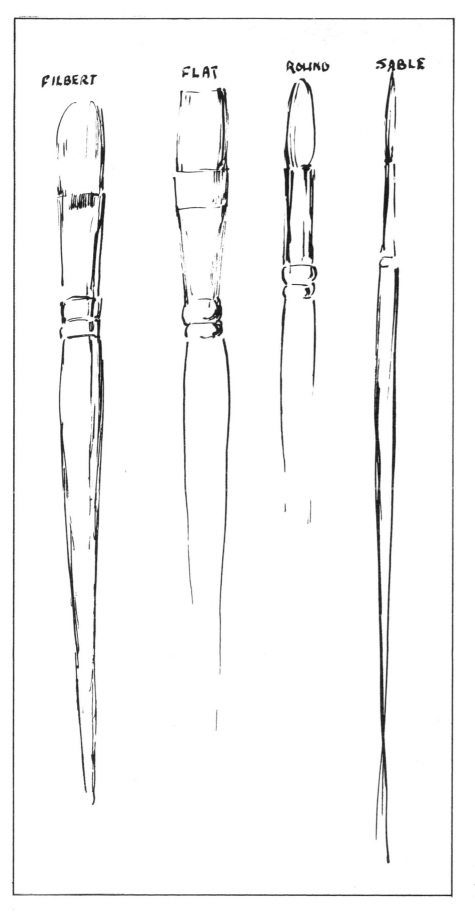

FILBERT FLAT ROUND SABLE

Filbert, flat, round, and sable are the four types of hog hair (bristle) brushes I keep on hand for oil painting.

151

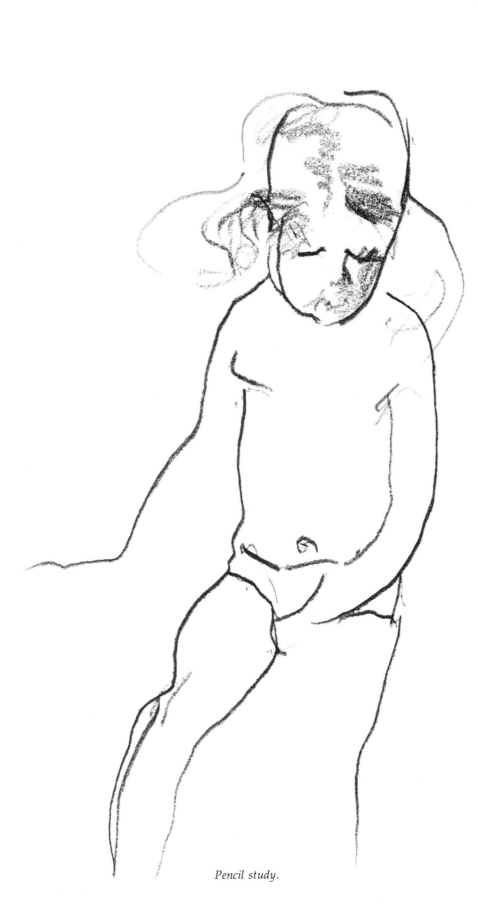

Pencil study.

includes: numbers 4, 6, 8, 10, and 12 hog hair (bristle) brushes, and numbers 4 and 8 sable brushes for adding fine details such as eyelids, lashes, the pupils in the eyes, and the shadowy lines that separate the upper lip from the lower. Sable brushes are the highest quality brushes. They are expensive and must therefore be treated with great care. They should be thoroughly rinsed in turpentine, wiped, and washed with soap and water after each sitting.

Knives. I sometimes use a palette knife to apply a thick, smooth or textured surface of paint to the canvas. Even a house painter's spatula is a useful tool for spreading paint thickly in background areas.

Cleaning Materials. I keep a large supply of rags and paper towels handy for wiping brushes and other painting equipment, as well as for cleaning paint off areas of canvas where I want to change the color.

Cardboard Window. I keep a piece of scrap cardboard roughly 6″ × 8″ with a window 3/4″ × 1″ or even smaller cut out of it. By using this device I can isolate the painting from the studio or parts of the painting from the canvas as a whole. I move the cardboard back and forth in front of my eye until I have just the designated area in focus.

Hand mirror. I use this for study purposes; it provides me with a reverse view of the painting, in which I can instantly see errors clearly.

Oil Painting Techniques

As with materials, the volumes published on the techniques of oil painting are legion, and many authors attempt to begin their histories in the days of the early renaissance if not the late Middle Ages. Giorgio Vasari was one of the first to produce a comprehensive account of oil painting tech-

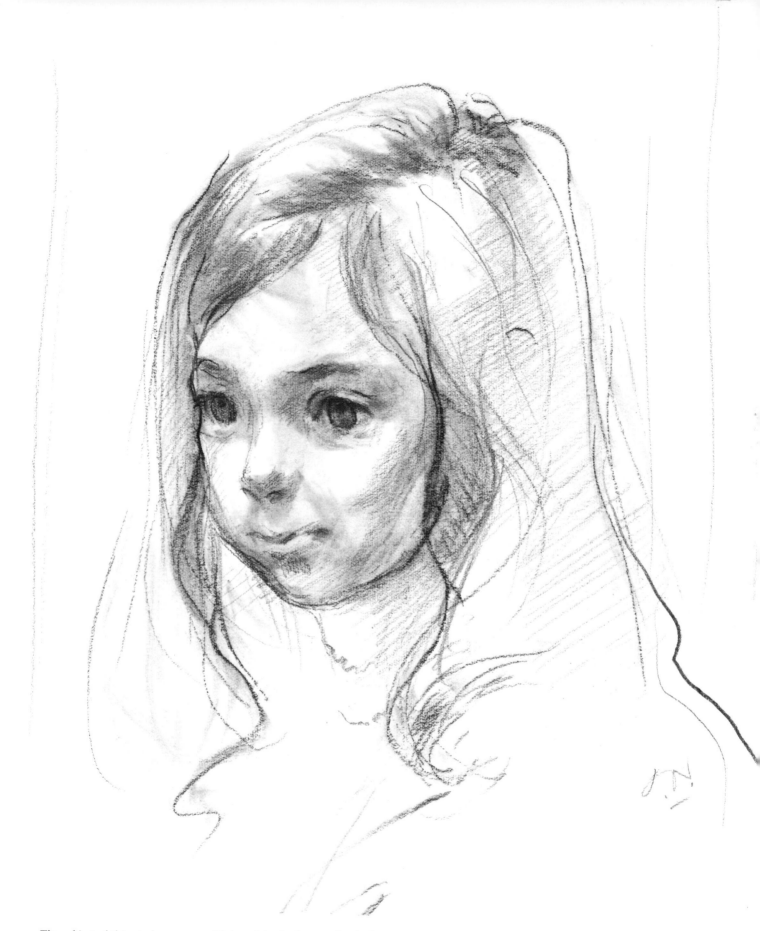

The subject of this study appears with her sister in the completed oil portrait reproduced in color on page 89. I used carbon pencil on 15" × 18" drawing paper for this sketch.

Charcoal pencil study.

niques. Leonardo da Vinci also left us accounts of his techniques, and there are even earlier records such as those left by Theophilus, the German monk of the twelfth century. The generally accepted theory, however, is that it was the fifteenth-century Dutch artist van Eyck who really developed the techniques of oil painting.

It is always worth the time to study different oil painting techniques, from the scumbling and glazing methods characteristic of the Dutch masters right down to our own spontaneous impasto methods of applying paint. Scumbling is the process by which one layer of paint is applied over another, still wet, layer without disturbing the first. In glazing, the first layer of paint is allowed to dry and remains visible through a subsequently applied layer of transparent color. As you probably know, these two techniques are not possible in any other medium. The more direct impasto techniques involve touches of undiluted color either side by side or one stroke on top of another.

Between these two ends of the scale, there is a vast range of techniques that can be used to apply paint to canvas. Since I am dealing mainly with my own painting techniques in this book, I have listed several titles in the Bibliography at the end of the book for those of you who have the time or inclination to inquire as far back as the Middle Ages for further information on the history of oil painting techniques.

To use the Italian phrase, I paint most of my portraits *alla prima*, which means that I aim for the overall effect—try to establish the colors, values, correct proportions, and so on—in the first painting session. This is more an emotional than a cool and technically objective approach. I use impasto techniques as well as scumbling and glazing, according to the style, character, and composition of the portrait, the subject, and my mood or reaction to the subject.

When I require a lively, vigorous texture, my handling of the brushstrokes becomes most important. I make my strokes either with or against the form as necessary, sometimes applying the paint so that it is thick and sensuous, and sometimes thinning it down with turpentine so that I can apply liquid touches of dripping paint.

When I want the surface of the paint to have a high degree of finish, I subordinate the brushwork to the quality of the paint by using a large, soft, fan-shaped brush to blend my strokes together.

In formal portraits, I abide more by the conventional techniques of scumbling and glazing, which also provide a wide range of textural effects.

Time Required

The time required to paint a finished oil portrait usually depends on several factors: the skill and confidence of the artist and his natural speed in handling paint; the personality of the sitter; the degree of finish required. If I am painting a fully worked canvas, it takes me approximately six to eight hours per figure. By this, I mean the time required for painting the actual portrait, not including the preliminary sketches, and so on.

I try to work in sittings of thirty minutes duration with five-minute breaks between. I also allow at least half an hour for preparing materials and posing the sitter before beginning to paint.

In some cases, painters have been known to take a whole summer to paint one child. I feel that such an approach, particularly these days, can hardly produce a lively and spontaneous result, let alone sustain the interest of the young sitter.

I always try to insist that the sittings be given sufficient pri-

Charcoal pencil study.

156

ority in the child's schedule. I have noticed that parents often give insufficient thought to the whole question of time, yet expect a wonderful result. Since you are engaged in a difficult if not precarious profession, you should be prepared in terms of time and convenience.

When time is short, I usually depend on my sketches and studies for guidance in applying finishing details and improving expressions. This applies particularly in the case of hands; I find that children rarely keep their hands in the same pose for any length of time.

Size of the Oil Portrait

After I decide what kind of portrait I am going to paint, I automatically know what size it should be. I use a small canvas—16″ × 20″ up to 20″ × 24″—for a head alone or a head-and-shoulders portrait and a canvas about 25″ × 30″ for a seated child and his hands.

If the portrait includes more than one child, I calculate the size of the canvas by allowing 7″ to 7½″ for the nearest child's head and about 5″ to 6½″ for the head of the child in the middle distance. (Remember that when seen in perspective your subjects will appear smaller as they recede into the distance. Those in the foreground will be larger than those in the middle distance, and those in the background will be smaller still.) If I have any doubts about the exact proportions, I ask two or three of the children to take up their poses so that I can observe the correct spatial relationships and compare my measurements.

As I estimate, I allow for space above and below the figures in the composition, usually about half the size of the most distant head or slightly more. I also think about allowing space to the right and left sides of the figures.

The ideal canon to use in planning the proportions of a single figure in a portrait is the ratio of five to eight

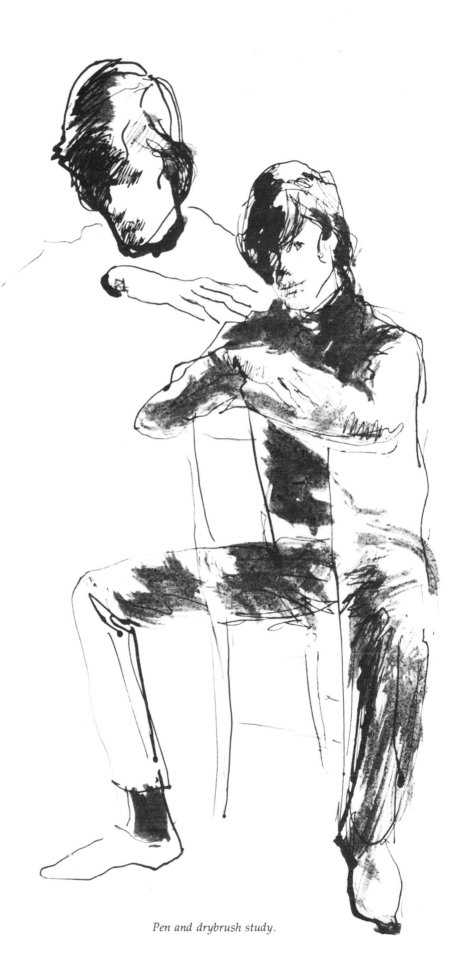

Pen and drybrush study.

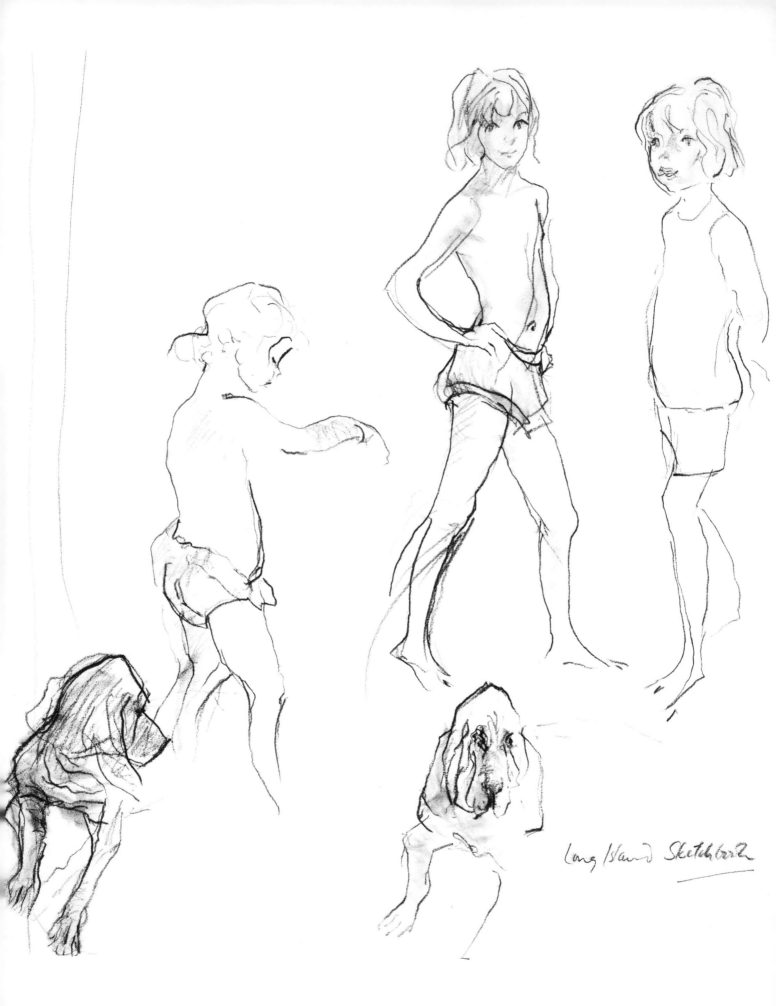

Long Island Sketchbook

based on the Greek golden mean. In other words, for every 3″ you allow horizontally on your painting surface, you should allow 4″ vertically.

A useful aid in making such calculations is a piece of cardboard about 6″ × 8″ with a window cut out of it in the same proportions and pieces of thread drawn vertically and horizontally across it to form either 1″ or ½″ square grids. You can use this device as you place your figures and estimate their proportions by holding it over your sketch and blocking in your figures using the three-to-four ratio. This scaled-down version of your canvas, with the grid across its face, will help you break down the area of your painting surface into sections so that you can place each shape and form where you want it.

You may also find it useful to draw enlarged squares in the same proportions on your canvas and then fill in the corresponding shapes and lines that you see in the sketch through the smaller squares in your cardboard.

Oil Painting Procedure

The following is a brief description of my approach to painting an oil portrait. A full-color, step-by-step demonstration of a finished oil portrait begins on page 142.

I usually paint the background so that it will appear to recede. To do this, I create very little texture in the background areas and save most of the heavy brushwork for the final touches in the figure.

I try to work in logical sequence, starting with the background areas farthest from the figure and working my brushstrokes forward until I have built up the part of the form nearest to me and highest in the composition. I also work around the entire portrait, keeping every part going at the same time. This is important in maintaining color harmony and balance.

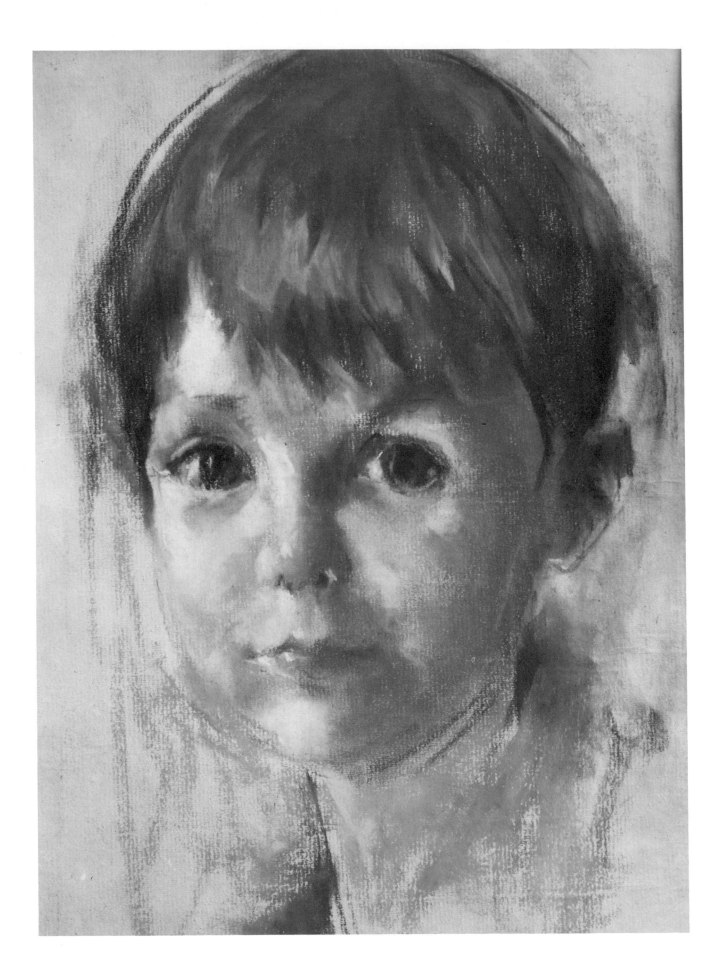

Chapter 13
Presentation of the Portrait

The qualities of a painting or a drawing can be visibly improved or diminished by the amount of attention the artist gives to the frame and the painting's surroundings. I have even changed the color or texture of the walls in my studio so that paintings due to be hung on them would be enhanced in tone, color, or visual importance.

Mats

Mats are generally required to finish off the appearance of a drawing. The beveled edge inside the cut-out area of the mat gives the drawing dignity and leads the eye to the frame. If you use a mat, the rule to follow is to provide a narrow, simple, neutral colored frame.

In addition to white mats, colored mats may also be used, but the selection of a colored mat requires a lot of thought and must be studied under a variety of lighting conditions. If it is a charcoal or pencil drawing, a white or pale blue mat is the best, and the safest, choice.

A thin pencil or watercolor line may be drawn or painted into the area immediately surrounding the window or cut-out area of the mat. This is known as a washed-line mat. The idea behind it is to soften the hard edge of the mat and, again, give the drawing more dignity.

I have used a wide variety of mats, including burlap, buckram (used in clothing to stiffen collars), and silk. In making such a choice, it is necessary to discuss your mat with an expert.

Frames

This subject requires special study not only because your portrait can be made or marred by the frame, but also because there are too many professional framers who have little knowledge of their work and even less genuine interest in pleasing the owner or helping improve a painting.

As you can imagine, there are innumerable examples and types of

Julian Barran. *(opposite) Pastel on paper, 19" × 22". Collection Sir David and Lady Barran, London, England. In this pastel portrait I tried to capture the subject's look of curious intelligence, which is seen quite often in the faces of children who haven't quite reached seven—the age of reason!*

REVERSE SWEEP TO
MOLDING - 3" TO 4½"

CLASSIC SWEPT BACK
MOLDING 3" TO 4½"
FOR OILS

CARVED OR PLASTER
FRAME 3" TO 4"

SIMPLE WOOD OR
METAL MOLDING
FOR DRAWINGS ½" TO 1"

*These are examples of the various types of molding used in frames, ranging from the
very simple (top left) to the ornate (bottom right).*

frames. In most large cities around the world, however, framers stock only mass-produced moldings. Gone are the days when a master framer would start with the raw wood, although I do know a very good—in fact a master—framer in London who does just that. He has made many superb frames for my portraits of children, each one especially designed to complement the portrait.

Generally speaking, children's portraits require fairly simple frames, particularly if the artist's style is bold and simple. I always avoid carved or molded plaster frames that have been cheaply gilded. Remember that the frame must serve two purposes: to act as a complementary outline for the portrait and to relate this marriage to the room where it is going to hang. If you have an important portrait, my advice is to try to find a good picture framer regardless of cost. The frame should "draw" you into an enjoyment of the painting.

Lighting

I have seen too many badly lighted portraits and paintings; I have even seen great paintings in family collections, some by the Impressionists, lighted by hideous brass-shaded lamps, with weak strips of light jutting out over the paintings and obscuring the full breadth of the work that was supposed to be illuminated. If painting a portrait is important, then seeing it under the best conditions must be just as important.

In the earlier chapters I have written at length about the relationship of light and color. Consequently, if a certain color has been painted under ideal studio conditions, it is obviously not going to appear as the painter intended if it is seen in half-light or cold light or too warm a light.

For natural lighting, it is best to hang an important painting near a large window, with the light coming from the side rather than from the front. If glass is used in the frame, as it is for pastel paintings or charcoal drawings, you must be careful to avoid reflections.

The ideal form of artificial lighting is the framed spotlight. The framed spotlight focuses a powerful light of the appropriate color on the area of the painting alone; even when the rest of the room is in darkness, the painting will be visible. The bulb may be exposed in its box or unit or concealed in the ceiling. However, concealing a framed spotlight is a very expensive business and can be done only by a specialist.

Where to Hang the Painting

Most people modestly avoid hanging portraits of themselves in the living or drawing room but are not averse to hanging a child's portrait there, particularly if it has pictorial qualities in addition to its values as a portrait. Large family portraits need a lot of space, and for this reason the living room is often the most suitable area. The dining room is also a good area, and many portraits are hung in the entrance hall. The bedroom or study is usually a good place for pastel paintings and drawings, as these have a quality of intimacy or personal family feeling.

To sum up, the location of the painting is for you to discuss with the parents and/or the interior decorator. Framing, lighting, and site are all related and must be treated together when you consider the ultimate purpose and location of the portrait.

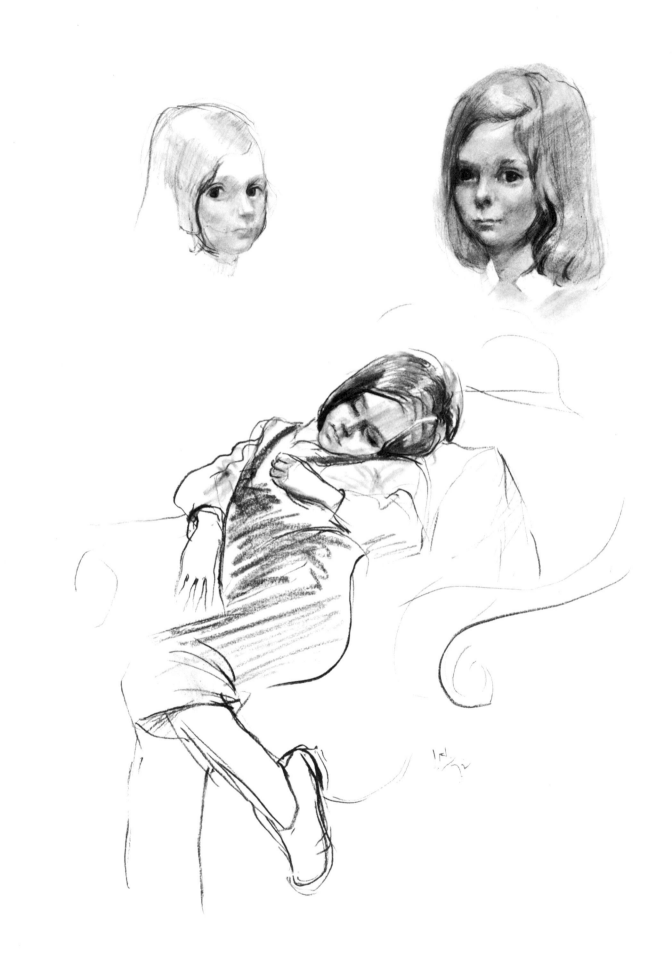

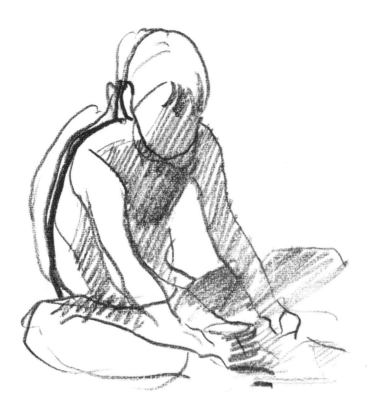

Chapter 14
Professional Portrait Painting

Unlike most professions, portrait painting has a few unwritten codes and ethics of practice. As a profession, portrait painting hovers between the social scene and the purely commercial, and your position within it will depend very much on how you look at it. Obviously, since you will be exchanging expertise or talent for money, it will be difficult to evaluate your work; your only criteria will be the experience of others and what you feel are the generally accepted market value and cost or value of time.

Fees

The best way to find out the current cost of portraits is to go to a gallery such as Portraits Incorporated in New York City and inquire about the fees being charged there. In London, the Royal Society of Portrait Painters provides a useful guide to painters' fees in that city. Of course, these fees will vary according to the artist's fame and skill, and generally according to the size of the canvas.

It is always advisable to charge modest fees at the start of your career and work up as your skill and confidence increase. One good way to calculate how much you should charge is to give yourself a flat hourly rate somewhat akin to any highly skilled worker's rate. To this you should add the cost of materials, traveling expenses, and so on, and then add a profit of at least fifty percent of the sum.

Exhibitions

It is always difficult for a portrait painter to arrange for a gallery to show his work, because portraiture is considered rather mundane art and well-known critics think it beneath them to review such a show —unless, of course, you have painted a very famous public figure or film star! Galleries avoid taking this sort of risk but may be willing to rent their space to

On the opposite page is what I consider one of my best spontaneous drawings of a child. I began with the drawing at the upper left, using a stick of willow charcoal, then moved to the one at the upper right, adding red chalk to give the drawing warmth. When the sitter fell asleep, I quickly switched to the larger and freer drawing in the lower half of the paper. The actual size of the drawing is 18" × 20", and I completed it in about twenty minutes.

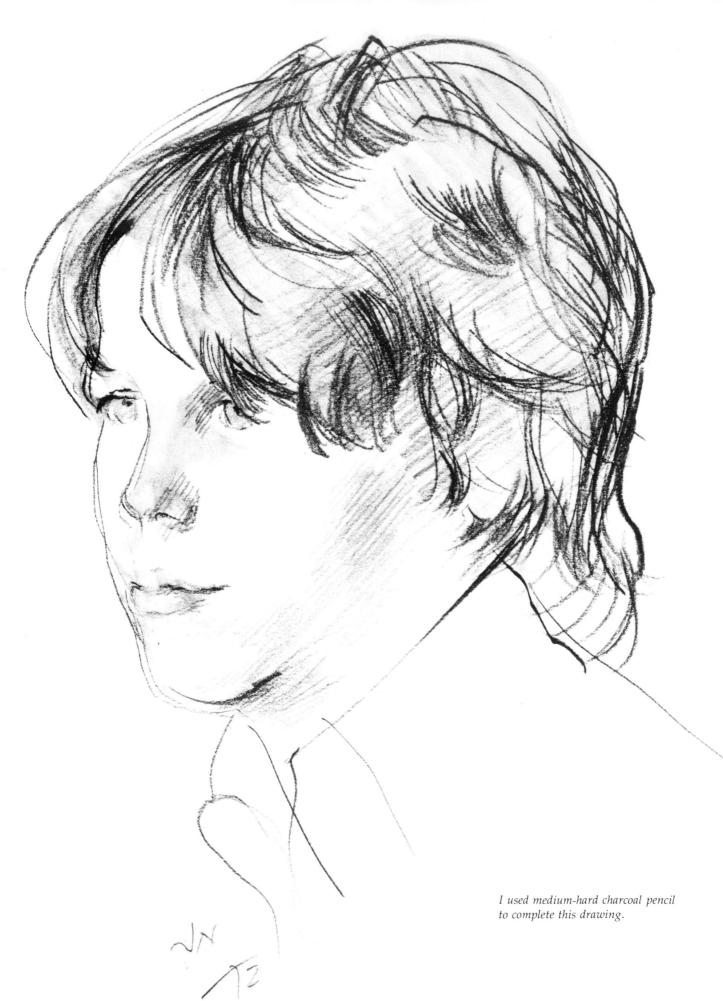

I used medium-hard charcoal pencil to complete this drawing.

you and perhaps to organize some publicity for a fee, usually a very high one. In addition, you will also have to pay the gallery a percentage of the sales or the fees resulting from commissions.

Agents

I do not operate with an agent but have managed to build up a clientele through word of mouth over the years. It is difficult to find a good agent, and only rarely will galleries consider handling a portrait painter. A gallery is a commercial organization and as such will put the profit motive first in its order of priorities. The painters it deals with will consequently have to be, in a sense, good "investments." If the artist attracts customers and high fees, he is a "good horse" to back, but not otherwise.

I have depended entirely on personal introductions and recommendations. If I have to consider a show at a commercial gallery, it is usually an exhibition of work that will attract the art critic rather than the prospective client who might commission a portrait.

Public Relations

Here is another expensive item for the professional painter to consider. Nothing comes cheap in this world anymore! Public relations experts are as professional as anyone else, perhaps even the painter himself, and they will charge a lot of money for the time they spend promoting an artist. Their job entails being well connected with the press and/or important people in almost every walk of life, especially people who are financially well off. This means entertaining them, and as we all know today, entertainment is costly. A very competent and genuine public relations expert can help a painter enormously, but at a price!

Typical Portrait Painting Schedule

The following schedule describes the sequence of events that take place as I carry out a typical commission to paint a family portrait:

First day. Arrive at the children's home and meet the parents and governess or nanny. Get to know the children and the house. Carry out a "reconnaissance" in order to choose the best room to paint in. Perhaps do some light sketching, mainly as an exercise in getting to know the children.

Second day. Begin serious sketching as early in the morning as possible, after a family breakfast during which I study the children carefully. Break for lunch. Children rest. Continue sketching in the afternoon.

Third day. Do more serious sketching and drawing of detailed studies if and when necessary. Begin to form ideas about grouping and perhaps try out one or two with all the children together. Discuss the portrait with the parents in the evening, before or after dinner, according to their schedule. Perhaps make some definite choice or decision as to grouping

Fourth day. Begin a small oil sketch, if necessary, early in the day. Try to finish this sketch during the day, with more sittings, so that a final discussion can take place the same evening.

Fifth day. Begin painting the final large canvas. Either sketch in the figures using charcoal and fixative or paint them in directly using a brush and oil paint.

Sixth day. Hold separate sittings with each child and bring the painting of each to a half-finished stage.

Seventh day. Finish the portrait. Check proportions, tones, colors, and likeness. (I often reach the finishing stage on the fifth day.)

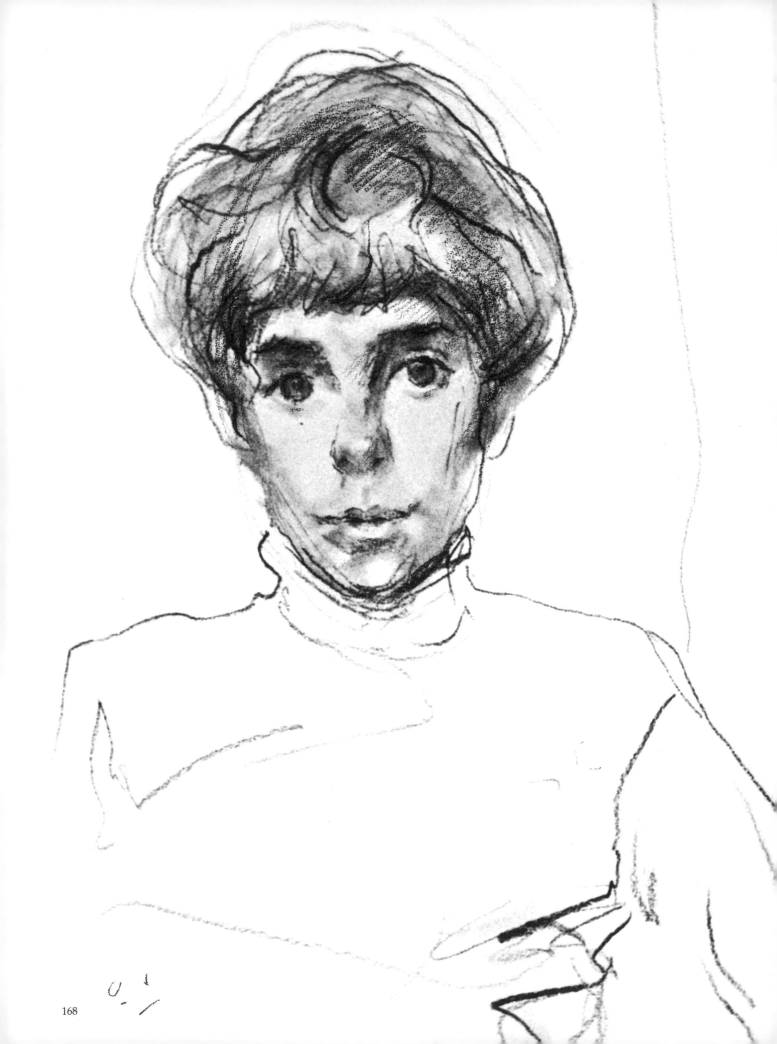

Conclusion

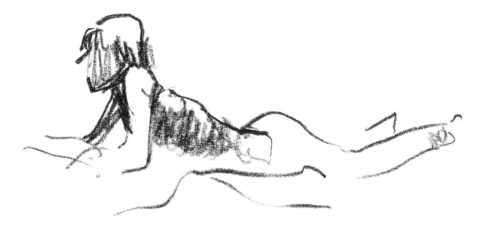

It is only through knowledge and much experience that an artist can hope to achieve skill and gain confidence. My advice, therefore, is practice painting as much as you can at every available opportunity. To quote Michelangelo: "Do the thing with a great amount of labor so that it seems to have been done almost without any."

To use a simple analogy, a drawing or painting has to be built just like a house. There is the foundation and there are the walls and the roof. All cannot be put down at once, so it is imperative to organize your mind before you begin work. Separate each component clearly, think about each independently, and then start with first things first.

For example, consider the size of your painting surface and then relate the proportions of the finished work to it. Commence with a *feeling* for structure, then a *feel-*ing for technique, and finally a *feeling* for color.

You will note here that I have emphasized *feeling*. This is the essence of a work of art, but it can be developed only after you have acquired a sound basis of *knowledge*. There is too much to think about at one time, and if the artist tries to begin painting while in a state of confusion the result will be disastrous.

I would like to end this book with another quotation from one of the greatest minds this world has produced—this time, Leonardo da Vinci: "A good painter has two chief objects to paint, man and the intention of his soul. The former is easy, the latter hard because he has to represent it by attitudes and movements of the limbs. . . . You must depict your figures with gestures which will show what the figure has in his mind, otherwise your art will not be praiseworthy."

For this drawing (opposite) I used carbon pencil on 18" × 20" drawing paper. Since I did not have my easel with me, I propped my drawing board on one chair and sat in another one.

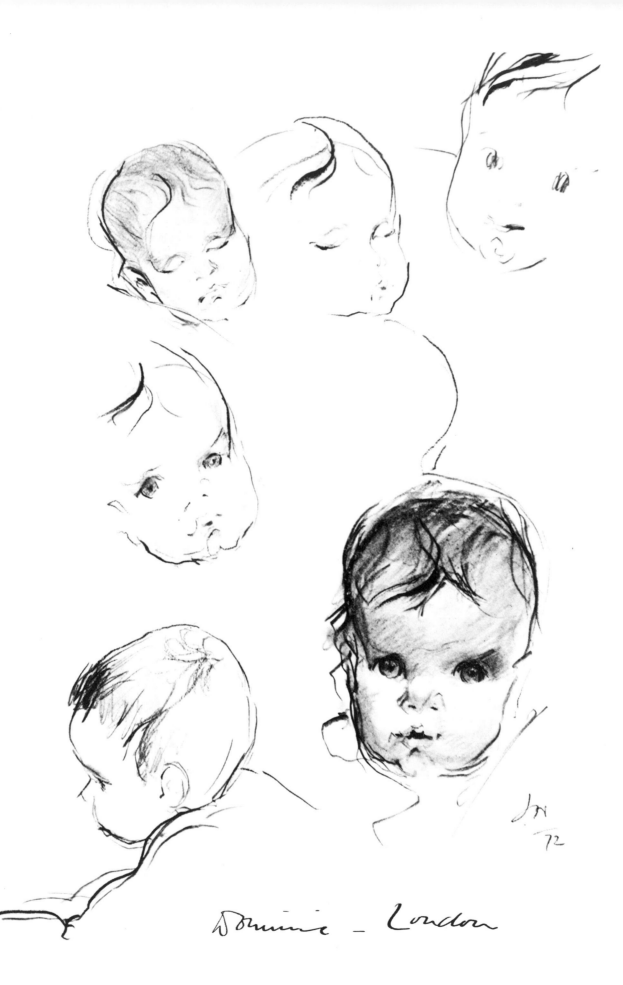

Dominic – London

Bibliography

Birren, Faber. *Principles of Color: A Review of Past Traditions & Modern Theories of Color Harmony.* New York: Van Nostrand Reinhold, 1969.

Dawley, Joseph. *Character Studies in Oil.* New York: Watson-Guptill Publications, 1972, London: Pitman, 1972.

Hogarth, Burne. *Drawing the Human Head.* New York: Watson-Guptill Publications, 1972.

————*Dynamic Figure Drawing.* New York: Watson-Guptill Publications, 1972, London: Pitman, 1974.

Klee, Paul. *The Thinking Eye.* Ed by J. Spiller. London: Lund Humphries, 1961.

Laurie, Arthur P. *The Painter's Methods & Materials.* New York and London: Dover Publications, 1967.

Malraux, André. *Saturn: An Essay on Goya.* New York: Phaidon Publishers, Inc., 1957.

Reid, Charles. *Portrait Painting in Watercolor.* New York: Watson-Guptill Publications, 1973, London: Pitman, 1973.

Rimmer, William. *Art Anatomy.* Pap. New York and London: Dover Publications.

Sartre, Jean-Paul. *Situations.* Pap. New York: French & European Publications, Inc., 1965, London: Pitman, 1973.

Singer, Joe. *How to Paint Portraits in Pastel.* New York: Watson-Guptill Publications, 1972.

Speed, Harold. *The Practice and Science of Drawing*. London: Seeley Service & Cooper, Ltd.

Thomson, Arthur. *Handbook of Anatomy for Art Students*. Pap. New York and London: Dover Publications.

Vasari, Giorgio. *Vasari on Technique*. Ed by B. Baldwin Brown. Pap. New York and London: Dover Publications.

Zucker, Paul. *Styles in Painting*. Pap. New York and London: Dover, 1950.

Index

Edited by Lois Miller
Designed by James Craig and Robert Fillie
Set in 10 point Palatino by Gerard Associates/Graphic Arts, Inc.
Printed and bound by Halliday Lithograph Corp.
Color printed in Japan by Toppan Printing Company Ltd.